Working With Plastic Laminates

A Home Craftsman's Handbook

Roger W. Cliffe & Marc Adams

 Sterling Publishing Co., Inc. New York

Library of Congress Cataloging-in-Publication Data

Cliffe, Roger W.
 Working with plastic laminates : a home craftsman's handbook /
 Roger W. Cliffe & Marc Adams.
 p. cm.
 Includes index.
 ISBN 0-8069-0570-0
 1. Cabinetwork. 2. Laminated plastics. 3. Veneers and veneering.
 I. Adams, Marc. II. Title.
 TT197.C58 1994
 684.1′6—dc20 94-16485
 CIP

10 9 8 7 6 5 4 3 2 1

Published by Sterling Publishing Company, Inc.
387 Park Avenue South, New York, N.Y. 10016
© 1994 by Roger W. Cliffe and Marc Adams
Distributed in Canada by Sterling Publishing
% Canadian Manda Group, One Atlantic Avenue, Suite 105
Toronto, Ontario, Canada M6K 3E7
Distributed in Great Britain and Europe by Cassell PLC
Villiers House, 41/47 Strand, London WC2N 5JE, England
Distributed in Australia by Capricorn Link (Australia) Pty Ltd.
P.O. Box 6651, Baulkham Hills, Business Centre, NSW 2153, Australia
Manufactured in the United States of America
All rights reserved

Sterling ISBN 0-8069-0570-0

Contents

CHAPTER 1
Basic Information

High-pressure decorative laminates (as distinguished from low-pressure laminates, which are not as durable, strong, or resilient) are a product that has evolved over the last century. Throughout the years, laminated products have taken on new shapes and functions, and have become more versatile. Today, there are literally hundreds of uses for plastic laminate in both residential and commercial areas (Illus. 1–1–1–4).

Because laminates offer an incredible media for expression, architects, designers, cabinet-makers, and home do-it-yourselfers are now able to produce a variety of products. Today's craftsman will find decorative laminate to be a product that has no equal.

In the late 1800's, the mineral mica was being used as an electrical insulating material. As the cost of mining went up and the inevitable depletion of this natural mineral became apparent, finding a suitable substitute became a challenge. Bonding kraft paper and plastic resin under heat and pressure created a product that was lightweight, strong, inexpensive, easy to fabricate, and in great supply. By the early 1900's, laminated plastics seemed to be the answer to replacing costly mineral and ceramic insulators. Before the end of World War II, the laminate industry was in full production. As methods of manufacturing improved, plastic laminates were utilized in more diverse ways. Laminated plastics were being used as insulators, airplane propellers,

Illus. 1–1. (Photo courtesy of Wilsonart and Gallery of Homes Design Team: Jon Spitz, Douglas Chapman, Gay Fly, and Molly Korb.)

Illus. 1–2. (Photo taken by Greg Hurlsley and provided courtesy of Wilsonart. Design layout by Pamela Berry.)

Illus. 1–3. (Photo taken by Alan Karchner and provided courtesy of Wilsonart and architect Tod Williams.)

Illus. 1–4. (Photo courtesy of Wilsonart and General Mica.)

gears, pulleys, cams, coil cores, internal parts of early radios, and other small mechanical parts in household appliances (Illus. 1–5).

Illus. 1–5. Laminated products were used for everything when first discovered—except counter surfaces.

The concept of using a laminate product for furniture applications was first conceived by the radio industry in the mid-1920's. Resistance to heat and moisture, durability, strength, dimensional stability, and ease of fabrication made plastic-laminated products a natural for many furniture surfaces. However, laminated products during this time period were used only as industrial components and were not very attractive (Illus. 1–6). However, in the 1930's laminate engineers decided to combine kraft-paper resin backing with a layer of colored paper and a thin protective coat of transparent plastic resin. "Sandwiching" these three layers together under extreme heat and pressure forced them to bond, and created a new decorative material: high-pressure decorative laminate. This is the same material we know and use today.

Just when decorative laminates were becoming popular, World War II broke out. The entire plastic-laminate industry then focused exclusively on producing military parts. After the war, there was a boom in almost all facets of industry. New homes, schools, hospitals, and factories were built. Since the laminate industries were no longer manufacturing military parts, they were able once again to focus on the new applications of laminates. With

Illus. 1–6. Almost all electrical-component boards use laminate as a core and copper as the conductive surface. The laminate body is a woven material.

Illus. 1–7. The potential of decorative laminate is endless. (Photo courtesy of Wilsonart.)

the development of contact adhesives, even more uses for laminated products became evident. Cabinet-makers, furniture-makers, builders, remodellers, and home do-it-yourselfers (Illus. 1–7) could now fabricate laminates to adhere to almost any surface. No other product has offered the craftsman so many qualities and options as that of decorative, laminated plastic surfaces.

The National Electrical Manufacturers Association (NEMA) is a trade association that was created in the years before World War II. It is through this association that all voluntary standards of quality for the decorative, laminated plastic industry are formulated. NEMA has also developed a set of standards for the application, fabrication, and installation of all laminated case goods. This book will help you to gain a better understanding of working with laminated products in accordance with NEMA standards.

HOW LAMINATES ARE MADE

NEMA defines high-pressure decorative laminates as: "Decorative laminated plastic sheets which consist of papers, fabrics or other core materials that have been laminated at pressures of more than 750 pounds per square inch, using thermosetting condensation resins as binders" (Illus. 1–8).

The Architectural Woodworking Institute describes a typical sheet of general-purpose, high-pressure decorative laminate as "made from a sandwich of melamine-impregnated alpha-cellulose overlay and decorative surface papers, superimposed over phenolic resin-impregnated kraft papers [Illus. 1–9]. The sandwich is pressed at temperatures exceeding 265 degrees Fahrenheit, at pressures as high as 1,000 pounds per square inch, or more" (Illus. 1–10). It continues:

"The thickness of the laminate is determined by the number of layers of papers and the resulting amount of resin absorbed. As the sheet is pressed, a steel caul plate contributes a surface texture to the decorative face. When the sheet has been pressed, the back (resin-impregnated kraft paper) is sanded. Since this surface resembles similarly sanded wood, it accepts adhesive readily and can be bonded easily to a substrate."

After examining the anatomy of a piece of decorative laminate, it becomes apparent that laminate is basically a wood product. Well over 80% of a sheet of laminate is composed of kraft paper (the same material that grocery sacks are made from, as shown in Illus. 1–11). *Kraft* is the German word for strong. Each resin-impregnated sheet of kraft paper is arranged so that the fibres all face in the same direction. Once the sheet has been pressed, the back is sanded. These scratch marks indicate the fibre direction, which will help determine expansion, contraction, and bending considerations (Illus. 1–12 and 1–13).

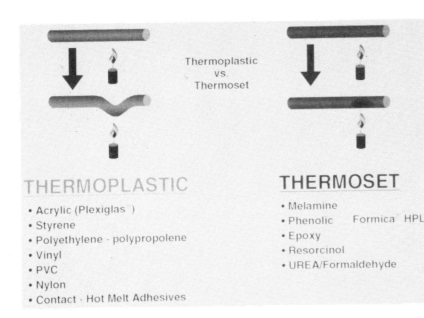

Illus. 1–8. High-pressure decorative laminates are a thermoset product. Once they have been heated and pressed, they become more like glass than plastic. (Photo courtesy of Formica.)

THERMOPLASTIC

• Acrylic (Plexiglas)
• Styrene
• Polyethylene - polypropolene
• Vinyl
• PVC
• Nylon
• Contact - Hot Melt Adhesives

THERMOSET

• Melamine
• Phenolic Formica HPL
• Epoxy
• Resorcinol
• UREA/Formaldehyde

Thermoplastic
vs.
Thermoset

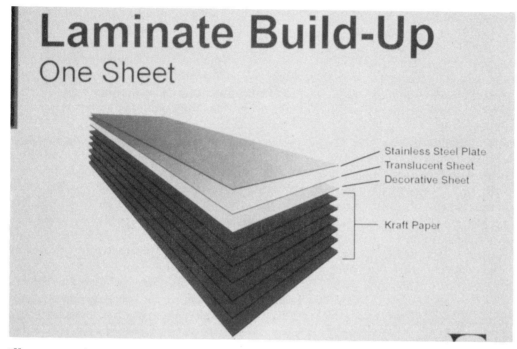

Laminate Build-Up
One Sheet

- Stainless Steel Plate
- Translucent Sheet
- Decorative Sheet
- Kraft Paper

Illus. 1–9. (Photo courtesy of Formica.)

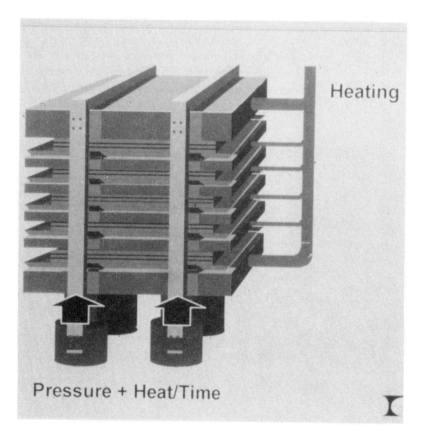

Heating

Pressure + Heat/Time

Illus. 1–10. Laminate requires heat and pressure. Once the laminate has reached proper temperature and pressure, it will be cooled gradually to room temperature. (Photo courtesy of Formica.)

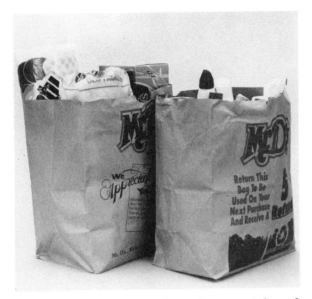

Illus. 1–11. Kraft paper, the same material used in grocery sacks, is what makes up most of a sheet of laminate.

Illus. 1–12. Sanding marks on the back of a sheet of laminate.

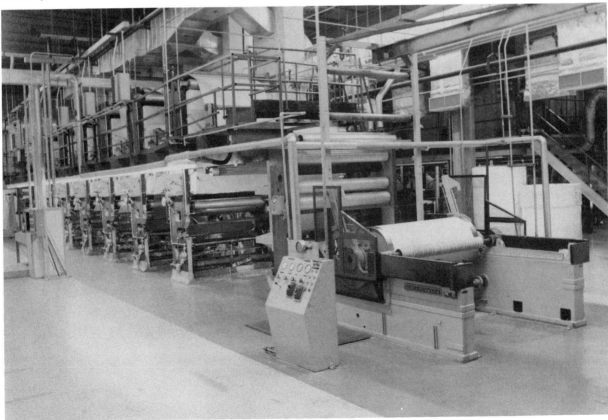

Illus. 1–13. Laminate sheets being manufactured at Westinghouse. (Photo courtesy of Westinghouse Micarta.)

CHARACTERISTICS OF LAMINATES

Decorative laminates are used as a surfacing material on countertops, desks, cabinets, wall panelling, and furniture. Since decorative laminates are always bonded to a substrate, a condition exists where the laminate and substrate will probably expand at different rates, unless a rigid glue bond has been made. (Rigid glue bonds are made when a thermoset-type glue is used.) There are three areas of concern that must be observed when planning any and all fabrication and installation of laminate: movement and stability, fibre grain direction, and expansion/contraction after fabrication.

Movement and Stability

High-pressure laminate is a wood product and like all wood products moves with changes in humidity. When humidity varies, the width of a laminate undergoes greater dimensional change than the length, by a ratio of two to one (Illus. 1–14). Dimensional change is a characteristic found in varying degrees in all cellulosic materials. When humidity increases, the laminate sheet expands, and, as the humidity decreases, the laminate sheet contracts. There is no way to stop this natural process of movement. However, there are ways to control this action, such as preconditioning substrates and selecting the proper substrates. Decorative laminates maintain a high degree of stability only if the atmospheric conditions—heat and moisture—remain constant.

Fibre Grain Direction

Like wood, decorative laminates have a definite grain direction. The grain direction is best observed by the directional scratch marks on the back or phenolic resin backing. The fibre bundles lie in the same direction, or are parallel to, the sanding marks. A piece of laminate that is being bent, such as occurs in radius corner-edge applications, will be more flexible if the bend occurs perpendicular to the sanding marks (Illus. 1–15). There will be a considerable amount of resilience or spring-back if the bend occurs in the same direction as the sanding marks. Laminates expand twice as much in their cross-direction as they do in their grain direction (the direction parallel with the sanding lines).

Whenever a panel is being laminated on both sides, it is important to align the sanding marks on the top and bottom. When possible, align the grain direction of the laminate with the longest panel dimension. It is also advisable to align the grain and cross-grain directions of the laminate with the grain and cross-grain direction of the substrate being used, if applicable.

Expansion and Contraction After Fabrication

It is essential to bring the laminate, substrate, and adhesive to a state of equilibrium in respect to temperature and moisture before any fabrication

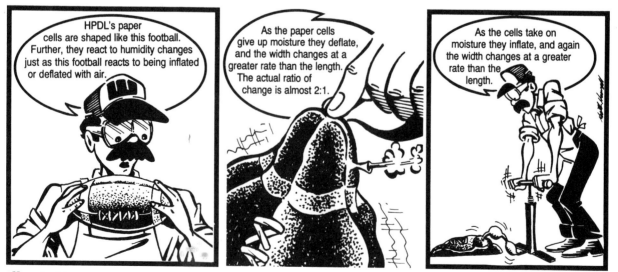

Illus. 1–14.

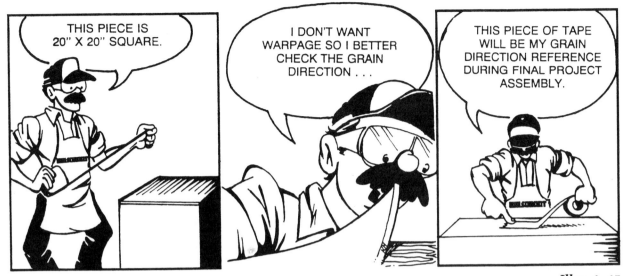

Illus. 1–15.

takes place. More information on conditioning appears in Chapter 5. One important item to remember about post-fabrication of laminate is the expansion/contraction difference between the laminate and the substrate. If a contact adhesive has been used to bond the laminate to the substrate, a semi-rigid glue bond will occur. This glue bond will allow both the laminate and substrate to move independently of each other. If a thermoset-type glue has been used, a rigid glue bond will occur. This bond will help pass the strength characteristics of the laminate directly to the substrate. At the same time, a rigid bond will control the independent movement between the substrate and the laminate.

Dealing with expansion and contraction after fabrication becomes a major concern when the finished project is to be geographically relocated. As competent craftsmen, it is our responsibility to understand the interaction of our work with the environment (Illus. 1–16). A countertop made in Aspen, Colorado, and then shipped to Tampa, Florida, will probably encounter problems unless the effects of heat and moisture are accounted for. Paying careful

Illus. 1–16. Know where your projects are going before fabricating the laminate. This map shows the relative humidity of the various American states.

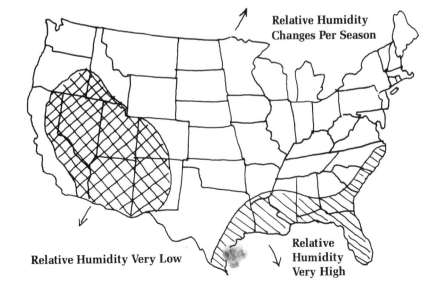

attention to the preconditioning of all materials being used and to substrate selection, and using a thermosetting-type glue will help avert possible failures related to abrupt environmental changes. This is discussed in more depth in Chapter 2.

TYPES OF LAMINATE

Today, manufacturers are driven by the competitive marketplace to keep current with trends and design concepts. In America there are at least five major manufacturers of high-pressure decorative laminates. They each offer well over one hundred different choices of varying colors, textures, and finishes (Illus. 1–17). New laser printing techniques have contributed to fine, exact details and special visual effects. Aesthetically, there is almost an unlimited variety of laminates to choose from.

All decorative laminates can be divided into nine different grades based on the application requirement: general-purpose, vertical-grade, post-forming, cabinet liner, backer, specific-purpose, high-wear, fire-rated, and chemical resistant.

General-Purpose or Standard-Grade Laminate

This type of laminate is the most common type available today (Illus. 1–18). It can be applied to both vertical and horizontal surfaces where good appearance, durability, and resistance to stains and heat are necessary. General-purpose laminate is .050 inch thick. Applications include kitchen counter, table, and desk tops, as well as fixtures, case goods, walls, and furniture items. Standard-grade laminates will bend to a 9-inch radius without heating, and to a radius of 2½ inches when heat is applied.

Vertical-Grade Laminate

This grade of laminate is specifically designed for vertical surfaces. Vertical-grade laminate is similar

Illus. 1–17.

Illus. 1–18. Standard-grade laminate is the most common type. It is durable and can be used in almost any application. (Photo courtesy of Formica.)

to standard-grade laminate in terms of its appearance and resistance to stains and heat. It is approximately .028 of an inch thick. Since this grade of laminate has one or two layers less of kraft paper than standard-grade laminate, it is inherently weaker. It is recommended for areas which will receive less wear and impact than typical horizontal areas. Vertical-grade laminates are best suited for cabinet-door and drawer fronts, and edge banding and trim. They can be bent to a 3-inch radius at room temperature, and to about a ¾-inch radius when heat is applied.

Postforming-Grade Laminate

While all laminates bend with heat to some extent, postforming laminates are designed to achieve consistent bending results with much tighter radii (Illus. 1–19). Postforming laminates are made with special papers and resins that allow a more controlled bending process.

Postforming-grade laminates are either .042 or .030 inch thick. They are designed to achieve a ⅛- to ⅝-inch outside radius and an inside radius as tight

as ³⁄₁₆ inch. They are commonly used around doors and sill ledges, countertops, and on tight-radius desktops.

There are two major advantages of formed surfaces on exposed casework. First, the formed edges are resistant to chipping. Most chip damage occurs at sharp 90-degree corners. Second, seams are eliminated when surfaces are curved, creating a surface that is much easier to maintain.

Cabinet-Liner-Grade Laminate

This type of laminate is decorative but limited to only specific colors. Cabinet-liner-grade laminate is intended to be used where it will withstand little wear, such as the inside of cabinets and closets. It is a very thin sheet material that is usually .020 inch thick.

Backer Sheets

Backer material is a nondecorative laminate that is usually available in black or brown. This is a low-cost material used on the under side or back of

Illus. 1–19. The process of bending laminate is called postforming. Chapter 7 discusses postforming techniques. (Photo courtesy of Evans Machinery.)

freestanding casework or tables. Backer sheets are available in thicknesses of .050, .042, and .028 inch. Their main function is to prevent warping and to protect against dimensional instability of both the laminate and substrate in conditions of changing temperature and humidity.

Specific-Purpose Laminate

This is a type of laminate that is available in the same colors as standard-grade laminate and in increased thicknesses. It is intended for applications where high strength and resistance to impact, water, and humidity are required (Illus. 1–20). It can be applied to either horizontal or vertical surfaces. Because of its inherently high strength, specific-purpose laminate may be used as structural material. It may be drilled, tapped, sanded, shaped, and cut with standard carbide tools. This material is not recommended for application directly to plaster, gypsum board, or concrete. Thick stock is available

on factory order only. It is available in thicknesses of up to 1.0 inch.

High-Wear Laminate

High-wear laminate is a general-purpose, high-pressure decorative laminate with increased surface-wear resistance. These laminate offer superior abrasion and scuff resistance due to a very thin deposit of microscopic particles of aluminum oxide on the top layer of melamine (Illus. 1–21). These laminates are available in thicknesses of .050, .042, .028, and .020 inch. Applications for high-wear laminate include any surface that is prone to scuffing, sliding, and abrasive wear.

Fire-Rated Laminate

Fire-rated, high-pressure decorative laminates are evaluated and certified by code-specifying agencies, such as the National Fire Protection Associa-

Illus. 1–20. Specific-purpose laminates make great commercial bathroom stall dividers. (Photo taken by C. P. Chris Smith and provided courtesy of Wilsonart. Design layout by Charlynn Casey.)

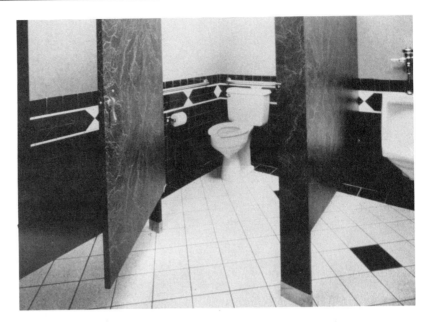

tion, the Building Officials Conference of America, and other local, state, and federal code agencies. Fire-rated grades of laminate are used where durability, heat resistance, and resistance to stains from ordinary sources are required. They can be applied to either vertical or horizontal surfaces. They are available in thicknesses of .050 and .028 inch. The laminate, adhesive, and substrate must all individually meet fire code ratings.

Major applications of fire-rated laminates include elevator panels, wainscot cladding in corridors, in stairwells, on doors, as well as a surface on fixtures and cabinetry. Fire-rated laminates are available in a wide range of colors and patterns. Be aware of the local fire code when installing or applying the laminate. A local fire code can be more strict and take precedence over the National Fire Code.

Chemical-Resistant-Grade Laminate

Chemical-resistant or laboratory-grade laminates are intended for applications where harsh acids, alkalies, corrosive salts, solvents, and other destructive or staining substances are required (Illus. 1–22). This grade of laminate can be applied to interior horizontal or vertical surfaces.

Laboratory-grade laminates may be postformed

Illus. 1–21. Each manufacturer offers a laminate that has a special surface coating to increase surface wear. (Photo courtesy of Wilsonart. Design layout by Elaine Mandel.)

Illus. 1–22. Chemical-resistant laminates can withstand solvents and acids much better than other laminates. (Photo courtesy of Wilsonart.)

to outside edge radii of ⅝ inch or greater and/or ¼-inch cove radii. They are .042 inch thick. Until recently, this laminate was available in black only. However, because of engineering breakthroughs, the laminate is now available in several different colors.

SIZES OF LAMINATES

High-pressure decorative laminates are available in several different combinations of width and length. They are most commonly available in widths of 24, 36, 48, and 60 inches. Almost all sheet stocks available today have an extra 1 inch added to their overall width, to allow a better yield. The most common lengths are 60, 72, 84, 96, 120, and 144 inches. Again, an extra inch is added to these lengths to help provide a better yield. It is important to keep in mind these sizes when designing a project. Most distributors carry 4 × 8-foot sheets as their most common stock size. Plastic laminates are sold by the square foot, with the .050-inch standard-grade laminate as the base size.

RANGE OF FINISHES

Today, there are almost as many choices for the top finish on laminates as there are colors of laminates (Illus. 1-23 and 1-24). A good finish must provide a durable surface as well as an aesthetically pleasing one. The standard finish available on all laminates is a soft, semi-gloss reflective surface referred to as mat, suede, or velvet. This surface will be easy to maintain and will not show every fingerprint.

For wood patterns, most manufacturers produce a soft, or satin, finish with the feel of wax (Illus. 1–25). This finish is for those who want to use a laminated product while trying to create a wooden appearance.

Today, architects and designers frequently use a high-gloss, or glossy, mirror or polished finish. These types of finish should not be used in applications of high wear. Because of their high level of shine, all scratches will become visible. This is especially true on the darker colors and patterns. Although these finishes show all fingerprints, they are very easy to maintain and clean.

Textured or embossed finishes provide various individual forms of creative expression. Included are leather, cane, tweed, flax, and slate (Illus. 1–26) finishes and a variety of geometric motifs such as grids, pinstripes (Illus. 1–27), discs, and dots. Embossed finishes will be slightly more difficult to maintain. They will also wear uneven on their high points, and be harder to clean on their low points.

Clear finishes today are a new concept that offer a pebbly texture. These new finishes are more characteristic of the mat finish. They have a very rich and lustrous appearance, and are maintained the same as any other laminate finish.

COLOR

Color is an important aspect of design. And since design is dictated by trend, manufacturers are constantly producing as many colors as possible to satisfy the ever-changing needs of the decorative-laminate designer. Many of us remember our first laminate countertop as being white with gold flakes. This was one of the first colors used on laminated countertops that replaced the old linoleum countertops in homes. At that time, in the 1950's, there were only a handful of colors available. By the mid-1970's, the white tops with the gold flakes were being replaced with wood-pattern butcher-block tops. Solid colors during this time period were not very popular; however, there was an increasing variety of laminates to choose from. By the 1980's, solid colors became popular, and there was a wide variety of laminates available.

Considering all the manufacturers making decorative laminates today, there are probably over 1,000 options to choose from. Because of the large variety and the exorbitant cost of inventorying all these laminates, manufacturers will often stop production of a certain type or color of laminate. Be sure to check on the availability of any color before you

Illus. 1–23. Wilsonart whites.

Illus. 1–24. Wilsonart granite gloss.

Illus. 1–25 (left). Formica wood grain. Illus. 1–26 (above). Formica slate.

Illus. 1–27. Formica stripes.

begin a project, especially if you are replacing a cabinet or other plastic-laminate project.

METAL, VENEER, TAMBOUR, AND THROUGH-COLOR LAMINATES

As the decorative laminate field started to expand, and manufacturing techniques became more sophisticated, some new and exciting products were developed. A whole new line of surface veneers was introduced. Also available were metal, veneer, tambour, and through-color laminates. Metal, veneer and tambour laminates are manufactured in much the same way as plastic laminates. Through-color laminates are decorative papers all the way through. Each is described below.

Metal Laminate

Metal laminate is a type of decorative laminate that has a thin metal face on top of a backer of kraft paper and phenolic resin (Illus. 1–28). These laminates can be applied either in horizontal or vertical positions, and should always be used for interior fabrications. Their primary advantage is that they are much easier to fabricate, as compared to conventional metals. They are easy to glue to a substrate and are not as prone to denting as regular veneering metals. The thin-metal top sheet will scratch through to the brown phenolic backing if mistreated.

Metal laminates can conduct electricity. Clean them with warm water and mild soaps such as those used for hands or dishes. You should never use any cleanser with abrasives, alkalis, or acids; they will mar the surface. Always wipe the surface completely dry with a clean, soft cloth after washing it.

Natural-Wood-Veneer Laminates

This type of decorative laminate (Illus. 1–29) is manufactured in two different ways. Both use a thin layer of wood veneer bonded to a core of kraft paper under high pressure and heat. One process leaves the veneer untouched and ready to finish. The other process adds the protective melamine resin to the face.

These veneers can be applied in either horizontal or vertical positions. They should always be used for interior applications. They can be bookmatched, or sequenced from sheet to sheet. For special projects, some manufacturers allow the craftsman to select the flitch and order of layup (the layup is the sequence in which veneers are taped or glued together to create uniformity in appearance). Other benefits of using wood-veneer decorative laminates are their flexibility, strength, species availability, and the economics of buying them in sheet sizes. Caring for and maintaining their melamine faces is similar to the maintenance and care of any other decorative laminate. If you are using the laminate that does not have the melamine protective coating, you will need to maintain it according to the finish that has been applied.

Illus. 1–28. Metal laminates look like metal and can be applied as easily as regular laminates.
(Photo courtesy of Wilsonart.)

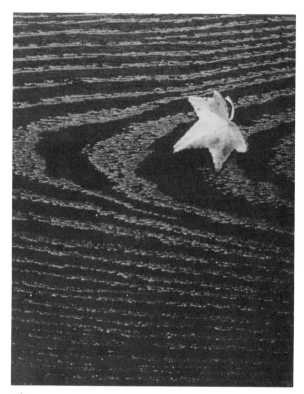

Illus. 1–29. Wilsonart simulated-wood-grain patterns.

Decorative Tambours

Tambours are used in two basic ways: as fixed decorative surfaces applied with an adhesive or construction mastic to a substrate, or as functional closure material, sliding in a track or routed groove. As fixed surfaces, decorative tambours clad walls and wainscoting, wrap columns and counter fronts, and "dress up" residential furniture (Illus. 1–30). Decorative tambours are intended for interior vertical applications. They are not structural materials, and must be bonded to a suitable substrate for fixed or nonfunctional applications. Decorative tambours can be purchased with laminate, metal, and wood surfaces. Their maintenance and care will depend upon the type of surface they have.

Functional tambours provide sliding doors that conceal appliances, books, large tools, and kitchen implements, and are used on old, traditional rolltop desks.

Through-Color Laminates

Through-color laminates were designed to provide color throughout the edges, eliminating the dark edge line that is often visible with regular laminates. (See color section.) Because this product is

Illus. 1–30. Tambours add a look of mystery to any project.
(Photo courtesy of Formica.)

treated entirely with melamine resins, dimensional changes occur as a result of fluctuations in the relative humidity. The movement of this type of material is much greater than the movement of conventional laminates. This material is available in thicknesses of .050 and .060 inch. Through-color laminates are slightly stiffer and more brittle than regular laminates.

From a design standpoint, through-color laminates offer a new approach to laminate fabrication. It is possible to create monolithic forms. Through-color laminates can be used to create inlays and stacked layers. They can also be sandblasted and sculpted. There are some specific fabrication techniques discussed in Chapter 8.

NEW PRODUCTS

Because the market today is so competitive, manufacturers are constantly developing new and exciting products. Because the surfacing industry is so competitive, manufacturers are constantly employing their latest technological developments and improvements in manufacturing to attempt to produce new and better plastic laminates. Most of these products offer greater resistance to wear, impact, staining, ultraviolet light, and even static dissipation. However, for every advantage there always seems to be a disadvantage. In almost every case, there is a significant expense added to the cost of these materials. The cost of these products is determined by the material they are made of, the quantity specified, and who manufactures the product. New products today include static-dissipative laminates, engraving laminates, flooring laminates, custom-made laminates, and alternative surfacing materials such as Nuvel, Vitricor, and solid-surfacing materials.

Static-Dissipative Laminates

Laminates were first used as electrical insulators. Laminates do not store static electricity, nor are they conductive. Because of this characteristic, laminates are a good material to use in areas where static electricity must be avoided, such as X-ray rooms, computer rooms, and specially controlled environments. However, there are some instances where electrostatic charges must be removed from the surface. This has caused the laminate industry to de-

velop a laminate that actually conducts electricity to a specific source. These decorative laminates have a conductive layer that is on the back of each sheet. This backing can be connected to a ground to aid in dissipating any static buildup. Static-dissipative laminates are used for benches and tool tops with electronic displays, in environments with lab equipment and instrument monitors, around photo equipment, and on computer desktops. Antistatic laminates are produced in many different colors, patterns, and thicknesses.

Engraving Laminates

Engraving laminates are new laminates that were developed for the sign and name plate industry. These laminates have the same features as general-purpose laminates. This material is available with a black, red, or white core. The face on this laminate is available in almost all colors.

Flooring Laminates

Flooring laminates have actually been around for quite some time. Yet, because of their low exposure to the marketplace they seem to be a new product. These decorative laminates are formulated for surfacing panels used for access or for raised-panel floors. They are thicker than general-purpose laminates.

Flooring-laminate panels can be removed for easy access to wiring or line work under the floor surface. This type of flooring is commonly used in hospitals in cardiac care areas, computer facilities, and heavy traffic areas where both pedestrian and wheeled traffic might be a concern. It can be made to provide a permanent static dissipation. This type of flooring can be cleaned in much the same fashion as a linoleum floor. It does not require sealing, varnishing, buffing, or waxing.

Custom-Made Laminates

Many designers and fabricators are unaware that laminate manufacturers can custom-make decorative laminate surfaces for individual needs (Illus. 1–31). Examples of custom-made surfaces would include bowling lanes, backgammon boards, maps, menus, charts, and game tables. Laminates can be produced with logos and special textures and can

Illus. 1–31. Some laminate manufacturers offer custom-made laminates with specific surfaces. (Photo courtesy of Wilsonart.)

even be produced to look like custom silk screening. This process would be very expensive in small quantities, and not all manufacturers offer this service. It is recommended that you contact your local distributor for more information on custom-made laminates.

Nuvel

Nuvel surfacing material is a new product that is produced by General Electric and distributed by Formica (Illus. 1-32). It is a product that will find a niche somewhere between high-pressure laminate and solid-surface material. Nuvel is a high-density, mineral-filled thermoplastic polymer that is .090 inch thick. It is durable, formable, and workable as laminate. It is possible to create a near-invisible seam where the material butts together and can be adhered to a substrate with contact adhesive or a seaming two-part system. Nuvel can be maintained by using any household mild abrasive cleanser, and will not stain easily.

Vitricor

Vitricor is produced by Nevamar. Vitricor surfacing material offers a reflective gloss appearance that is unlike the appearance of any other surfacing material. It achieves the look of a fine hand-lacquered finish with considerable depth.

Vitricor is a decorative surfacing material on the

Illus. 1–32. Nuvel is a General Electric and Formica product that is formable, durable, renewable, and workable. (Photo courtesy of Formica.)

backside of a molecular-weight methacrylate sheet that is ⅛ inch thick. It is available in both horizontal and vertical sheet stock and is recommended for

interior applications, but can be fabricated for exterior applications by following specific guidelines. Although the tools used for fabricating Vitricor are the same ones used for plastic laminates, there are several differences in the actual fabricating technique.

Vitricor should only be cleaned by using a soft cloth or sponge and soap and water. Glass cleaner is also effective. Vitricor is best suited for applications where appearance and a clear reflection are important factors in the overall design.

Solid-Surface Materials

Solid-surface materials such as Corian by DuPont, Fountainhead by Nevamar, Surell by Formica (Illus. 1-33), and Gibraltar by Wilsonart are widely accepted as superior materials for kitchen countertops, vanity tops, sinks, and bowls. These materials can be used in such various commercial applications as teller counters, laboratory tops, serving countertops, toilet partitions, and window sills.

Solid-surface materials are solid throughout and are available in thicknesses of ¼, ½, and ¾ inches. Solid-surface materials are highly resistant to impact. They resist fracturing and chipping better than marble, and normal surface abrasions, nicks, scratches, and cuts can be removed by regular cleaning and maintenance (Illus. 1–34). Solid-surface materials resist staining and heat much better than most decorative laminate materials. Although the solid-surface materials produced by different manufacturers are composed of different materials, they all have plastic resins and mineral fillers. These materials are inherently strong and do not require a substrate under normal conditions. Solid-surfacing materials can be machined with the same tools used for woodworking; however, carbide tools cut considerably better than high-speed-steel tools.

There are two major drawbacks to this type of surfacing material. First, since this is a premium product, it is considerably more expensive than decorative laminates. Second, it is recommended that all fabrication be done by a certified fabricator. Some manufacturers will only sell their product to a certified shop; this will ensure that installations are completed properly and will keep the warranty intact.

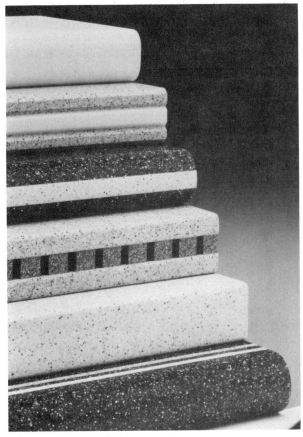

Illus. 1–33. Surell by Formica.

PROPERTIES OF LAMINATES

In general, all high-pressure decorative laminates have specific properties and limitations that you should consider before attempting any fabrication. Following is a list of five general rules that should be followed to ensure successful fabrication when working with decorative laminates:

1. Laminates are intended for interior use only, and should not be submitted to heavy exposure of ultraviolet rays of the sun.
2. Laminates should not be used as cutting surfaces. Deep scratches will damage the melamine surface and lead to staining of the color paper underneath.
3. Laminates should never be exposed to caustic chemicals such as drain and toilet bowl cleaners. These chemicals will permanently mar the surface, almost on direct contact.

4. Laminates will blister or discolor under extreme heat. Avoid overexposure to constant heat. Laminates should not be subjected to temperatures over 150 degrees Fahrenheit for any period of time.

5. Laminates must always be applied to a substrate surface. While laminates are inherently strong, they cannot function structurally on their own.

Illus. 1–34. Solid-surface material offers durability as well as beautiful looks. Shown here is Gibraltar, by Wilsonart.

CHAPTER 2

Handling, Storing and Maintaining Laminate

Decorative laminate material is generally purchased through some type of retail distributor (Illus. 2–1 and 2–2). Your local cabinet-maker can assist you in locating a laminate distributor in your area. However, your local distributor might require a tax identification number or a minimum purchase amount. Other supply-source options might include your local countertop shop, some department stores, and any home do-it-yourself lumber store.

With all the colors and textures available today,

most likely the laminate you intend to use will have to be ordered. Delivery is usually within a week, and since laminate only weighs ½ pound per square foot it can be rolled up and shipped (Illus. 2–3) via United Parcel Service, Federal Express, or common carrier. Once you receive the laminate, you should immediately remove it from its protective box (Illus. 2–4) and check that its color matches your original color sample (Illus. 2–5). Make sure that the laminate has not become wet, contaminated, or physi-

Illus. 2–1. Formica Corporation Warehouse in Indiana.

Illus. 2–2. Laminate ready for shipping.

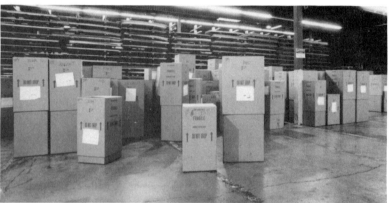

Illus. 2–3. Rolls of laminate ready to be shipped.

Illus. 2–4. As soon as you receive your shipment of laminate, remove it from the shipping container, unroll it, and store it flat.

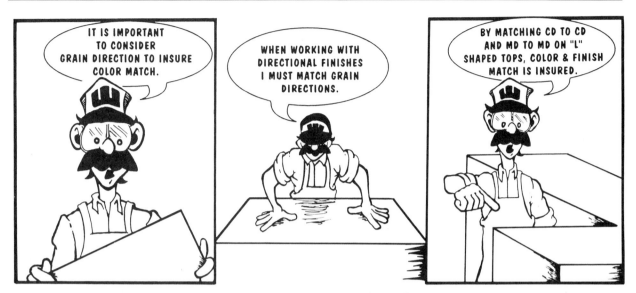

Illus. 2–5. Not only is it important to make sure the color of your laminate matches the sample, you should also line up the directional marks on the back of the laminate to ensure color consistency.

cally damaged during transport. If any of these conditions are found, contact the delivering carrier as well as the supplier to report the problem.

HANDLING PROCEDURES

1. Always carry laminate sheets vertically. It is recommended that two people carry full-size sheets (Illus. 2–6).

Illus. 2–6. It is easier to handle large sheets of laminate if two people carry them.

2. Do not allow the material to flex uncontrollably; this could cause the laminate to crack or break. Once laminate is fractured, the edges become very sharp.
3. When moving laminate, do not strike it against anything which would damage the surface or edges (Illus. 2–7).

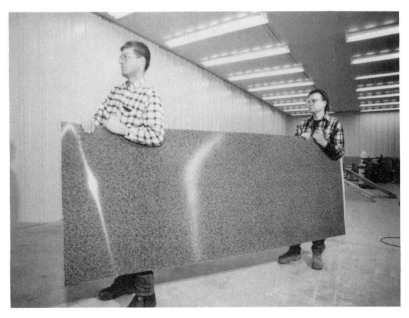

Illus. 2–7. Always remove laminate from any storage area with care.

4. Never slide the panel on its decorative surface. Leave any protective film on the laminate until after fabrication. It is best when accepting a laminate with a protective film to peel back a small area and make sure it matches the color of your sample (Illus. 2–8).
5. Treat high-gloss surfaces with extra care to prevent scratches.
6. Never drag one sheet across the face of another.
7. Be careful when unwinding the laminate if it has been rolled up for shipping purposes. It may spring back towards you.

STORAGE

Laminate sheets should never be stored outdoors (Illus. 2–9 and 2–10). The indoor storage area should be clean, dry, well ventilated, and isolated from machining operations that create dust, dirt, or airborne particles that could contaminate the laminate. Laminates should never be stored in an area where they will be exposed to direct sunlight or rain. It is best to store laminate sheets in a horizontal position with the top sheet turned facedown or a caul board placed on top to protect the material from possible damage and reduce the chance or warpage of the top sheets (Illus. 2–11 and 2–12). If the laminate is to be stored in a vertical position, it is best to have a caul board on both sides to help maintain a flat position.

Always make certain that no debris is between the sheets; any debris might scuff or scratch the face surface(s) of the product. If the laminate has been rolled up for shipping reasons, it is important to

Illus. 2–8. Some laminates come with a protective cover sheet.

immediately unroll the material to prevent it from taking on a temporary curved shape.

The optimum conditions for storage consist of a temperature of approximately 75 degrees Fahrenheit (24 degrees Celsius) and a relative humidity of 35 to 45.

Illus. 2–9. A special storage area designed for all size cut-offs of laminate.

Illus. 2–10. A storage system for storing finished countertops before delivery.

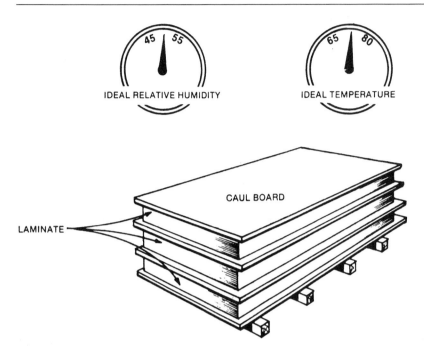

IDEAL RELATIVE HUMIDITY

IDEAL TEMPERATURE

Illus. 2–11. It is best to store laminate horizontally. It is recommended that the top of the laminate stack be covered with a ¾-inch-thick piece of particleboard. (Drawing from NEMA Standards Publication No. LD 3.)

CAUL BOARD

LAMINATE

Illus. 2–12. The top sheet of any laminate that is not covered with a caul board should be flipped over to help protect the good face.

CONDITIONING OF MATERIALS PRIOR TO FABRICATION

All the materials that are to be used in the fabrication process must be properly conditioned. The laminate, the substrate, and the adhesive must be in equilibrium at the same relative humidity and temperature before any assembly begins. It is recommended that a conditioning process of at least 48 hours take place before any fabrication. In other

words, if the substrate has been stored in the garage, the laminate in your workshop, and the adhesive in the basement on a concrete floor, chances are that all three elements do not contain the same percentage of moisture or will not have equal ambient temperatures (Illus. 2–13). The conditioning process requires that your substrate, laminate, and adhesive all be brought to the area of intended fabrication so that they can acclimate to the environment for a period of time before being used.

When conditioning the materials, also make allowances for the geographical location in which fabrication or installation will take place. For example, laminate work that is being done in the southeastern part of the United States will not be as susceptible to shrinkage of the laminate and substrate because of higher yearly humidity and temperature rates. However, northern regions of the United States have continual seasonal changes in temperature and humidity, and, consequently, both the laminate and the substrate are perpetually moving.

Today, the end product is often fabricated in one part of the country and then shipped to another. It is possible for a cabinet to be made on a Monday in a location where the temperature and the humidity are both high, and by Wednesday be shipped to an area where they are both low. As the laminate

Text continues on page 41

There are hundreds of residential and commercial applications for plastic laminates. (Photo courtesy of Wilsonart. Design layout by Susan Orena, CKD.)

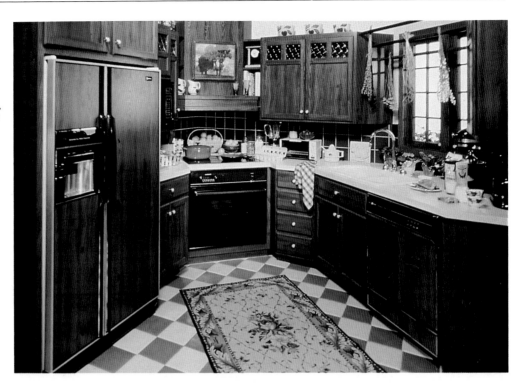

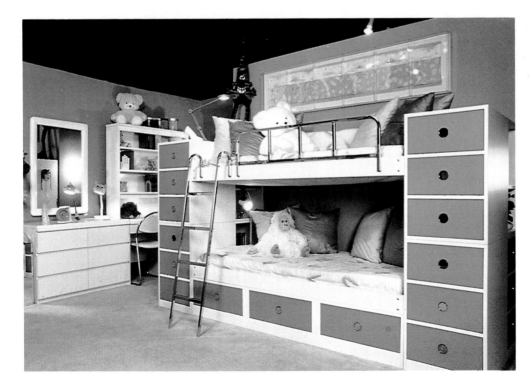

Bunk beds, dressers, and bookshelves, all faced with laminates. Plastic laminates stand up well in a children's room. They are easy to clean and withstand rough play. (Photo courtesy of Wilsonart. Design layout by Janet Biddick, Interior Architect Furniture Design.)

Laminates remain sanitary and resist spills; they are well suited to fast-food areas. (Photo courtesy of Wilsonart. Design layout by Rod Lopez-Fabrega Design, Inc.)

Laminate has great moisture resistance, making it the perfect product for bathrooms. (Photo taken by Dan Ham and provided courtesy of Wilsonart. Design layout by Gay Fly and Ambrogio Rossari.)

The bell captain's station in this hotel is covered with plastic laminate. It looks good, and will wear well.

Glossy black plastic laminate was used to replace the cracked marble on this storefront. Laminates are not designed for outdoor use, but this laminate has withstood ten Illinois winters with no ill effects.

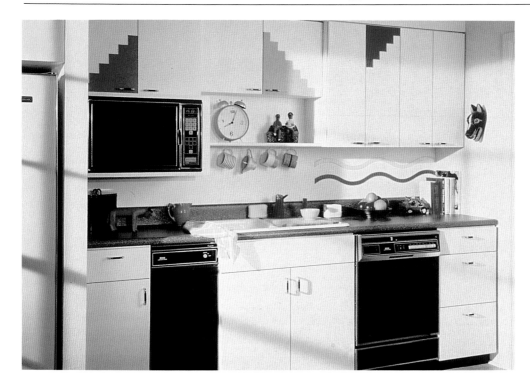

Laminates are favored for traditional kitchen designs. (Photo courtesy of Wilsonart.)

Laminates also lend themselves to nontraditional designs. (Photo courtesy of Wilsonart.)

(Photo courtesy of Wilsonart.)

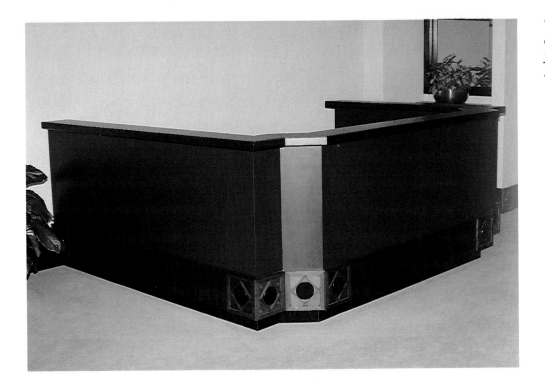

This reception desk was made from blue laminate, combined with mahogany wood.

The lines in this decorative laminate help the designer make a statement. (Photo courtesy of Formica.)

Since laminates are stain-resistant, they work well around food.

Plastic laminates are available in an almost limitless range of top finishes. Shown here is Wilsonart diagonal gloss.

Wilsonart touchstone finish. Can you think of some applications for this finish?

Patterns that were first popular in the 1950's are popular today.

Tambours can be used as a fixed decorative surface applied with an adhesive or construction mastic to a substrate or as a functional closure material that slides in a track or routed groove. Here is an example of a decorative tambour. This design is called Tambour City. (Photo courtesy of Formica.)

Through-color laminates allow the craftsman to fabricate laminates with a monolithic look. (Photo courtesy of Formica.)

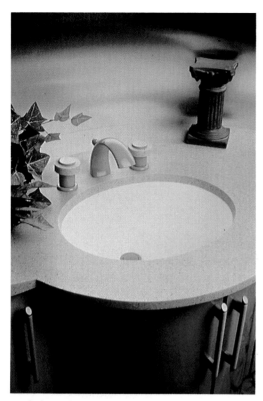

Gibraltar solid-surface material has been used in this kitchen counter application.

Solid-surface materials are considered superior for kitchen countertops, vanity tops, sinks, and bowls. Solid-surface products are more comparable to cultured marble than to laminate. They can be as much as seven times higher in cost than laminate. Shown here is Gibraltar solid-surface material, by Wilsonart.

The edge treatment on this countertop has utilized a mitred design, to eliminate any seams. (Photo courtesy of Formica.)

reaches moisture equilibrium with the new environment it will shrink, possibly at a different rate than the substrate. It would be advisable to dry all the components (the substrate and the laminate) to a lower moisture content before any original fabrication takes place. This drier material will already be acclimated to the lower moisture content of the new environment.

One other way to minimize environmental stress on the laminate is to use a rigid or thermoset type of adhesive. A rigid glue bond will help to pass the inherent strength of the laminate to the substrate, and vice versa.

The following is a list of general information that best summarizes the process of conditioning:

1. Stored laminate stock should be rotated so that older sheets will be used before the new ones.
2. Most problems which arise after fabrication and installation are due to differentials in expansion and contraction between the laminate and the substrate. It is recommended that, no matter where you live geographically, the laminate, substrate, and the adhesive be stored for a period of no less than 48 hours in the intended area of fabrication. This environment should be at least 75 degrees Fahrenheit (24 degrees Celsius) and at a relative humidity of 45 to 55 percent. Provisions should be made to allow air to circulate around the components.
3. Never allow the components to lie on a concrete floor during the acclimation process.
4. Remember that any warp in the laminate sheet prior to bonding will not cause warp in the finished panel. Warped laminate sheets can be used unless they are warped so badly that they are hard to handle.
5. Always know the intended location of the finished project. Make all necessary changes to the components before any fabrication takes place. Use a humidifier to add moisture during the acclimation process if the project is to be shipped to a high-moisture environment. Use a dehumidifier to remove moisture if the project is to be shipped to a low-moisture environment.
6. When possible, use a rigid glue bond to help diffuse any stress that might build up from contraction/expansion between the substrate and the laminate.

CARE OF DECORATIVE LAMINATES

One of the great attributes of decorative laminates is their ability to look attractive and contemporary for many years with the proper care (Illus. 2–14). You can clean them every day by simply wiping them with a damp sponge. As a general rule, laminates are cared for in the same way, no matter who was their manufacturer.

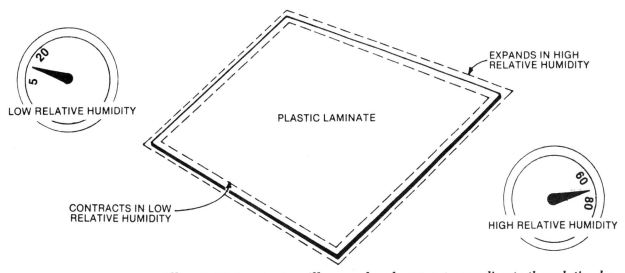

Illus. 2–13. Laminate will expand and contract according to the relative humidity. (Drawing from NEMA Standards Publication No. LD 3.)

Illus. 2–14. Decorative laminates will maintain an attractive appearance for many years—with the proper care. (Photo courtesy of Formica.)

When discussing the care of laminates, it is important to remember that laminates are not a surface on which to make cuts or on which to place hot pots and pans. Always use trivets and hot pads to help protect the life of the counter surface. Following is a list of several basic cleaning steps to help protect decorative laminated surfaces:

1. Wash the surface with mild dish-washing liquid or powdered detergent and warm water. Use a soft dish cloth. Rinse with warm water, and dry with a soft cloth.
2. For spots that cannot be removed by step 1, use an all-purpose cleaner or bathroom cleaner such as Formula 409, Lestoil, Lysol, Pine-Sol, and Top Job (Illus. 2–15). Follow the manufacturer's instructions. Rinse with warm water and dry with a soft cloth.
3. For very stubborn spots, make a paste with baking soda and water (Illus. 2–16). The paste will be slightly abrasive, so work carefully to keep from damaging the surface. (Avoid commercial abrasive cleaning agents such as Comet and Soft Scrub.) Dip a soft-bristle brush into the paste so that the bristles are covered. Then gently rub the spot with the brush, moving in a circle and pressing very lightly. Rinse the surface with warm water and dry it with a soft cloth. Repeat steps 1, 2, and 3 as necessary, if the spot seems to be going away.
4. If the spot still remains, use undiluted household bleach. Make sure you protect your skin—it would be a good idea to wear rubber gloves. Apply the bleach to the spot and let it stand *no more than 30 seconds.* Rinse the spot several times with plenty of warm water. Dry it with a clean, soft cloth. If the spot seems to be going away, repeat the steps 1, 2, and 3.
5. Stains from inks and dyes can become permanent. These types of stain should be removed as quickly as possible using one of the already listed all-purpose household cleansers. If these cleansers do not work, follow the procedures in step 4. If stubborn stains persist, a solvent such as denatured alcohol, fingernail polish remover,

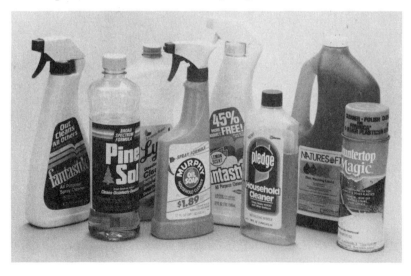

Illus. 2–15. Here are some products that can remove spots on high-pressure decorative laminate.

Illus. 2–16. Baking soda and a toothbrush work well for removing grease and deep stains from laminate.

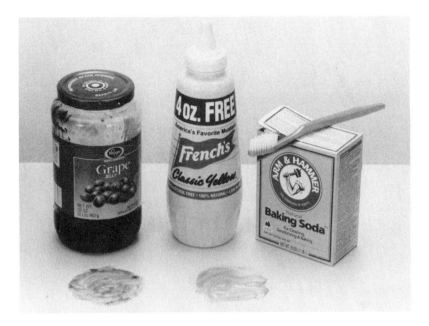

or paint thinner may be required. Several applications may be needed. **Caution:** Most solvents are *extremely flammable*—keep them away from flames or electrical sparks.

6. When a recommended product is advertised as being "improved," test it before using. Sometimes an ingredient has been added, or one already present has been intensified, and the change may be harmful to the laminate surface.

7. Abrasive cleaners/powders and metal- or abrasive-coated scouring pads (Illus. 2–17) should *not* be used, since they will permanently dull and scratch the laminate and make it more susceptible to staining.

Chemical Stains

High-pressure laminates can resist many chemicals, including alcohol, paint thinners, most cosmetics, and drugs (Illus. 2–18). Care must be exercised, however, when using bleaches, hair dyes, rinses, drain cleaners, and full-strength detergents from automatic dishwashers because these chemicals can cause permanent stains. Precautions *must* be taken to protect your laminate surface from chemicals commonly found in rust removers, metal/oven cleaners, and drain/toilet bowl cleaners. *Never* put such cleaners on laminate surfaces. Spills from these acid- or caustic-based products will corrode, discolor, and permanently damage the lami-

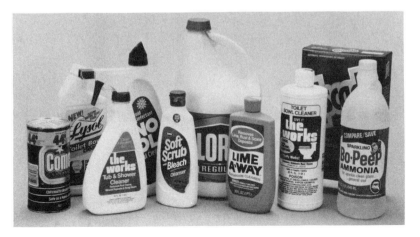

Illus. 2–17. Although all these products work well in their respective areas, they should not be used to clean laminate.

Illus. 2–18. There are special laminates that are formulated to handle chemical contact. (Photo courtesy of Wilsonart.)

nate if allowed to remain on the surface. Accidental spills should be wiped off immediately, and the area rinsed thoroughly.

Scratches, Abrasions, and Chips

Although decorative laminates will resist scratches and cracks, even in normal use the surface can accidentally be damaged. Care must be taken when using heavy earthenware and other ceramic products that have rough bottoms on a laminated surface (Illus. 2–19). These objects will cause deep scratches and excessive wear to the laminate surface. Use knives and other sharp implements only on a chopping board or trivet. Never hammer on the laminate with hard objects, especially near its edges. Heavy impact caused by falling dishes, cans, or utensils can result in chips and/or cracks in the laminate surface.

Repairing Laminate

Unfortunately, the overlay sheet of alphacellulose

Illus. 2–19. Never slide heavy objects over the laminate surface. Always use cutting boards and hot pads on the surface.

melamine-impregnated resin (the top coating) is not easy to repair if physical damage such as scratches, cracks, chips, and blisters occur. If it is minimal damage, it might be possible to cover or hide the problem with a good coat of wax or furniture polish; however, these products can sometimes leave a residue that will show smudges and fingerprints. The best way to disguise small imperfections on the surface is to mix acrylic paints to match the color of the surface and apply them with a small brush. Be certain that the area is clean and free from oils, debris, and waxes before applying any color.

There is a product available today that will aid in the filling of seams and could possibly be used to fill small imperfections in the laminate surface. This product, called SeamFil (Illus. 2–20), is manufactured by Kampel Enterprises, Incorporated. The standard SeamFil kit contains 12 colors for mixing (according to a color match chart that is provided for each manufacturer's brand of laminate), a specially polished putty knife, ½ pint of solvent, retarder, and complete instructions.

There are four areas of concern when working with SeamFil: preparing the surface, mixing the colors, applying the SeamFil, and cleaning up the surface. Each is discussed below.

Preparation

Make sure that the laminate is bonded securely to

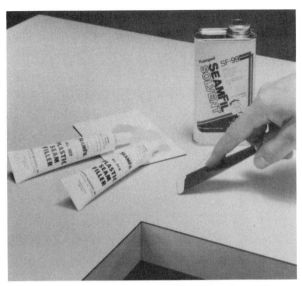

Illus. 2–20. SeamFil is a product used to fill seams and hide small imperfections. (Photo courtesy of Kampel Enterprises.)

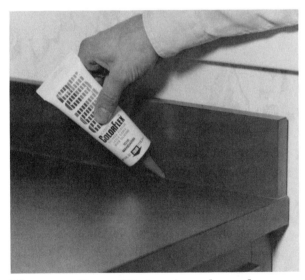

Illus. 2–21. Kampel Enterprises also makes custom-color acrylic latex caulk with silicone. This product works well to fill in any gaps at backsplashes and imperfect fits between the countertop and the wall. (Photo courtesy of Kampel Enterprises.)

the substrate. Use a clean cloth or paper towel that is moistened with the solvent supplied with the kit to remove sawdust, contact adhesive, oils, and dirt

from the joint surface. Make sure that the crack or deep scratch being repaired shows the phenolic backing or the substrate, to ensure that the SeamFil will adhere properly.

Mixing Colors

Refer to your laminate brand on the SeamFil color matching guide to determine the mixing proportions of the different colors. Squeeze an amount of the first color onto a scrap of laminate that is the same color as the piece being repaired or seamed. Add the color mix according to the guide. Using the polished putty knife, mix the colors on the scrap piece of laminate until you have the exact color. SeamFil begins to set quickly. If you need to slow down the setting time, add some retarder (which is included in the kit).

Applications

After the SeamFil has thickened, press it into the seam with the putty knife (Illus. 2–22 and 2–23). Clean the blade with the provided solvent and level the seam or repair.

Cleanup

Wipe the excess SeamFil from around the repair with a cloth or paper towel moistened with the provided solvent (Illus. 2–24 and 2–25). If shrinkage occurs, repeat the process in about one

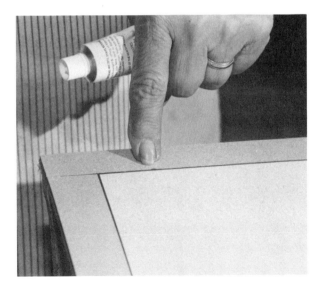

Illus. 2–22. Notice the chip in the laminate on a backsplash.

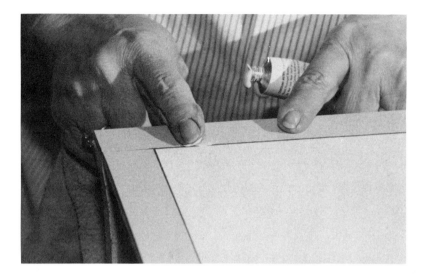

Illus. 2–23. By working the proper color of SeamFil into the chip, it is possible to conceal (not repair) the chip.

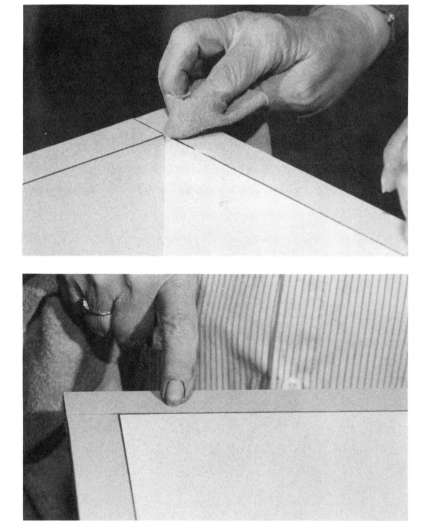

Illus. 2–24. Cleanup involves using a cloth and the provided solvent. Carefully remove the excess from the chip.

Illus. 2–25. An inconspicuous repair. SeamFil reaches a maximum cure strength in a couple of days.

hour. SeamFil reaches a maximum cure strength after several days.

GENERAL SAFETY PROCEDURES

Safety is an act of common sense. To avoid accidents and possible injury, it is important always to make safety your priority whenever working in the shop. Remember that machines and tools cannot think, but you can. Do not let yourself become over-confident—even if you know all of the safety guide-lines. Here are some basic safety rules; learn and follow them. Safety guidelines for specific tools are given in the next chapter.

1. Wear the proper clothing. Do not wear loose clothing or, for that matter, jewelry. It can get caught in the moving parts of power equipment and pull you into the machine.

2. Wear safety glasses when using power tools.
3. Keep your work area clean and accessible.
4. Work in a well-ventilated area.
5. Be sure the power is off on power tools before plugging into the power source and/or adjusting the tools.
6. Plan your work ahead of time.
7. Keep alert; know what your hands are doing at all times. Never work when you are under the influence of drugs or alcohol.
8. Use sharp tools; they are much safer than dull tools.
9. Read adhesive and chemical solvent precautions before using them.
10. Handle broken laminate with care; it is as sharp as glass.

CHAPTER 3

Tools and Accessories

The tools used for working laminate are grouped in this chapter as either hand or power tools. These tools may be specially designed for laminate work, or they may be part of the family of woodworking tools already available.

It is important that you be able to correctly identify and use all the tools listed in this chapter. This will help you work plastic laminate in a safe and efficient manner. Occasionally review the safety practices described in this chapter to be sure you are working safely. Practise the techniques described in this chapter on scrap pieces to become familiar with them.

HAND TOOLS

Safety Techniques

A safe worker always plans a working sequence before beginning. There are many steps to planning the entire job. The stock must first be laid out accurately, and then the cutting, planing, boring, or shaping operations must be planned.

Follow these safety techniques when working with hand tools:

1. Gather the tools for the work and then inspect them. If the tools are dull or in poor repair, sharpen or repair them before beginning the work.
2. Plan the best way of working the stock. When planing or carving, it is best to work with the grain. Knowing how you will work the stock helps you determine the best way of clamping it for easiest cutting. Clamp the stock securely before you begin. If the work is complicated, the clamping sequence may require a plan.
3. Use the tool correctly. This includes keeping it well maintained and using it for its intended purpose. Poorly maintained tools increase operator fatigue, decrease accuracy, and cause accidents. Using the tool for any other purpose could damage the tool or cause injury.
4. Only use hammering tools that have a well-fitted handle without defects. The head should not be chipped, cracked, or have a mushroom shape (flattened outward).
5. Only use screwdrivers with undamaged tips and which fit the screw. Never hold the work while driving a screw. Do not use a screwdriver to pry open something or as a knife.
6. Only use chisels and other cutting tools that have undamaged handles and cutting edges. Always use a handle over the sharp edge of a rasp or a file (Illus. 3–1). A rasp or a file without a handle may cause blisters or pierce your hand.
7. Do not force a tool. This can cause problems. You could slip while driving the tool, or the tool could break. Keep a secure footing and guide your tool into the work.
8. When working with a hand tool, it is important that you guide the tool away from your body. Most hand tools have sharp cutting edges. If they are pulled towards your body, you could be cut. If the tool is designed to be pulled towards you, avoid forcing the tool. Keep your balance and pull the tool with moderate force. Tools are safest to use when guided away from your body.
9. When you work with chisels and carving tools, keep your hands behind the tool's cutting edge.

Illus. 3–1. When using files, make sure they have a handle. The sharp tang of the file could injure your hand.

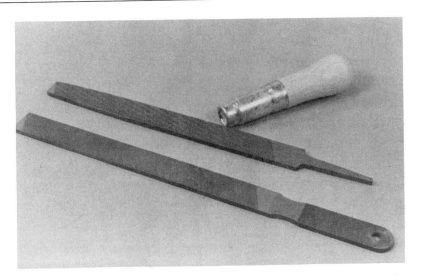

This will protect you from injury if the wood splits or if the tool slips.

10. Storing tools properly is important. When you are finished using a tool, put it away. Cover its cutting edges when it is not being used. The cover protects the cutting edge from dulling, and protects you from being cut. A piece of wood, leather, or cardboard can be used to protect the tool. Never put sharp tools into your pocket; a serious injury could result.

11. Always wear eye protection while working with wood and tools. Just a piece of sawdust in your eye can cause discomfort.

12. Keep the shop neat and clear of scrap. This helps guard against injuries caused by slipping or falling. When moving large pieces of stock, always check the area before you swing or turn the stock. The stock could strike someone and cause serious injury.

13. Avoid distracting other workers. You could cause them to have an accident. Develop the habit of assisting others when needed. Work cooperatively and the job can be done safely.

List of Hand Tools

The hand tools used to work plastic laminates may actually be woodworking tools, or they may be specialty laminate tools. Whichever category they fall into, they can be grouped into cutting, clamping, or rolling tools.

Cutting Tools

Cutting tools for plastic laminates include the *awl*

and the *scoring knife*. Each of these tools cuts a groove in the exposed face of the laminate about one-half the thickness of the laminate. The laminate is then bent along that line until it snaps into two sections. The awl (Illus. 3–2) is a common woodworking tool, and the scoring knife (Illus. 3–3) is a common tool for cutting many types of plastic. The awl has a tool-steel point, while most scoring knives have a carbide cutting edge.

Another cutting tool for plastic laminates is the *laminate slitter* (Illus. 3–4). This tool is a specialty laminate tool. The rollers in the device score the laminate by forming a slit on the exposed and back faces. A fence within the slitter controls the width of

Illus. 3–2. The awl has a tool-steel point which is very sharp. Use it carefully.

the laminate being cut. It can be adjusted to a width of about 5 inches.

The slitter is engaged with the plastic laminate. One edge of the laminate is butted against the fence. The laminate is then pulled through the slitter (Illus. 3–5). When the slitting is complete, the laminate strip should snap away. If the strip does not snap away, the slitter must be adjusted. Tighten the knob on top of the slitter (Illus. 3–6) to increase tension on the slitting wheels and make another cut. The laminate strip should snap away.

It is also possible to tighten the knob too much. This makes is difficult to guide the slitter through the plastic laminate. Adjust the knob so that the laminate snaps away from the sheet. Any additional

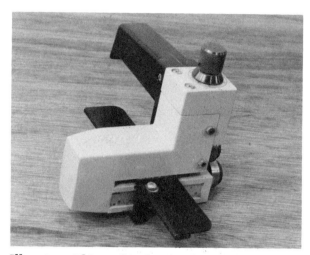

Illus. 3–4. This tool is designed to slit plastic laminates into strips. The fence allows you to cut widths up to 5 inches.

tightness makes it difficult to operate the slitter. The tightness will change according to laminate thickness, so each cut could vary.

There is a clamping device that can be used with the slitter (Illus. 3–7). The handle of the slitter is clamped to the device. The unit is then clamped to a bench. The laminate can now be fed into the slitter (Illus. 3–8). This increases the speed of the operation because stock can be moved faster than the slitter.

The *plastic laminate shear* (Illus. 3–9) and *universal laminate shear* (Illus. 3–10) are hand-held devices used to cut plastic laminates. The plastic laminate shear cuts straight lines in plastic lami-

Illus. 3–3. This scoring tool has a carbide tip. It will remain sharp longer than a tool-steel tip.

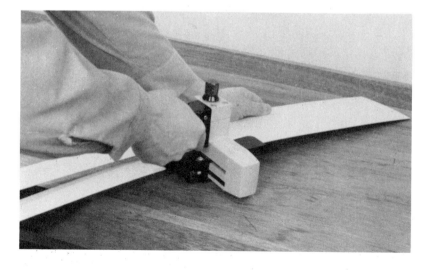

Illus. 3–5. The laminate is positioned and then pulled through the slitter. Work carefully, to keep the width uniform. Jerking the laminate could throw it off course.

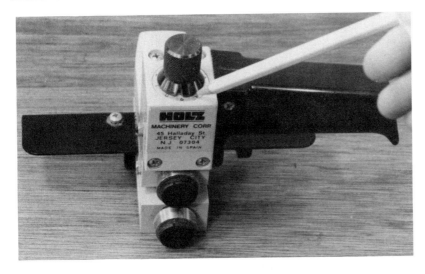

Illus. 3–6. The knob on top of the slitter adjusts the tension on the slitting wheels.

Illus. 3–7. This clamping device can be used with the slitter. It holds the slitter in place while the laminate is fed through it.

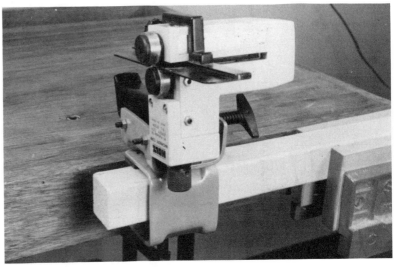

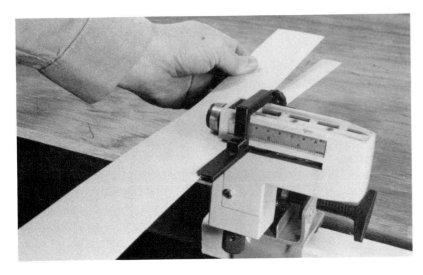

Illus. 3–8. Guide the laminate into the stationary slitter. Be sure to check the width of the laminate to verify that it is the correct size.

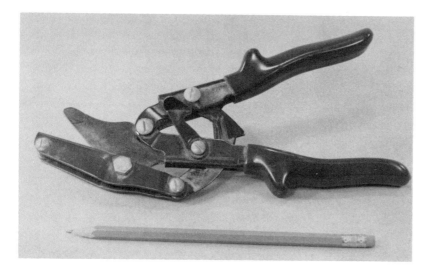

Illus. 3–9. The plastic laminate shear cuts straight lines very accurately. Cut the laminate with its good face up.

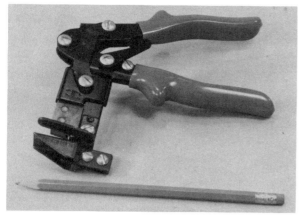

Illus. 3–10. The universal laminate shear will cut curves and irregular shapes. Cut the laminate with its good face up.

nates, while the universal laminate shear will cut curves and patterns. The plastic laminate is always cut with its good face up, when either of these shears is used (Illus. 3–11).

The *mitring machine* can be used to cut straight lines at any angle. It will make straight cuts on widths of 5⅝ inches and 45-degree mitre cuts on 3½-inch widths. The angle is set with the pivoting fence and locked in position (Illus. 3–12). The laminate strip is positioned under the shearing blade with its good face up. The edge of the laminate is butted against the fence and the handle is pushed downwards. As the handle is pushed down, the clamp engages first; then the shear cuts the laminate (Illus. 3–13). The clamp acts as a barrier to keep your fingers away from the shear, but do not let them get pinched under the clamp.

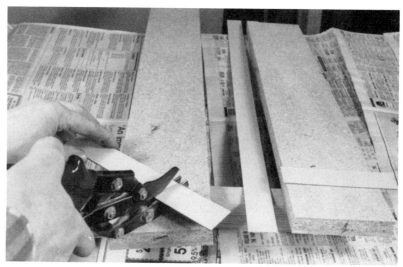

Illus. 3–11. Hold the laminate securely and squeeze the handles firmly. Advance the shear as you get to the end of the cutting edge.

Another specialty tool in the laminate field that can be used to cut plastic laminates is the *laminate trimming tool*. This tool is used to trim laminate after installation. It has a carbide cutter mounted in a housing. The housing surrounds the overhanging laminate. The portion below the plastic laminate rides along the edge of the work and controls the path of the carbide cutter. The carbide cutter scores the laminate so that it can be broken off.

A similar device can be used to scrape the cut laminate into a smooth, finished edge. This tool is called a *Mica Knife* (Illus. 3–14). The plastic housing rides along the edge of the laminate and the carbide

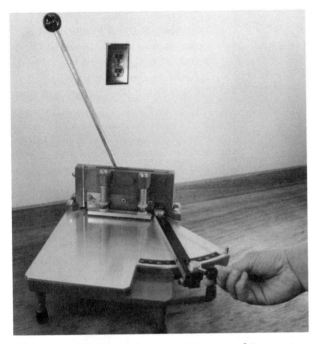

Illus. 3–12. When using a mitring machine, set the angle of cut by pivoting the fence and locking it in position.

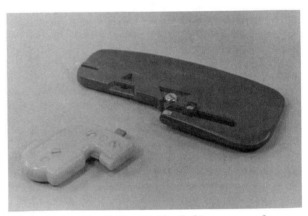

Illus. 3–14. The Mica Knife (left) scrapes the plastic laminate to finished size. The tool on the right scrapes and trims laminate overhang.

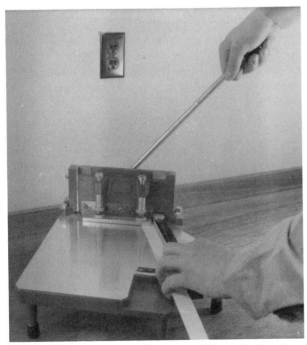

Illus. 3–13. Once the clamp positions the laminate, the shear begins its cut. The cut is made with the laminate's good face up.

Illus. 3–15. Make sure that the scraper on the Mica Knife is adjusted correctly before working on finished stock. If it is taking a deep cut, it could scratch the laminate face.

Illus. 3–16. A cabinet scraper can also be used to smooth the edge of plastic laminate. It is made of tool steel, so it will require frequent sharpening.

knife edge scrapes the laminate until it is smooth. The housing limits the depth of cut, but the carbide knife is also adjustable for depth of cut. Be sure to cut lightly until you know your scraper is adjusted correctly (Illus. 3–15).

A *cabinet scraper* can also be used to smooth the edge of a plastic laminate (Illus. 3–16). It has a hook on its edge which was formed by a burnisher. The cabinet scraper is a woodworking tool. It is made of tool steel, so it will have to be sharpened or burnished on a regular basis. There is no control surface to guide the path of the cabinet scraper. Use it carefully and take light cuts.

Files are another way of cutting plastic laminates. They are used to smooth the plastic laminate edges after trimming. There are specialty files which are designed for cutting plastic laminate. These files have a special cutting edge which works well on most plastics (Illus. 3–17). As you look at the files, you will see that many have coarse teeth on one side and fine teeth on the other. Practise on some scrap stock to determine how fast the files remove stock. Some files are very aggressive and could damage the laminated surface.

When using any file on plastic laminates, make sure that the work is clamped securely and always file towards the backing stock (Illus. 3–18). This reduces vibration and eliminates the chance of delamination. Delamination occurs when the laminate is pulled away from the backing material. Working away from the backer tends to pull the laminate away from the backer and break the glue bond.

When files are not being used, protect them from

Illus. 3–17. Specialty files are used to cut plastic laminate. There are coarse and fine grades. When using a coarse file, work carefully because it will cut quite aggressively. (Photo courtesy of Skil Power Tools.)

Illus. 3–18. When filing plastic laminates, make certain that the work is clamped securely. Be sure to file towards the backing stock.

contact with other files or other objects. Contact with other files dulls the file and reduces its ability to cut plastic efficiently. Separate the files with wooden strips or wrap them in newspaper between uses (Illus. 3–19). If the teeth of the file become loaded with chips or glue, clean them with a *file card*. A file card works like a brush to remove debris (Illus. 3–20). Some file cards also have a metal pick attached to them. This pick can be used to remove stubborn debris from the teeth (Illus. 3–21).

Clamping Tools

Laminate clamping tools include bar or pipe clamps, C-clamps, F-clamps, parallel clamps, edge-banding clamps, and spring clamps.

 Bar or *pipe clamps* are sometimes used to join two pieces of sheet stock together. They are also

Illus. 3–19. Protect the files when they are not in use. Separate them with wooden strips or wrap them in newspaper.

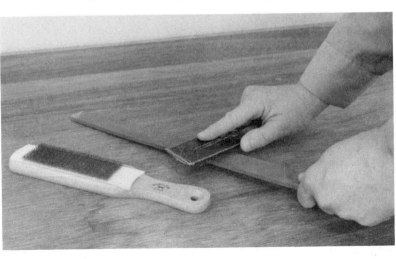

Illus. 3–20. A file card will keep the file clean. Its wire bristles remove debris from the file.

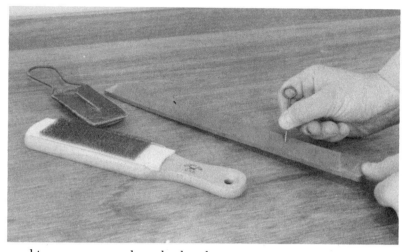

Illus. 3–21. A pick or nail can be used to remove stubborn debris from a laminate file.

used to secure a wooden edge band to a countertop before of after lamination (Illus. 3–22). Bar clamps have a metal bar and an adjustable jaw. The opposite jaw has a threaded mechanism to put pressure on the jaw.

Pipe clamps are attached to ½- or ¾-inch metal pipes. The moveable jaw slides on the pipe (Illus. 3–23). The stationary jaw has a threaded mechanism to put pressure on the jaw. The moveable jaw on pipe clamps may have a tendency to slip when pressure is applied. This can be prevented by squeezing the lock mechanism while applying pressure.

C-clamps are used to secure a buildup to the countertop while glue cures or metal fasteners are installed. They are also used to secure work in progress to the sawhorses or worktable.

In some shops, F-clamps are used along with C-clamps. An F-clamp has a moveable jaw and can be used for all of the jobs listed for C-clamps. F-clamps also work well for securing the back-splash to the countertop for assembly.

When working with C- or F-clamps, protect finished surfaces with a clamp pad (Illus. 3–24). A small piece of ¼-inch stock makes a good clamp pad. It spreads the clamping pressure over a larger area and reduces the chance of damage to the finished surfaces.

Parallel clamps are used chiefly for woodworking, but are also used for plastic-laminate work (Illus. 3–25). The two threaded rods adjust the angle and pressure on the wooden jaws. The outer rod should be tightened last, after the jaws have been adjusted parallel to the surfaces that are to be clamped. If the work is finished, clamp pads may be necessary, but, in most cases, the wooden jaws will not damage finished surfaces.

Edge-banding clamps are also useful when you

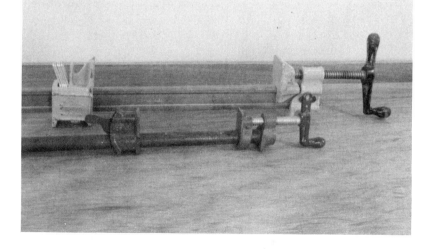

Illus. 3–22. Bar or pipe clamps are used to secure edge banding to the counter blank.

Illus. 3–23. Slide the moveable jaw of the clamp up to the work and then tighten the stationary jaw. Use only hand pressure to tighten the clamp.

Illus. 3–24. Use clamp pads to protect your work from the jaws of the clamps. Thin plywood cut-offs work well as clamp pads.

Illus. 3–25. Parallel clamps are sometimes used for plastic-laminate work. The threaded rods adjust the angle and clamping pressure of the jaws. (Photo courtesy of Skil Power Tools.)

Illus. 3–26. Edge-banding clamps are similar to C-clamps except that they exert force in two directions. Center the clamp on the work and then secure the edge band to the work.

are working with plastic laminates. These clamps hold a wooden edge band in position until the glue cures. An edge-band clamp looks like a C-clamp except that it has two additional threaded rods. The two opposing threaded rods are used to position the rod, which holds the edge band against the work (Illus. 3–26).

Once the clamp is positioned on the work, the center rod is tightened against the edge band. The entire clamp may slip if the two opposing rods are not tightened securely. Keep an eye on the clamp while tightening the center rod. Be sure to protect finished surfaces with clamp pads to avoid damage.

Spring clamps are used to hold guides or buildups in place. A spring clamp works much like a clothespin. The spring center exerts pressure on the jaws to hold parts together. Spring clamps do not have the holding power of other clamps, so they should only be used as a secondary means of clamping until a more secure clamping method is used.

Rolling Tools

Rolling tools are used to ensure a good bond between the plastic laminate and the backing. The rollers force the laminate against the backing. This causes contact between the surfaces. Since the glue being used (contact cement) bonds to itself on contact, rolling is an important part of any plastic-laminate job.

The most common laminate roller is the *J-roller*

(Illus. 3–27). It is used for general rolling tasks. The roller itself is about 3 inches wide, and the handle is about 12 inches long. Two hands are used on the J-roller to exert pressure on any laminated surfaces.

The *seam roller* is like a small J-roller. It is used to ensure a good bond where two pieces of plastic laminate form a seam. The seam roller has a metal 2-inch-wide roller attached to a 9-inch-long handle (Illus. 3–28). The heavier metal roller is centered over the seam and rolled along the seam. This roller

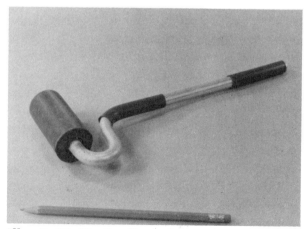

Illus. 3–27. The J-roller is the most common laminate roller. It is used to roll over the laminate surfaces after bonding. The pressure of the roller ensures a better bond between the laminate and the backing.

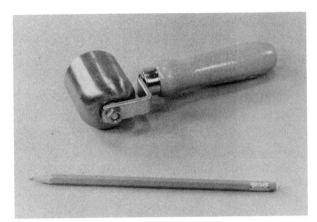

Illus. 3–28. The seam roller is similar to the J-roller except that it has a heavy metal roller and a shorter handle. It is used to smooth seams in laminated surfaces.

helps align the two mating pieces while achieving a solid glue bond.

The *two-fisted hand roller* unfolds so two hands can be used to roll it over the laminated surface. The rubber roller is about 4 inches long. This roller exerts total body-weight force onto a small area. Movement with the two-fisted hand roller is slower, but more accurate (Illus. 3–29).

Another type of roller is the one-hand roller (Illus. 3–30). It is gripped with one hand and can exert sufficient pressure to get a good contact-cement bond (Illus. 3–31).

The *extension roller* and the *T-roller* are used to roll over larger areas. These rollers are 6–8 inches in length, so the area of contact is much larger. Two hands are generally used with these rollers. The extension roller has a telescoping handle that is adjustable from 18 to 27 inches in length. It is adjusted for operator comfort and space limitations

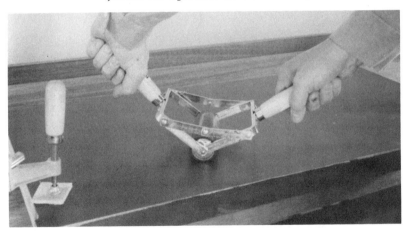

Illus. 3–29. When this hand roller is used, two hands can exert a great deal of pressure over a small area.

Illus. 3–30. This one-hand roller is used to roll plastic laminate over any area.

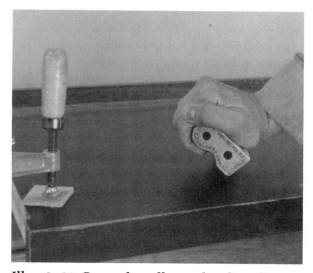

Illus. 3–31. Grasp the roller so that the roller portion is pointing away from your hand. Move the roller over the laminate to obtain a good contact-cement bond.

(Illus. 3–32). The T-roller has an extension; when the extension is used, the handle reaches a length of 24 inches (Illus. 3–33). It can be separated into two 12-inch sections for travel or when space is limited.

The *edge squeeze roller* is used to roll over edges and drive the laminate edge into contact with the backing (Illus. 3–34). It is also known as a pinch roller. The edge squeeze roller has two rollers about 1 inch long. They are mounted on a single handle about 3 inches apart. One roller hooks under the counter blank—the foundation upon which plastic laminates are applied or glued—while the other

rests on the laminate. When you push down on the handle, the roller on the laminate is put under pressure and squeezes the laminate into contact with the counter blank (Illus. 3–35).

POWER TOOLS

Safety Techniques

Power tools perform the same operations as hand woodworking tools, but power tools are faster than hand tools. The additional speed of power tools limits your reaction time if you make a mistake. This means that you will have to plan the job carefully to avoid mistakes or accidents.

Safety techniques for power-tool use comprise four areas: protective devices, handling material, power-tool features, and adjusting power tools. If you are familiar with these four areas of power-tool use, you will be able to operate power tools safely and efficiently.

Protective Devices

When working with power tools, there are many hazards from which you must protect yourself. The woodworking shop has potential hazards that include dust, flying wood chips, noise, rotating shafts, sharp cutting tools, and rough stock. All of these hazards can lead to injuries if you do not protect yourself.

Personal protective equipment has been designed to guard against injury. You should always wear personal protective equipment.

Eye protection is essential when you work in the

Illus. 3–32. The extension roller has an adjustable handle for various conditions. This roller is designed for a two-hand operation.

Illus. 3–33. The T-roller has a screw-on handle extension. It can be used with or without the extension for one- or two-hand rolling.

Illus. 3–34. The edge or squeeze roller drives the laminate into contact with the backing along the edges, where it will most likely delaminate.

Illus. 3–35. Pressure is exerted when one roller is in contact with the laminate while the other is in contact with the counter blank. As the handle is pushed down and moved laterally, the laminate is rolled into contact with the backing.

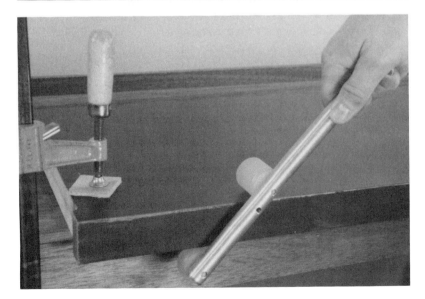

wood shop. Flying wood chips and dust can cause eye discomfort and possible injury. *Protective glasses* eliminate any chance of chips striking your eyes.

In addition, you should wear a *face shield* when you use bits or cutters with carbide tips. The face shield will protect your face and eyes if a carbide tip should shatter. A face shield also makes it easier for you to see what the tool is doing. No sawdust or chips strike your face or eyes when you wear a face shield. As a result, you can guide the tool and work more efficiently.

When performing sanding operations, be sure to use a *dust-collection system*. If you shop does not have a dust-collection system, wear a respirator. The respirator will filter dust particles from the air you breathe.

The noise level in some wood shops exceeds the 90-decibel level recommended by the Occupational Safety and Health Act (OSHA). Prolonged exposure to this noise can cause a hearing loss. You can protect your hearing with *ear plugs* or *hearing protectors*. Both ear plugs and hearing protectors seal out most noise and protect your hearing from damage.

Rotating blades, cutters, and shafts may also present a hazard. A loose shirtsleeve can become wound into any rotating object and pull you towards it. Always roll your sleeves up above your elbow and tuck in your blouse or shirt. Remove rings, watches, and neckties. These objects may catch on a rotating blade, cutter, or shaft. Long hair may also become entangled in a cutter or rotating shaft. Tie hair back or restrain it under a cap.

Some people wear *gloves* to protect their hands from slivers when moving rough stock. Gloves may be worn when moving rough stock, but they should *not* be worn when machining stock. A glove can become caught in a rotating blade or cutter and pull your hand into it.

Handling Material

Handling material near power tools or feeding material into power tools requires your complete attention. There should be no distractions. Before you machine stock in the wood shop, plan your work. Allow plenty of time for the operation. Rushing a job may cause an accident or ruin the piece. Make sure the machining sequence allows safe handling of the stock.

Check your stock before you feed it into a machine. Make certain that the stock is large enough to be machined safely. Use hand tools to shape or cut small pieces. Check the piece to see if it has been planed. Certain machines, such as the table saw, cannot safely cut rough stock. Stock with knots and other defects should be cut into smaller pieces with the defects removed.

Do not stand behind stock when feeding it into a machine. The stock could kick back. A kickback pushes the stock back out of the machine with great force. A kickback is caused when stock is pinched between a cutter or blade and a stationary object such as a fence. If you stand on the side of your work, you should be clear of any stock that kicks back. Feed stock into the cutter. Do not force the stock; let the cutter do the work.

If a pice of stock is too large or difficult to feed into a machine, get help. Sometimes you can clamp the piece and machine it with portable power tools. Small portable power tools will be easier to handle than large pieces of stock.

Some pieces of stock should be fed with a push stick or push shoe. These are shop-made devices used to control stock. They keep your hands clear of the blade or cutter, but maintain complete control of the stock.

Another shop-made device that can be used to hold stock against a fence or table is the feather board (Illus. 3–36). The feather board acts like a spring to hold stock against a surface while it is fed into the machine. A feather board should not be installed next to the blade or cutter because it may pinch the stock and cause a kickback.

Some material you handle will be irregular in shape. Irregularly shaped pieces require special holding devices. Round stock should be placed in a V block for most machining procedures. Other shapes will require a special holding fixture. The type of fixture will vary with the job.

Power-Tool Features

The features of any power tool affect its safe operation. There are many features you should look for when you purchase or use a power tool. All tools should be grounded or double-insulated to protect you from electrical shock. Grounded plugs should be used only in grounded outlets. A grounded or double-insulated tool will protect you in normal conditions, but should not be used in damp or wet locations.

Illus. 3–36. A feather board can be used to keep stock on the table or against the fence of a power tool. This keeps your hands away from the cutting tool. This feather board holds the laminate on the table and also houses the blade.

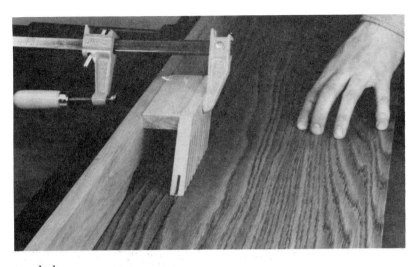

A power tool should also have enough horsepower to do the job without stalling or slowing down. Tools with too little power tend to chatter and are difficult to control. When they slow down, they burn and dull the cutting tool.

Power tools should also be equipped with appropriate guards to protect the operator. Guards should be durable and easy to adjust (Illus. 3–37). They should not make the tool difficult to use.

You should wear hearing protectors or ear plugs when using power tools that operate at a high noise level. Failure to do so could cause a hearing loss. Check the owner's manual to determine the operating noise level of the tool.

Before you use any power tool, become familiar with its operating features. Study the owner's manual and learn how to operate the power tool correctly and safely. Make sure that you know how to adjust, maintain, and operate it.

Adjusting Power Tools

Power tool adjustment is very important. Improper or incorrect tool adjustment could affect operation safety. Tool adjustment is done with the power turned off or disconnected. Adjust the tool for a light cut. Do not overwork the tool or the cutter. Two light cuts are better than one heavy cut.

Check all adjustable parts of the power tool. Make sure they are locked or tightened securely. Make sure moving parts are lubricated and work easily. Keep machine tables and beds well waxed so that the mitre gauge and other accessories move smoothly. A well-waxed bed or table also makes the stock easier to feed into the machine.

Follow maintenance procedures as recommended in the owner's manual. If your power tool makes an unfamiliar noise, shut the machine off and find the cause before the tool is damaged. Beware of

Illus. 3–37. Guards should be available for all power tools. They should be durable and easy to adjust.

vibration problems. They can also be a danger signal.

Always adjust the machine with safety in mind. Use the guards for all operations. Let your stock cover the cutter whenever practical. The stock is then acting like a guard to protect you from the cutter. Keep your bits or cutters sharp. A sharp tool requires less energy and yields a smoother cut. There is less chance of a kickback when tools are sharp. Stock does not have to be forced into a sharp tool.

Remember, all power tools have limitations. Use a power tool to perform the operations for which it was designed. Avoid attempts to modify a power tool or its function.

When you work with power tools, you have an obligation to watch out for other workers. Whenever another worker needs assistance, volunteer to help. Always use shop courtesy. Stay clear of those using power tools. They should not be distracted.

When you finish a job, return the machine to its normal operating position and clean up your mess. Scraps left on or near the machine could cause an injury.

List of Power Tools

Power tools are used in the fabrication of plastic laminates and the counter blanks beneath them. These tools can be grouped as stationary and portable power tools. All these tools must be used according to proper safety practices, as listed in this chapter and throughout the book. You should also refer to the owner's manual for each tool to make sure you are working safely.

Stationary Power Tools

LAMINATE SLITTER

The *laminate slitter* is a stationary tool used to separate laminate sheets into smaller parts (Illus. 3–38). The slitter can be designed for tabletop use or as a floor model. The laminate slitter can cut strips of laminate from 4 to 31 inches in width.

Some slitters do not produce any dust, and most slitters produce very little noise. They have polished tables to protect the laminates as they are fed into the slitter. There are specialty slitters which offer two slitters powered by one motor. One side of the slitter can be set for a single cut up to 12 inches wide. The other side can be used for multiple slitting. A laminate 12 inches wide can be cut into three 4-inch pieces, four 3-inch pieces, or pieces in any other combination of widths.

Slitters may be used in conjunction with table saws or shears. A 12-inch slitter wouldn't work when you are preparing 24-inch countertops. An alternative would be used to reduce the 48- or 49-inch sheet into a 24- or 30-inch width. If you select a slitter, make sure that it meets your laminating needs.

Most plastic laminate slitters have one open end. This allows subtractive cutting. For example, a 12-inch slitter could remove 12 inches from a 48-inch sheet. The result would be a 36-inch sheet. This could be used for a 36-inch counter, or other pieces

Illus. 3–38. The stationary laminate slitter will separate laminate sheets into strips.

used for the backsplash and edge band could be subtracted from the sheet.

Cutting width is determined in one of two ways. If the slitter is stationary, the fence is moved to set the slitting width. If the slitter is moveable, the fence remains stationary and the slitter position determines slitting width.

When slitting plastic laminates, keep the laminate against the fence for accurate results. Check your parts frequently to make sure that the fence or slitter has not moved. Be sure to give yourself an adequate allowance for fitting the parts to the counter blank. It is far easier to trim an additional ⅛–¼ inch off the assembly than it is to do it over because the part does not fit.

PINCH ROLLERS

Pinch rollers are specialty stationary tools for laminate work. Pinch rollers do the same job as hand rollers except they are faster, more thorough, and more uniform. Laminated surfaces are sent through the pinch rollers with the laminate up. The rollers exert pressure on the laminate to ensure a perfect bond of the contact cement between the substrate and the laminate (Illus. 3–39).

Pinch roller machines vary in width from 30 to 60 inches. Some have an open end, while others have both ends closed. Open-end machines can be

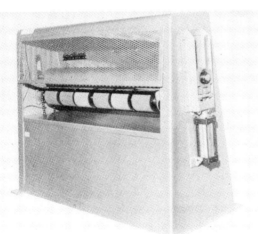

Illus. 3–39. Pinch rollers do the same job as hand rollers in a quicker and more efficient way. They ensure a perfect bond between the plastic laminate and the substrate. (Photo courtesy of Evans Machinery, Inc.)

used on laminates that are twice as wide as the machine. For example, a 30-inch-wide open-end pinch roller machine could be used on a 60-inch-wide piece in two operations. The first operation would roll over one half, or 30 inches, of the width. The excess width would extend out the open end. The second operation would roll the portion which extended past the rollers on the first operation.

POSTFORMING MACHINES

Postforming machines are used in larger manufacturing facilities (Illus. 3–40). They can wrap plastic laminates around curved or irregular surfaces. The laminate is heated and bent at the same time. It also applies the appropriate pressure to the laminated surface. This pressure ensures a strong contact-cement bond between the plastic laminate and the substrate.

Postforming machines will bend postforming plastic laminate to an outside radius of about 2 inches and an inside radius of ³⁄₁₆ inch. Postforming machines require electricity and compressed air to operate.

TABLE SAW

The table saw is a stationary power tool found in all fabricating shops. The table saw can be used to cut countertop stock, backsplashes, buildups, and plastic laminates. It is also used to cut materials after lamination. The most common operation performed on the table saw is cutting sheet stock.

The table saw can be operated safely. The rules listed here will help you become a safe table-saw operator:

1. Saw only smooth stock. Twisted stock should not be cut on the table saw.
2. Use a push stick for ripping strips narrower than 5 inches.
3. Rip strips narrower than ¾ inch on the band saw and then plane them to thickness.
4. Adjust the blade height no more than ¼ inch above the stock thickness.
5. Use sharp blades. Make sure that you have the right blade for the job.
6. Use the guard for all sawing operations. The guard protects you from contact with the blade.
7. Control your work with the fence or mitre gauge. Never cut freehand (without using the fence or the mitre gauge).

Illus. 3–40. Postforming machines heat and bend postforming laminates to a tight radius. They require electricity for heat and compressed air for clamping. This Model 0138 All-Form machine will wrap laminates at 90, 180, and 360 degrees. It is designed to hold down the laminate while it cools with either a vacuum or clamp system. (Photo courtesy of Evans Machinery, Inc.)

8. Stand to the side of your work. Do not stand behind it.
9. Use a stop block or stop rod when you crosscut. Do not pinch stock between the fence and blade.
10. Wear protective glasses when using the table saw. Wear a face shield when using a carbide-tipped blade.
11. Make all adjustments with the switch off. Disconnect the saw while changing blades.

When cutting sheet stock on the table saw, it is best to have a takeoff table behind the table saw. The takeoff table will support pieces after they have been cut (Illus. 3–41). Since most of the sheet stock being cut is particleboard, some type of dust collection is also essential. The dust from particleboard and other wood materials can be harmful to your respiratory system. If you do not have a dust-collection system, wear a dust mask for all sawing operations.

Cutting Sheet Stock To cut sheet stock accurately, you must keep the stock against the fence. Balance the stock on the table saw and line up the stock's edge with the fence. As you guide the stock into the blade, keep your eyes on the fence (Illus. 3–42). This will help you guide the sheet stock along the fence. As you complete the cut, be sure to push the work completely past the saw blade.

When cutting narrow strips, be sure to use a push stick to guide the work past the blade. This will keep your hands clear of the blade. All cuts made on sheet stock are through cuts; they separate the stock into two pieces. Through-cutting can always be done with the guard and splitter in place. Avoid cutting sheet stock at the table saw without the guard in place.

Illus. 3–41. A takeoff table supports sheet stock while it is being cut into countertop parts.

Illus. 3–42. Keep your eyes on the fence when cutting sheet stock. This ensures that the stock will remain against the fence. (Photo courtesy of Delta International Machinery, Inc.)

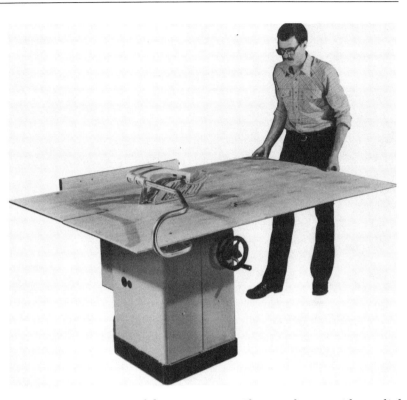

You can crosscut strips to length on the table saw using the mitre gauge. The gauge rides in a slot formed in the table. The workpiece is placed against the head of the mitre gauge and fed into the blade. For angular work, the mitre gauge can be turned to the desired angle (Illus. 3–43).

Wider counter blanks are difficult to crosscut on the table saw. This is because of their weight and the size of the mitre gauge. They can be cut with a radial arm saw or portable circular saw.

The blade of the table saw can also be tilted to make angular cuts on the edges of sheet stock. When adjusting the saw, make sure that the blade is no more than ¼ inch above the workpiece thickness. Use the guard and splitter for angular cuts as well (Illus. 3–44).

Illus. 3–43. Mitres are cut at the table saw by turning the mitre gauge to the desired angle.

Illus. 3–44. The blade has been tilted to make an edge mitre. The blade should be no more than ¼ inch above the workpiece thickness.

Cutting Laminated Counter Blanks Laminated counter blanks can also be cut with a table saw. The best results are achieved with a scoring table saw. A scoring table saw has a smaller blade in the table. This blade scores or cuts the underside of the counter blank to a depth of about ⅛ inch. This scoring cut prevents the larger blade from chipping the underside of the counter blank during the cutting operation.

Cutting Plastic Laminates Plastic laminates can also be cut on the table saw (Illus. 3–45). These thin pieces of plastic are more difficult to handle. It is also possible for them to slip under the fence of the table saw during the cut. An auxiliary face can be attached to the fence to prevent the laminate from creeping under the fence.

Specialty jigs can be made for handling plastic laminate strips (Illus. 3–46). These jigs can guide the laminate and act as a guard. They help increase cutting accuracy and safety. Narrow strips can be cut using the mitre gauge. Wider pieces of plastic laminate can be cut using the radial arm saw. When cutting plastic laminates, keep blade exposure low and use a dust collector.

Because of the flexibility of plastic laminates, it may be necessary to have a helper to control the plastic laminate while you are cutting it. In some

Illus. 3–45. Plastic laminates can be cut on the table saw. Make sure that the edge of the laminate cannot creep under the fence.

Illus. 3–46. This jig keeps the plastic laminate from creeping under the fence and acts as a barrier between you and the blade.

cases, it is a good idea to support the laminate on the in-feed side of the saw. This can be done by putting the counter blank in front of the saw on sawhorses. This provides support on the in-feed side of the saw. For more information about table-saw operations, please consult *Table Saw Techniques* or *Table Saw Basics*, by Roger W. Cliffe.

RADIAL ARM SAW

The radial arm saw can be used to crosscut parts to length. It can also cut plastic laminate strips into parts.

The radial arm saw can be operated safely. The following instructions will help you do so:

1. Do not try to cut warped stock. Stock that is to be ripped must have a true edge in contact with the fence.
2. Keep your work in contact with the fence at all times.
3. Before you use the radial arm saw, make sure that all its controls and latches are clamped securely.
4. Use the guard for all operations.
5. Adjust the blade guard so that it clears the stock by no more than ¼ inch.
6. Keep your hands clear of the blade's path. Hands should be 4 inches away from the blade at all times and parallel to the blade's path.
7. Wear protective glasses when using the radial arm saw. Wear a face shield when using a carbide-tipped blade.
8. Collect dust with a dust collector.

9. Use sharp blades. Make sure that you have the right blade for the job.
10. Make all adjustments with the power off. Disconnect the power before you change blades.
11. Use a block or jig to cut round stock.
12. When crosscutting, pull the saw into the work. When the cut is complete, return the yoke to the back of the table and clamp it in position. Clamping keeps the yoke from creeping.
13. When crosscutting, do not allow the blade to climb the workpiece. This can stall the motor and may throw the saw out of adjustment.
14. When ripping stock, feed it against the blade's rotation.
15. Use a push stick for ripping strips under 5 inches wide.
16. Avoid ripping strips less than ¾ inch wide on the radial arm saw. Instead, use a band saw or plane them to thickness.
17. Do not rip stock shorter than 12 inches with the radial arm saw. Instead, use the table saw or band saw.
18. Do not stand directly behind the stock when you are ripping it.

Crosscutting Sheet Stock and Plastic Laminate When crosscutting sheet stock, position the part against the fence of the radial arm saw (Illus. 3–47). Position the cutting line relative to the blade's path. Make sure that the blade's path is on the waste side of the line. Turn on the saw, release the carriage clamp, and pull the handle on the carriage. This will guide the saw blade into the workpiece. Once the cut is made, turn the saw off. Return the carriage

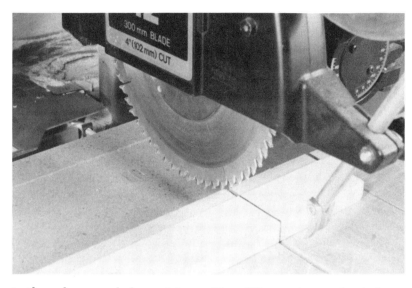

Illus. 3–47. Position the work firmly against the fence when crosscutting with the radial arm saw. Make sure the blade is cutting on the waste side of the line.

to the column and clamp it in position. When cutting long strips, support the ends with stands or table extensions (Illus. 3–48).

Plastic laminates can be cut in the same way as sheet stock (Illus. 3–49). Angular cuts can be made by pivoting the arm at the column. You can also make bevel cuts by tilting the motor in the carriage.

For more information on the use of the radial arm saw, please consult *Radial Arm Saw Techniques* or *Radial Arm Saw Basics*, by Roger W. Cliffe.

Portable Power Tools

MOTORIZED MITRE BOX
The motorized mitre box can be used to crosscut

plastic laminate or sheet stock. The saw blade on a motorized mitre box moves up and down. The stock is positioned under the blade against the table and fence. The cutting line is positioned with the blade on the waste side (Illus. 3–50). Stock is held with one hand, while the other hand turns on the saw and plunges it into the work (Illus. 3–51). When the cut is complete, shut off the saw and allow it to come to a complete stop. When the blade stops, lift the blade out of the workpiece (Illus. 3–52).

When using the motorized mitre box, keep your hands clear of and parallel to the blade. Never cross your hands. If you are using the saw in the shop, attach a dust collector for best results.

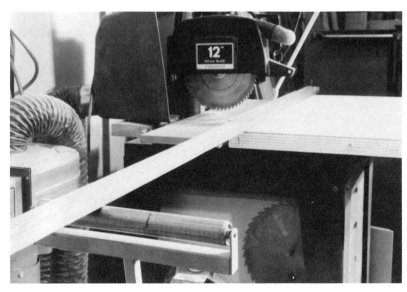

Illus. 3–48. This stand supports the work during a crosscut. Long pieces should be supported for both safety and accuracy.

Illus. 3–49. Plastic laminates can also be cut on the radial arm saw. Use the same procedures you would for solid stock.

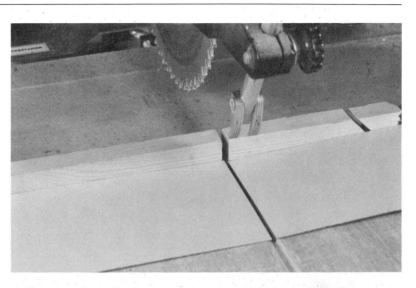

Illus. 3–50. Make sure that the blade is on the waste side of the cutting line when using a motorized mitre.

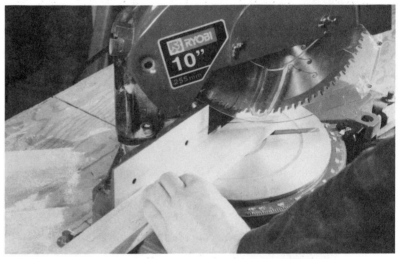

Illus. 3–51. Stock is held against the fence and table with one hand, while the other controls the blade and cut. Keep your hand clear of the blade's path.

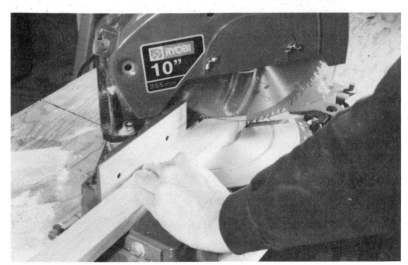

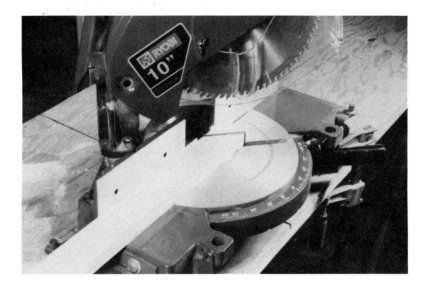

Illus. 3–52. The blade should come to a complete stop before it is lifted out of the work.

The following rules will help you safely operate the motorized mitre box:

1. Make certain that the saw is grounded correctly.
2. Make sure that the guard is working correctly.
3. Use a blade of the correct size that is rated for high rpm operations.
4. Wear protective glasses. When using a carbide-tipped blade, wear a face shield.
5. Make all adjustments while the saw is disconnected.
6. Never attempt to hold pieces less than 12 inches long. Clamp short pieces to the fence. This will keep your hands away from the blade.
7. Keep the stock in contact with the fence and table when cutting.
8. Do not force the tool; let it cut through the stock.
9. Make sure that the motorized box is anchored securely.
10. Clamp around stock when cutting it.

PORTABLE CIRCULAR SAW

The portable circular saw is often used in the fabrication of laminated counters. It allows the work to remain stationary while the saw travels across it. This is an ideal way of sawing large or heavy pieces. The work is clamped in position to keep the cut accurate.

Cutting guides can be made for portable circular saws. These guides are clamped to the workpiece and control the path of the saw blade (Illus. 3–53).

When cutting counter blanks with the portable circular saw, make sure that it is clamped in position and that the blade exposure is no more than the stock thickness plus ¼ inch (Illus. 3–54). Position the saw on the workpiece with the blade aligned with the cutting line. *Note:* Since the blade of the portable circular saw thrusts upwards, put the good face of the work down for best results.

Keep your eye on the saw base and the cutting line. Guide the saw along the line at a speed that does not strain the motor. Make sure that the piece that is to be cut off is supported (Illus. 3–55). An unsupported piece can pinch on the saw blade and cause a kickback. Use sawhorses or other work aids to control the work. If it is necessary to get a smooth cut, cut within ⅛ inch of the finished line with the portable circular saw, and clean up the cut using a router controlled by a guide. This will produce a smooth edge (Illus. 3–56).

The following rules will help you to safely operate the portable circular saw:

1. Make certain that the saw is grounded correctly.
2. Make sure that the guard is working correctly. Never remove the guard when operating the saw.
3. Use the correct blade for the job.
4. Wear protective glasses when operating the portable circular saw. If you use a carbide-tipped blade, be sure to wear a face shield.

Text continues on page 81

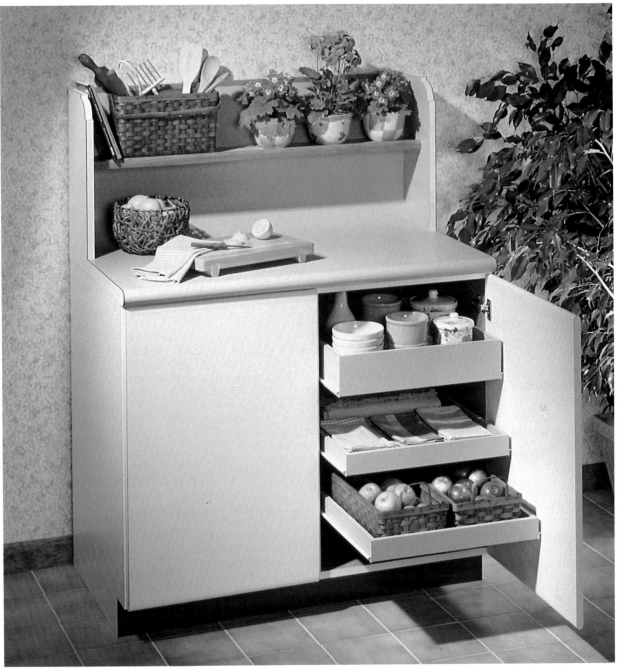

Using the proper tools and adhesive are two of the keys to constructing attractive and durable plastic-laminate projects. Be sure to work safely and to follow the manufacturer's recommendations.

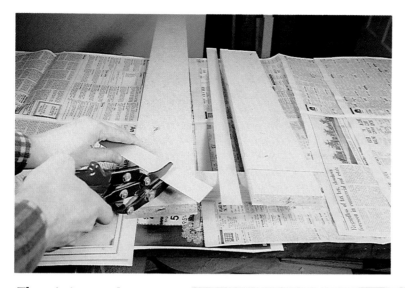

There are specialty tools available that are used to work plastic laminate. Laminate shears are used to cut plastic laminate. To cut it, hold the laminate securely and squeeze the handles firmly. Advance the shear as you get to the end of the cutting edge.

The mitring machine can be used to cut straight lines at any angle. The angle is set with the pivoting fence and locked in position. The laminate strip is positioned under the shearing blade with its good face up. As the handle is pushed down, the clamp engages first and then the shear cuts the laminate.

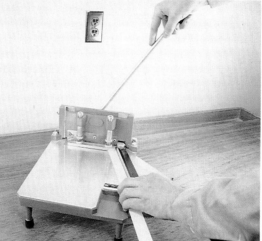

This hand roller allows you to apply pressure over a small area of plastic laminate with two fists.

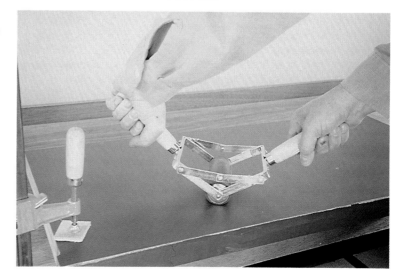

The one-hand roller is gripped with one hand and allows you to exert sufficient pressure to get a good adhesive bond.

The stationary laminate slitter is used to separate laminate sheets into strips.

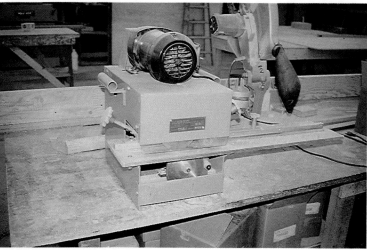

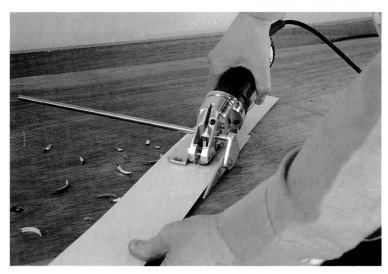

The power shear is a specialized laminate tool that can be air- or electric-powered. It cuts plastic laminates quickly and accurately. It is equipped with a fence for cutting uniform strips.

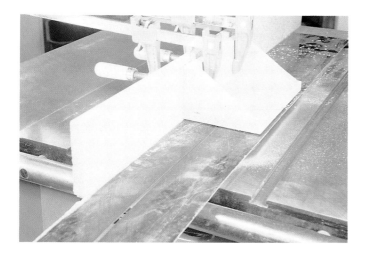

General woodworking tools are also used to work plastic laminates. The table saw is used to cut plastic laminates. Shop-made jigs can be used to handle the plastic-laminate strips. This jig prevents the plastic laminate from creeping under the fence and acts as a barrier between you and the blade.

The radial arm saw can also be used to cut wood and plastic laminates. This stand supports the work during a crosscut. To ensure both safety and accuracy, make sure that you support long pieces.

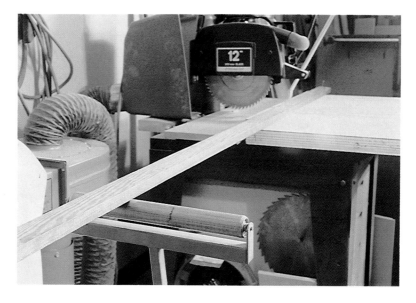

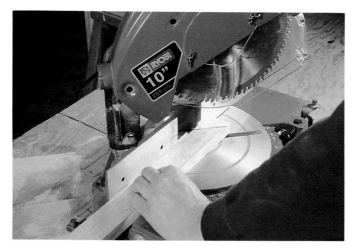

The motorized mitre box can also be used to cut plastic laminates. When using the motorized mitre box, position the cutting line of the workpiece with the blade on the waste side of the workpiece.

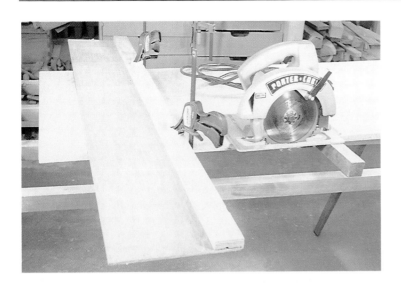

A portable circular sawing machine is used in the fabrication of laminated counters. It is an ideal means of sawing large or heavy pieces. When using a portable circular sawing machine, expose its blade to no more than ¼" greater than stock thickness.

A laminate trimmer is also used to cut plastic laminates. In some cases, two pieces of laminate are cut simultaneously. This is done to make a perfect joint cut between two pieces. A shop-made jig is being used to help ensure this perfect joint. (Photo courtesy of Skil Power Tools.)

Clamp the laminate under the guide. If you are making a joint, insert two pieces (one from each side). Allow for a slight overlap. The pieces should be clamped firmly. (Photo courtesy of Skil Power Tools.)

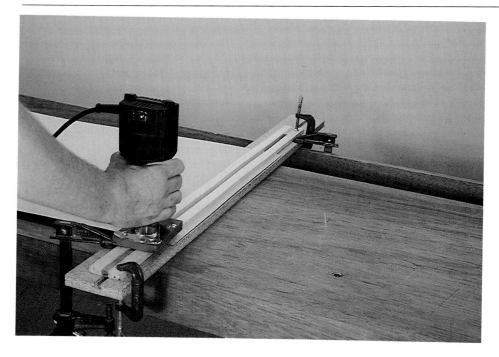

Position the follower guide inside the guide and turn the laminate trimmer on. (Photo courtesy of Skil Power Tools.)

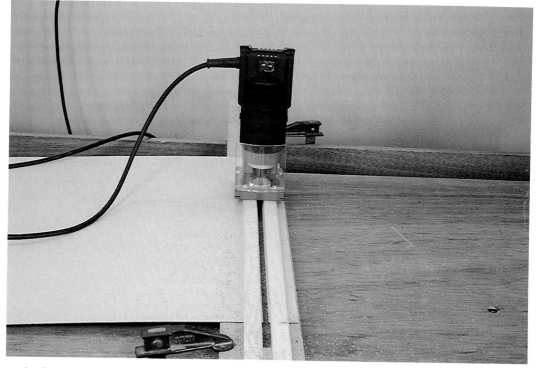

The laminate trimmer cuts both pieces and produces a perfect-fitting joint.
(Photo courtesy of Skil Power Tools.)

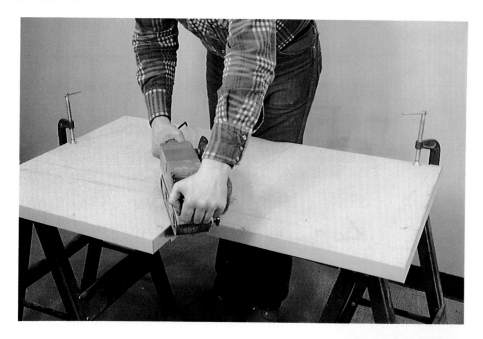

Sometimes the top surfaces are sanded after the edges are laminated. This evens up the surface and ensures a good fit between the edge and top surface. Here a belt sander is being used to even up an inside corner. Note that the belt is pulling towards its backing piece. Clamp the work securely. Do not over-sand the edges. The joint between the edge and top may not be square. This could encourage delamination.

A few of the hand tools used when working with plastic laminate.

A typical shop-made "dedicated" spray area for spraying contact adhesive.

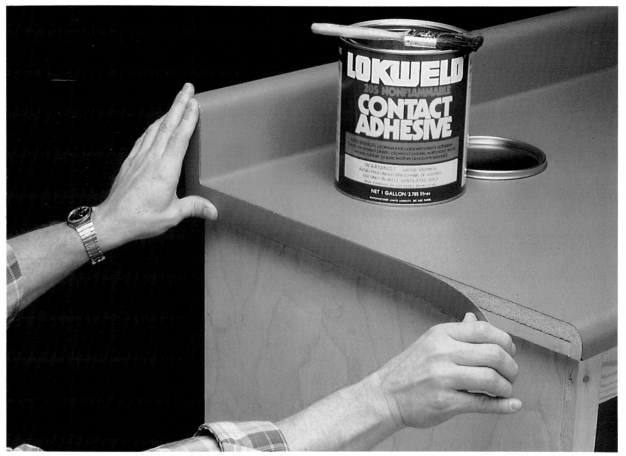

Once the type of contact adhesive has been selected and a suitable method for applying it has been chosen, the process of applying the adhesive is simple. (Photo courtesy of Wilsonart.)

Illus. 3–53. Cutting guides can be used to control the blade's path. Clamp them securely to the work.

Illus. 3–54. Adjust the blade exposure on a portable circular saw to no more than ¼ inch greater than stock thickness.

Illus. 3–55. Make sure the piece you are cutting off is supported. This will keep the saw from binding in the cut.

Illus. 3–56. A laminate trimming router bit will smooth an edge when controlled by a straight-edge.

5. Make all adjustments with the power disconnected.
6. Set the blade exposure to no more than ¼ inch greater than stock thickness.
7. Always support the stock on a bench or sawhorse. Clamp short stock to the bench or sawhorse.
8. Do not allow the stock to pinch the blade while cutting.
9. If the saw has two handles, use them. Your hands cannot come into contact with the blade if you use the handles.
10. Keep yourself balanced while sawing. Do not reach out too far.

Circular-Saw Blades Experience has shown that the two best carbide-tipped saw blades for cutting particleboard and plastic laminate are ground with a triple-chip cutting design or a high, alternate top bevel (Illus. 3–57). A blade with a triple-chip design better resists the abrasive action of the plastic laminate and countertop stock. The alternate top-bevel blade produces a chip-free cut, but will dull somewhat quicker. If you do not have access to a scoring saw, use an alternate top bevel blade; it will produce less tear-out.

A typical 7–8 inch portable circular saw should use a 40-tooth blade. A 10-inch motorized mitre box should use a 40–60-tooth blade. Motorized mitre boxes turn at 30–50% higher rpm than table or radial arm saws. This means that a 40-tooth blade

used on a motorized mitre box functions more like a 60-tooth blade on a table or radial arm saw.

For radial arm saws and motorized mitre boxes, choose a blade with less than a 10-degree hook angle. This will reduce climbing and tear-out. If tear-out is excessive, check the saw's alignment and the saw blade sharpness. Remember, an alternate top bevel blade will produce less tear-out and may be desirable for some cuts.

Illus. 3–57. The high, alternate top bevel on this blade will cut laminate and particleboard very smoothly.

ROUTER

The router (Illus. 3-58–3-60) is also a portable tool the laminate fabricator relies upon for many operations. Some of these operations include cutting sheet stock or laminate, forming curves or radii, shaping hardwood edges, and trimming hardwood edges.

Before you operate the router, it is important that you study the safe operating procedures described below:

1. Always wear protective glasses and a face shield when operating the router.
2. Some routers operate at high noise levels. Protect your hearing with ear plugs or protectors when operating one.
3. Change bits and make all adjustments with the power disconnected. Make sure that the bit is sharp.
4. Before operating the router, restrain long hair. Remove jewelry and neckties. Loose sleeves

Illus. 3–58. This D-handle router works well for general routing. The handle makes the router easy to control. (Photo courtesy of Porter-Cable Corporation.)

Illus. 3–59. This variable-speed router allows you to reduce speed when using larger router bits. (Photo courtesy of Porter-Cable Corporation.)

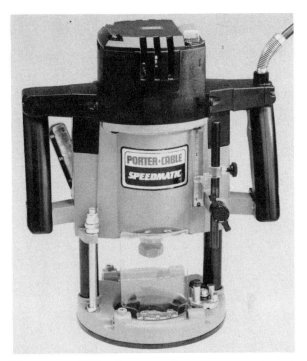

Illus. 3–60. This plunge router allows you to cut through surfaces with a router bit. Sink cutouts are often made with plunge routers. (Photo courtesy of Porter-Cable Corporation.)

should be rolled above the elbows, and shirt-tails should be tucked in.

5. Make sure stock is clamped securely before routing. Never attempt to hand-hold the stock you plan to rout.

6. Do not start the router while the bit is in contact with the workpiece. The bit must be fed into the work at full speed.

7. When you use a shaping table or edge guide with the router, make sure that they are attached securely.

8. Feed the router from left to right as you face the work. On curved edges, feed the router in a counterclockwise direction.

9. Take light cuts. Heavy cuts slow the router, burn and tear the wood, and dull the bit. Limit cuts to maximum depths of ⅛ to ³⁄₁₆ inch.

10. Use only carbide-tipped router bits to cut plywood or particleboard. These materials will dull steel bits rapidly.

The best choice of router for laminate and countertop work is a ½-inch-collet plunge router. The ½-

inch collet allows you to use larger-diameter bits without deflection. The plunging action allows you to make a plunge cut into a piece of sheet stock or countertop to make an inside cut. When a router plunges into the opening, there is less stress on the bit.

Router Bits The router bits you select should be carbide-tipped. The following bits would be a useful starting selection: a ½-inch, solid-carbide spiral upcut bit (Illus. 3–61); a ½-inch laminate-trimming bit (Illus. 3–62); a ½-inch stagger-tooth bit (Illus. 3–63); and a ½-inch (or larger) pilot panel bit (Illus. 3–64) (this bit may be a single-flute, spiral downcut, or stagger-tooth bit).

Spiral bits are chosen most often because of their shearing cut. Straight bits tend to slap the work surface and cause more tear-out and larger mill marks. The slapping action can cause the bit to deflect and turn in an eccentric orbit. This can lead to bit breakage.

The *½-inch spiral upcut bit* can be used to smooth rough edges. This can be done using a straightedge or jig. The straightedge clamps to the work, and the

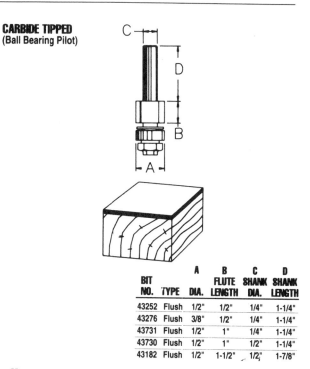

CARBIDE TIPPED
(Ball Bearing Pilot)

BIT NO.	TYPE	A DIA.	B FLUTE LENGTH	C SHANK DIA.	D SHANK LENGTH
43252	Flush	1/2"	1/2"	1/4"	1-1/4"
43276	Flush	3/8"	1/2"	1/4"	1-1/4"
43731	Flush	1/2"	1"	1/4"	1-1/4"
43730	Flush	1/2"	1"	1/2"	1-1/4"
43182	Flush	1/2"	1-1/2"	1/2"	1-7/8"

Illus. 3–62. The laminate-trimming bit cuts sheet stock or plastic laminate flush with an edge. It is used for counter fabrication. (Drawing courtesy of Porter-Cable Corporation.)

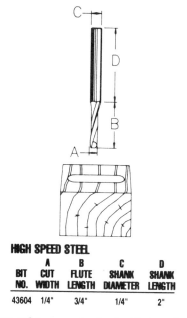

HIGH SPEED STEEL

BIT NO.	A CUT WIDTH	B FLUTE LENGTH	C SHANK DIAMETER	D SHANK LENGTH
43604	1/4"	3/4"	1/4"	2"

Illus. 3–61. This upcut, single-flute spiral bit cuts stock to size when controlled with a follower guide. This bit is important to quality fabrication. (Drawing courtesy of Porter-Cable Corporation.)

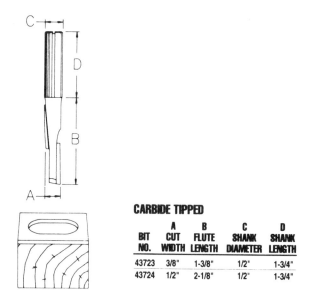

CARBIDE TIPPED

BIT NO.	A CUT WIDTH	B FLUTE LENGTH	C SHANK DIAMETER	D SHANK LENGTH
43723	3/8"	1-3/8"	1/2"	1-3/4"
43724	1/2"	2-1/8"	1/2"	1-3/4"

Illus. 3–63. The stagger-tooth router bit is a good bit for making plunge cuts and for template work. The bit's cutting action is balanced in a kerf, due to its design. (Drawing courtesy of Porter-Cable Corporation.)

CARBIDE TIPPED

BIT NO.	A CUT WIDTH	B FLUTE LENGTH	C SHANK DIAMETER	D SHANK LENGTH
43708	1/4"	3/4"	1/4"	1-3/16"
43709	3/8"	1"	3/8"	1-1/8"
43064	1/2"	1-1/4"	1/2"	1-1/4"
43066	1/2"	2"	1/2"	1-1/2"

Illus. 3–64. A pilot panel bit drills through the laminate, and its pilot edge controls the path of the bit. Laminates are cut away from an opening with this bit. (Drawing courtesy of Porter-Cable Corporation.)

router base rides along the straightedge. The spiral bit shears a small amount of material and straightens the edge.

When using a jig, you can mount a follower guide on the router base. This guide rides against the template edge. The router bit extends through the follower guide to trim the edge. The advantage of the follower guide is that it will follow irregular (nonstraight) edges. The disadvantage is that the template must be offset to compensate for the distance from the outer edge of the follower guide to the tip of the router bit.

The ½-inch *laminate-trimming bit* is equipped with a ball bearing at its lower end. This ball bearing is the same diameter as the cutting circle. The router bit will follow any straight or curved edge attached to the underside of the blank. This means that the template can be cut to exact size.

The cutting depth of a laminate-trimming bit is

limited. About ⅛ inch of stock should be removed. The bit should only be trimming, not cutting, stock. A bit that cuts stock is cutting in a kerf, not along an edge.

Smaller laminate-trimming bits are available, but they should only be used for trimming plastic laminates. They are usually used in laminate trimmers or small routers.

Recently, router bits have been developed which are similar to laminate-trimming bits except that the ball bearing is above the bit (Illus. 3–65). This type of router bit cannot trim plastic laminates, but it works well with templates. The templates can be positioned above the workpiece, and the bit will trim the exact shape. Patterns are exact size, and no follower guide is needed. This makes jig fabrication and setup easier.

HIGH SPEED STEEL

BIT NO.	A CUT WIDTH	B FLUTE LENGTH	C SHANK DIAMETER	D SHANK LENGTH
43450	5/16"	3/4"	1/4"	1"

Illus. 3–65. This straight-cutting bit has a ball-bearing guide over it. It can be used to trim stock to the size of a template. (Drawing courtesy of Porter-Cable Corporation.)

The *½-inch stagger-tooth bit* is designed for trimming or cutting. The stagger-tooth blade is like two single-flute router bits joined together. The two carbide cutting edges are staggered or offset; this allows the bit to cut on both sides without binding or overloading the router. Stagger-tooth bits also have a design that allows them to cut on the end. This

makes it possible to plunge into the work and make an inside cut.

Stagger-tooth bits are usually installed in a plunge router equipped with a follower guide. The follower guide controls the path of the bit as it rides against the template. Stagger-tooth bits are frequently used to make cutouts in laminate blanks. The template is always placed on top of the workpiece (Illus. 3–66).

Illus. 3–66. When using a follower guide, always place the template on top of the work. (Photo courtesy of Skil Power Tools.)

Another processing bit used with the router is the *pilot panel bit*. The pilot panel bit is similar to the laminate-trimming bit and the stagger-tooth bit. The pilot panel bit has a drill point which allows it to drill through the workpiece. The pilot tip, which is a solid, noncutting portion of the bit, is just above the drill point. Once it is through the workpiece, the bit cuts its way to any solid edge. The pilot tip then follows the straightedge. This bit is used when a border of bracing has been positioned on the underside of the counter. The pilot tip will ride along the bracing and make the cutout. The bracing is actually the template.

When using this bit, you must set the plunging depth accurately. The plunge depth is adjusted so that the pilot tip will ride on the edge of the bracing or template beneath the work. Otherwise, the pilot tip cannot control the cutting path. It is also important that the bit is drilled through the work in the correct spot. If the hole is drilled in the wrong place,

then the pilot tip may not have a guide and the work will be ruined. Use a plunge router to drill with this bit. The plunging action eliminates lateral stress on the bit. Lateral stress is a chief cause of bit breakage.

Working correctly with routers and router bits is important to your safety and the quality of your work. Always disconnect the router from the power source before changing bits or making adjustments. Always be certain that the bit's path is adjusted correctly so that the appropriate cut is made and no nails or staples are hit by the bit. Make sure that at least 1 inch of the bit is in the collet before tightening the collet. Less of the bit in the collet could result in the bit working its way out of the collet under power.

For more information about routers, consult the *New Router Handbook*, by Patrick Spielman, or the *Woodworker's Handbook*, by Roger W. Cliffe.

LAMINATE TRIMMERS

Laminate trimmers are a modification of routers designed specifically for laminate work (Illus. 3–67 and 3–68). Laminate trimmers are smaller in size and usually turn at a faster speed than a router. This is because they turn bits of a smaller diameter. When using laminate trimmers, observe the following safety procedures:

Illus. 3–67. This laminate trimmer consists of a motor and an adjustable base. (Photo courtesy of Porter-Cable Corporation.)

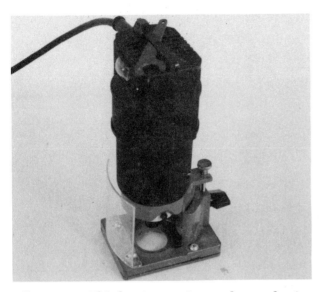

Illus. 3–68. This laminate trimmer has a plastic shield to deflect chips. The base is controlled by the height and clamp knobs. *(Photo courtesy of Skil Power Tools.)*

1. Be aware of motor torque. When you turn the laminate trimmer on, the torque of the motor could cause it to turn in your hand. Be sure to hold it securely.
2. Watch where you position your hands. It is possible to touch the cutter if you grip the laminate trimmer incorrectly. Work with the laminate trimmer is done with one hand. Make sure that your other hand is clear of the tool's paths and that the bit has come to a complete stop before you put the trimmer down.
3. Protect your face and eyes. When plastic laminates are trimmed, chips are thrown with great force. Use protective goggles or a face shield.
4. With prolonged use, the laminate trimmer could affect your hearing. Wear ear muffs or plugs for every operation.
5. Inspect the work. The cutter must not hit nails, loose knots, or other objects in the work.
6. Know your cutting path. The laminate trimmer should travel from left to right as you face the work and counterclockwise around any object. The cord should be clear of the cutter and cutting path.
7. Make sure that the bit is installed according to the procedure described in the owner's manual. Always disconnect the power when changing bits or making an adjustment.

8. Before you make a cut, make sure that all clamps, screws, and other settings are securely fastened.
9. Keep the amount of laminate overhanging the edge to a minimum. An overhang of over 2 inches should be first cut with an overhang bit.

Laminate-Trimmer Bits Laminate trimmers use a ¼-inch collet and generally turn the following types of bits: ¼-inch carbide straight- and spiral-cutting bits, ⅛-inch carbide straight-cutting bits (Illus. 3–69), two- and three-flute flush-trimming laminate bits (Illus. 3–70), overhang cutoff bits (Illus. 3–71), bevel-trimming bits (Illus. 3–72), combination flush- and bevel-trimming bits (Illus. 3–73), and boring and flush-cutting bits (Illus. 3–74). The uses of these bits are discussed in the following paragraphs.

Straight-cutting bits are used to cut laminate sheets into parts. This is done with the use of a jig. The jig may be controlled by a follower guide in the base of the laminate trimmer or by a straightedge controlling the base of the router. Straight bits are carbide-tipped or solid carbide.

In some cases, two pieces of plastic laminate are cut simultaneously. This is done to make a perfect joint cut between the two pieces (Illus. 3-75–3-80).

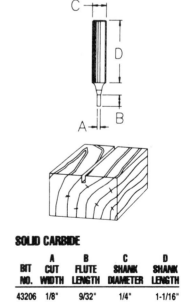

SOLID CARBIDE

BIT NO.	A CUT WIDTH	B FLUTE LENGTH	C SHANK DIAMETER	D SHANK LENGTH
43206	1/8"	9/32"	1/4"	1-1/16"

Illus. 3–69. This ⅛-inch straight-cutting bit is used to cut plastic laminate. It is usually controlled by a follower guide. *(Drawing courtesy of Porter-Cable Corporation.)*

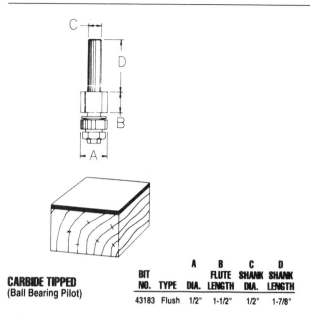

CARBIDE TIPPED
(Ball Bearing Pilot)

BIT NO.	TYPE	A DIA.	B FLUTE LENGTH	C SHANK DIA.	D SHANK LENGTH
43183	Flush	1/2"	1-1/2"	1/2"	1-7/8"

Illus. 3–70. This three-flute flush-trimming bit does a very smooth job of trimming plastic laminate. The ball bearing controls the path of the bit.

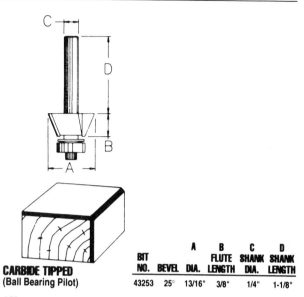

CARBIDE TIPPED
(Ball Bearing Pilot)

BIT NO.	BEVEL	A DIA.	B FLUTE LENGTH	C SHANK DIA.	D SHANK LENGTH
43253	25°	13/16"	3/8"	1/4"	1-1/8"

Illus. 3–72. The bevel-trimming bit cuts a bevel on a plastic laminate edge. The more bit you use, the more stock you remove. If it is set too deep, you could cut through the laminate. (Drawing courtesy of Porter-Cable Corporation.)

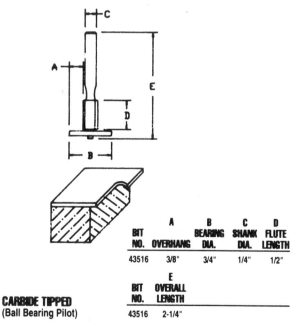

BIT NO.	A OVERHANG	B BEARING DIA.	C SHANK DIA.	D FLUTE LENGTH
43516	3/8"	3/4"	1/4"	1/2"

BIT NO.	E OVERALL LENGTH
43516	2-1/4"

CARBIDE TIPPED
(Ball Bearing Pilot)

Illus. 3–71. The overhang bit has a bearing ½ inch larger than the bit diameter. This allows a ¼-inch overhang after trimming. The surface is then cut with a flush-trimming bit. (Drawing courtesy of Porter-Cable Corporation.)

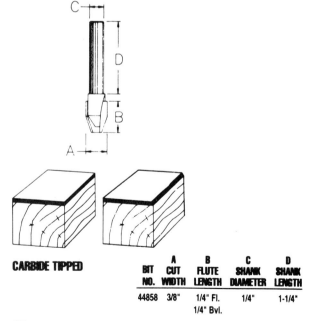

CARBIDE TIPPED

BIT NO.	A CUT WIDTH	B FLUTE LENGTH	C SHANK DIAMETER	D SHANK LENGTH
44858	3/8"	1/4" Fl. 1/4" Bvl.	1/4"	1-1/4"

Illus. 3–73. Combination flush- and bevel-trimming bits are used to flush- and bevel-trim plastic laminate. This bit is used on laminate trimmers equipped with an edge guide. (Drawing courtesy of Porter-Cable Corporation.)

SOLID CARBIDE

BIT NO.	A CUT WIDTH	B FLUTE LENGTH	C SHANK DIAMETER	D SHANK LENGTH
43231	1/4"	1/4"	1/4"	7/8"

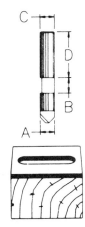

Illus. 3–74. The boring and flush-cutting bit bores a hole through the laminate and follows the opening beneath it. (Drawing courtesy of Porter-Cable Corporation.)

Illus. 3–75. This jig has been built to cut a perfect joint between two pieces or to cut strips of laminate. (Photo courtesy of Skil Power Tools.)

Illus. 3–76. The laminate is clamped under the guide. If a joint is going to be made, two pieces are inserted (one from each side) with a slight overlap. The pieces should be clamped firmly. (Photo courtesy of Skil Power Tools.)

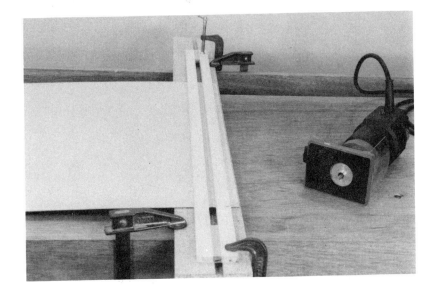

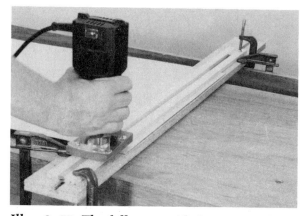

Illus. 3–77. The follower guide is positioned inside the jig, and the laminate trimmer is turned on. *(Photo courtesy of Skil Power Tools.)*

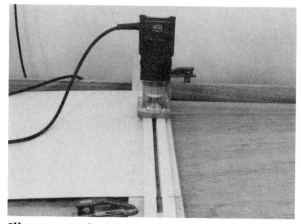

Illus. 3–78. The laminate trimmer cuts both pieces and produces a perfect-fitting joint. *(Photo courtesy of Skil Power Tools.)*

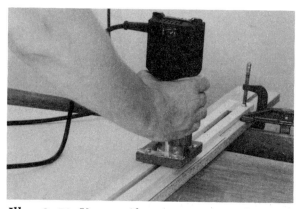

Illus. 3–79. Keep uniform pressure on the trimmer and guide it into the laminate at moderate speed. *(Photo courtesy of Skil Power Tools.)*

Illus. 3–80. Quality results can be achieved with shop-made jigs. *(Photo courtesy of Skil Power Tools.)*

If the bit moves even slightly off the intended path, the bit cuts the opposite error on the mating piece. This means that they will fit together perfectly. The ⅛-inch bit will move less than the ¼-inch bit. This makes it a better choice when cutting mating pieces.

One-quarter-inch *spiral-cutting bits* can also be used in the same way as straight-cutting bits. The difference is the spiral orientation of the cutting edges. The spiral-cutting edge produces a smoother cut.

The *two-* or *three-flute flush-* or *laminate-trimming bits* have a ball bearing attached to their bottoms. This ball bearing is the same diameter as

Illus. 3–81. The two- or three-flush flush- or laminate-trimming bits remove any laminate extending beyond the edge of the work.

Illus. 3–82. The ball bearing on this bit runs smoothly along the edge of the work and trims the laminate. This is a laminate fabricator's bit of choice for many jobs.

the cutting circle of the two or three cutting edges or flutes. The ball bearing rides on the edges which are perpendicular to the laminated surface. The cutting edges then remove the overhanging plastic laminate (Illus. 3–81).

The ball bearing rolls smoothly on the work surface (Illus. 3–82). It also rolls over laminated surfaces without burning or damaging the laminate. Always check the ball bearing to be sure it is spinning freely before installing it in the laminate trimmer's collet. Two-flute bits usually have a smaller diameter than three-flute bits. Smoother cuts are attained using the three-flute bit.

Flush-trimming bits can also be used to cut plastic laminates to size (Illus. 3-83–3-89). The lami-

Illus. 3–84. The laminate is clamped to the wider piece of stock. Note the position of the cutting line. (Photo courtesy of Skil Power Tools.)

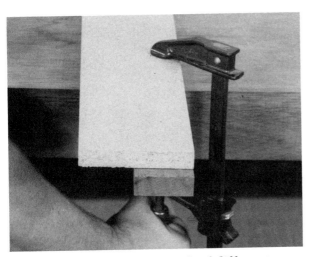

Illus. 3–83. Two pieces of stock of different widths are clamped to the workbench. (Photo courtesy of Skil Power Tools.)

Illus. 3–85. The laminate bit is smaller than the cutting allowance; this ensures that the workpiece will be large enough. (Photo courtesy of Skil Power Tools.)

Illus. 3–86. The solid tip of the flush-cutting bit rides along the straightedge. The laminate trimmer is guided through the plastic laminate. (Photo courtesy of Skil Power Tools.)

Illus. 3–88. The separated piece drops to the bench, and the stock can be repositioned for additional cuts. (Photo courtesy of Skil Power Tools.)

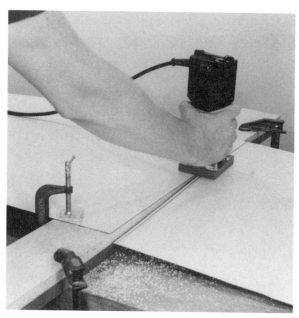

Illus. 3–87. Keep the laminate trimmer balanced on the guide as the plastic laminate begins to separate. (Photo courtesy of Skil Power Tools.)

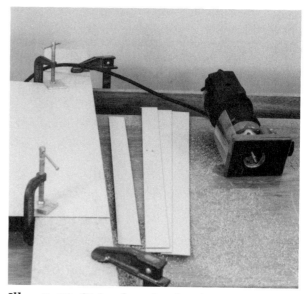

Illus. 3–89. Strips for edge-laminating were cut using the setup shown here. (Photo courtesy of Skil Power Tools.)

nate piece is attached to a straightedge with clamping pressure. The bit now rides along the straightedge while the laminate above the straightedge is separated into two pieces.

There are also flush-trimming laminate bits with solid pilot tips. These bits are used in the same way as the ball-bearing bits. The difference is that the solid pilot tip can generate friction and burn the plastic laminate that is controlling its path. Many

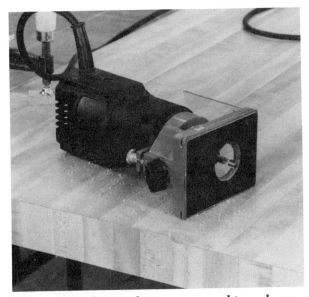

Illus. 3–90. This surface was waxed to reduce the possibility of the solid pilot tip burning the laminate. (Photo courtesy of Skil Power Tools.)

Illus. 3–91. By keeping the laminate trimmer (and bit) moving, there is little chance of burning a waxed surface. (Photo courtesy of Skil Power Tools.)

laminate fabricators wax the laminate edge on which the solid pilot rides (Illus. 3–90). This reduces the chance of burning. When using solid pilot bits on laminated surfaces, be sure to keep the bit moving. This also will reduce the chance of burning the wood surface (Illus. 3–91).

Overhang cutoff bits do a job similar to that performed by flush-trimming bits. The difference is that the diameter of the ball bearing on overhang cutoff bits is larger than the cutting diameter by ½ inch. This means that the bit leaves an overhang of ¼ inch rather than trimming the laminate flush (Illus. 3–92).

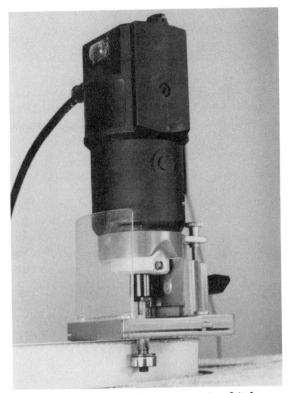

Illus. 3–92. The overhang trimming bit leaves the laminate slightly larger than the surface. This makes the final trimming easier. (Photo courtesy of Skil Power Tools.)

The overhang cutoff bit is used before the flush-cutting bit. By removing most of the excess laminate with this bit, it is easier to control the laminate trimmer when completing the flush-trimming operation. The small overhang reduces the strain on the trimmer and ensures a quality job.

The *bevel-trimming bit* is used after the flush-

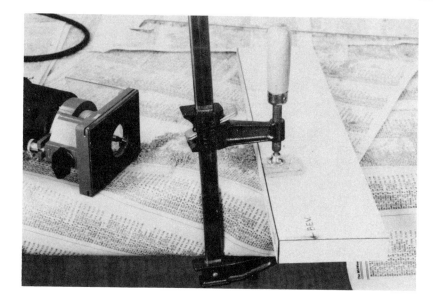

Illus. 3–93. The bevel trimming bit is used after the flush-cutting bit. Bevel bits ease sharp corners and give the parts a finished look. (Photo courtesy of Skil Power Tools.)

trimming bit. Its purpose is to bevel the edges of the plastic laminate so that they look finished and are not sharp (Illus. 3–93). Bevel-trimming bits may be controlled by a ball bearing or a solid pilot tip. Ball bearings reduce the likelihood of burning the laminated edge.

When working with bevel-trimming bits, the depth of cut is an important adjustment. The deeper the bit cuts into the laminate, the more material it removes. It is possible for the bit to cut through the decorative surface of the laminate, or through the laminate into the substrate. Make test cuts in scrap to be sure the setup is correct before proceeding.

The angle of the bevel-trimming bit varies from about 7 to 22 degrees. These angles change from one manufacturer to another. If bits with smaller angles are used, less of the core area will be shown. If the core is brown, the smaller cut angle will show less of that material.

There are also *combination flush-and-bevel-trimming bits.* These bits have no pilot tip. When using these bits, you must use a laminate trimmer with a guide assembly under the bit (Illus. 3–94). The guide assembly can be adjusted laterally to control the depth of cut. By positioning the bit relative to the base of the laminate trimmer and adjusting the guide assembly, you can use the bit for straight or bevel routing. Make these setups in a piece of scrap before actually cutting the workpiece. The advantages to these combination bits are

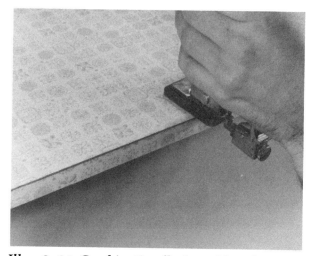

Illus. 3–94. Combination flush-and-bevel trimming bits must be used with laminate trimmers equipped with an edge guide. (Photo courtesy of Skil Power Tools.)

that your initial financial investment is lower and the guide assembly will not burn or damage the laminate. The disadvantage is that every operation requires a different setup. This consumes a great deal of time. Production laminators would buy additional bits and laminate trimmers to save time.

The *hole- and flush-cutting laminate-trimming bit* is used to cut the plastic laminate away from a hole in a counter blank. Some common holes are sink and stove cutouts. The laminate covers the entire

counter, and the laminate covering the cutout is cut away after the counter has been laminated. The hole- and flush-cutting bit drills its way through the laminate. The noncutting portion above the cutting portion separates the laminate around the opening. If the noncutting portion of the bit is not positioned correctly, then the piece could be damaged. This is because the bit will cut beyond the original cutout area.

Laminate Trimmer Kits　Many laminate trimmers are sold as kits (Illus. 3–95). They contain specialty equipment such as slitters (Illus. 3–96 and 3–97), underscribe, offset bases, tilting bases (Illus. 3–98), and router bases. These accessories can be used to cut plastic laminate, trim narrow edges or close corners after installation, and extend the versatility of the tool (Illus. 3–99). Be sure to follow the directions furnished by the manufacturer to work safely.

There are many specialty bases to be used with laminate trimmers. Some of them are presented here. The speciality bases and attachments are sold as accessories by the manufacturer of the laminate trimmer or by aftermarket manufacturers.

Straight-Line Trimming　Straight-line trimming bases are designed to trim the edge of a laminate after it has been glued into place. The base can be used horizontally or vertically and extends only ⅞ inch beyond the edge. The trimming base shown in Illus. 3–100 fits most popular laminate trimmers and produces a smooth edge without filing.

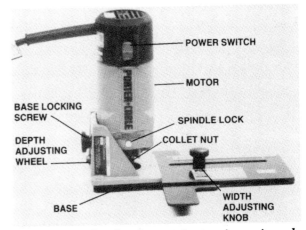

Illus. 3–96. This laminate trimmer is equipped with a slitter. It will cut laminate sheets into strips up to 4¼ inches wide. (Photo courtesy of Porter-Cable Power Tools.)

Illus. 3–97. Once the slitter is set up, the laminate is butted to the fence and guided into the opening. The pin between the bases will prevent you from feeding the laminate from the wrong end.

Illus. 3–95. Many laminate trimmers come in kit form. The specialty parts are designed for specific applications. Be sure to follow the instructions furnished with the kit before use.

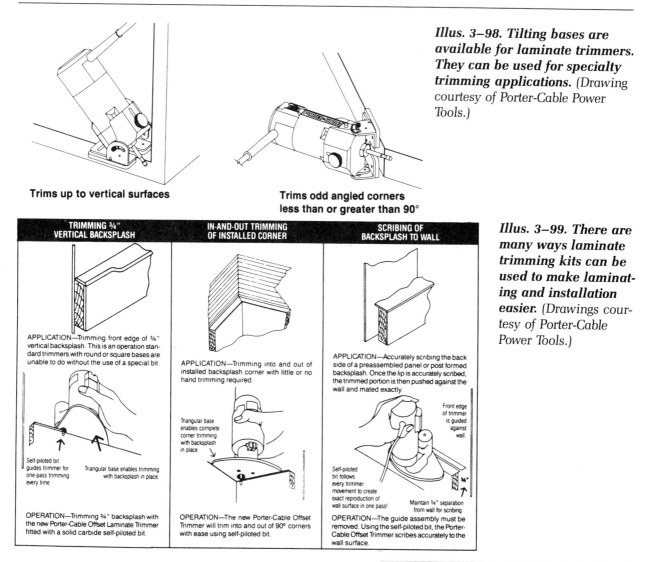

Trims up to vertical surfaces

Trims odd angled corners less than or greater than 90°

Illus. 3–98. Tilting bases are available for laminate trimmers. They can be used for specialty trimming applications. (Drawing courtesy of Porter-Cable Power Tools.)

TRIMMING ¾" VERTICAL BACKSPLASH	IN-AND-OUT TRIMMING OF INSTALLED CORNER	SCRIBING OF BACKSPLASH TO WALL

APPLICATION—Trimming front edge of ¾" vertical backsplash. This is an operation standard trimmers with round or square bases are unable to do without the use of a special bit.

Self-piloted bit guides trimmer for one-pass trimming every time.

Triangular base enables trimming with backsplash in place.

OPERATION—Trimming ¾" backsplash with the new Porter-Cable Offset Laminate Trimmer fitted with a solid carbide self-piloted bit.

APPLICATION—Trimming into and out of installed backsplash corner with little or no hand trimming required.

Triangular base enables complete corner trimming with backsplash in place.

OPERATION—The new Porter-Cable Offset Trimmer will trim into and out of 90° corners with ease using self-piloted bit.

APPLICATION—Accurately scribing the back side of a preassembled panel or post formed backsplash. Once the lip is accurately scribed, the trimmed portion is then pushed against the wall and mated exactly.

Front edge of trimmer is guided against wall.

Self-piloted bit follows every trimmer movement to create exact reproduction of wall surface in one pass!

Maintain ¾" separation from wall for scribing.

OPERATION—The guide assembly must be removed. Using the self-piloted bit, the Porter-Cable Offset Trimmer scribes accurately to the wall surface.

Illus. 3–99. There are many ways laminate trimming kits can be used to make laminating and installation easier. (Drawings courtesy of Porter-Cable Power Tools.)

Illus. 3–100. The straight-line trimming base eliminates filing because it trims edges so smoothly. (Photo courtesy of Art Betterley Enterprises.)

Underscribe Cutting The underscribing base cuts joints between two pieces of plastic laminate (Illus. 3–101). Both pieces are glued in place, and when the overlap on the piece is trimmed off, the fit between the parts makes a perfect joint. None of the material trimmed from the upper part gets in the joint because the base deflects the chips away from the joint. There is also a specialty attachment (Illus. 3–102) that allows the underscribing base to trim ends on cylinders. The attachment holds the base in the correct plane for trimming the overlap (Illus. 3–103). The pieces ride along the lip on the base, so the control edge has to be straight.

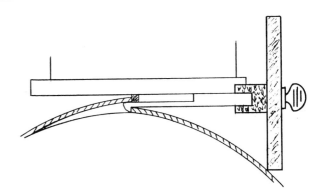

Illus. 3–103. The straight edge of the laminate provides a guide for the lip on the base. The overlapping piece is cut for a perfect joint. (Photo courtesy of Art Betterley Enterprises.)

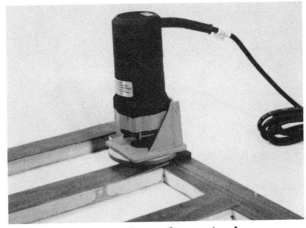

Illus. 3–101. The underscribe-cutting base produces a tight-fitting joint between two pieces that have been glued in position. The upper piece must overlap the lower piece for trimming. (Photo courtesy of Art Betterley Enterprises.)

Seaming Laminates The seaming base (Illus. 3–104) allows you to make a perfect seam between the two plastic-laminate sheets. A true edge is needed on the controlling piece. It can be glued or clamped in place. The mating piece overlaps $1/8$–$7/8$ inch and must be moved after it has been cut. The seaming base cuts a mating image of the lower laminate edge (Illus. 3–105).

Mitring Laminates Laminates can be mitred in place so that the pattern wraps around the object. A tilting base is required for this operation (Illus. 3–106). The tilting base cuts the laminate overlap so that it folds itself around the object (Illus. 3–107).

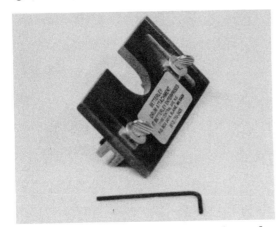

Illus. 3–102. This attachment allows the underscribe base to be positioned correctly on a cylinder. (Photo courtesy of Art Betterley Enterprises.)

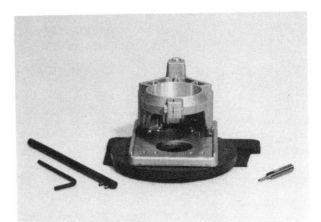

Illus. 3–104. This seaming base allows a perfect seam between two pieces of plastic laminate. It comes with a special wrench for fine adjustments. (Photo courtesy of Art Betterley Enterprises.)

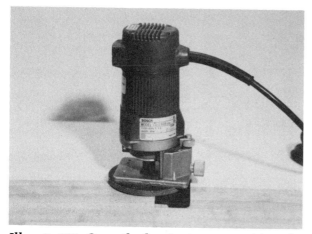

Illus. 3–105. Once the laminates are positioned and clamped, the lip on the base follows the edge of the lower piece. (Photo courtesy of Art Betterley Enterprises.)

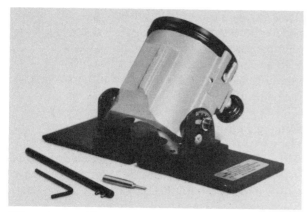

Illus. 3–106. You can cut overlapping mitres on laminates with a tilting base and attachments. (Photo courtesy of Art Betterley Enterprises.)

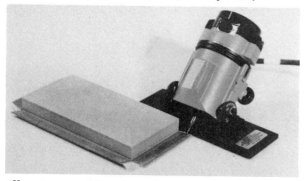

Illus. 3–107. After the edges are mitred, they are folded into place. This allows the pattern to wrap the workpiece. (Photo courtesy of Art Betterley Enterprises.)

After the cuts are made, the mitred pieces are folded and glued into place. Any edge trimming can then be done.

When working with laminate trimmers, work carefully. Clamp your work securely. Be sure to make all adjustments with the power disconnected. Most laminate trimmers are designed to be hand held. They usually have no handles, but are gripped in the hand. Make sure that when you grasp the laminate trimmer your fingers do not contact the cutter. There is a great temptation when using laminate to hold the work with one hand and to hold the laminate trimmer with the other. This is a dangerous practice. You have a sharp bit being pushed towards your hand. Any error is sure to cause an injury. Work safely by clamping the work and keeping your hand out of the bit's path.

BELT SANDERS

Belt sanders are also an important tool in the laminating shop (Illus. 3–108). Blanks are sanded at joints, hardwood edge bands, filled or patched areas, and along trimmed laminate edges (Illus. 3–109). Most laminators use 3 × 21-inch belt sanders, that is, belt sanders that use a belt 3 inches wide and 21 inches long. The 3 × 21-inch size is chosen because it can be used effectively on the sanding area and because the weight of a sander with a 3 × 21-inch belt is one that can be controlled easily.

Most sanding is done with belts ranging from 60 to 150 grit. Belts with 60 to 80 grit are used for rough fabricating. Belts with 100 to 150 grit are used for

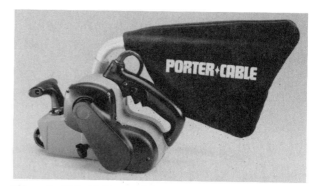

Illus. 3–108. Belt sanders are used for many laminating operations. They are an essential tool for laminate fabricators. (Photo courtesy of Porter-Cable Corporation.)

Illus. 3–109. This trimmed edge has been belt-sanded with a very fine belt before laminate was applied to the surface.

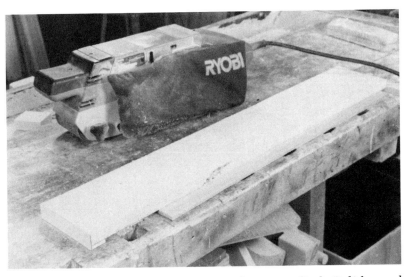

finish work. When sanding particleboard, sand the long way when possible. Keep the sander moving; this makes the surface more uniform.

In some cases, the top surfaces are sanded after the edges are laminated. This evens the surfaces and ensures a good fit between the edge and top surface (Illus. 3–110). Always use fine abrasives. Position the belt sander so that the belt is pulling the laminate towards the substrate. This will ensure that the contact-cement bond remains intact. Always keep half of the sanding surface on the work when belt-sanding. This prevents the sanding belt from rounding a square corner. It is very difficult to get a good bond when the surface is rounded.

When belt-sanding wooden edges, sand with the grain. Cross-grain scratches are extremely visible

when stain and finish are applied. Solid-wood edges can also be sanded with orbital (Illus. 3–111 and 3–112) or random-orbit sanders (Illus. 3–113). These sanders use fine abrasives (100 grit and finer) to smooth solid wood for finishes. These sanders should be used with the grain of the wood. When the power-sanding is complete, some hand-sanding at the finest grit will improve finishing results. Again, this sanding is done with the grain.

PLATE OR BISCUIT JOINER

The plate or biscuit joiner is another woodworking tool that is used in laminate work (Illus. 3–114). The plate joiner cuts a slot into two mating pieces. A plate or biscuit is then inserted into the two slots to

Illus. 3–110. Here a belt sander is being used to even up an inside corner. Note that the belt is pulling towards the backing piece. Clamps hold the work securely.

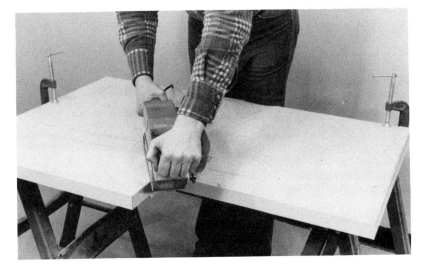

Illus. 3–111. Solid wood is usually sanded with an orbital sander. Be sure to sand with the grain. It provides a smooth surface for stains and topcoats. (Photo courtesy of Porter-Cable Corporation.)

Illus. 3–112. Dust collection improves the efficiency of the orbital sander and makes breathing easier. Be sure to sand with the grain. (Photo courtesy of Porter-Cable Corporation.)

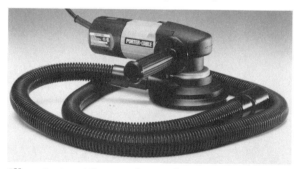

Illus. 3–113. The random-orbit sander can be used on solid stock or sheet stock. It removes stock faster than orbital sanders, so practise on a piece of scrap to learn how to use it.

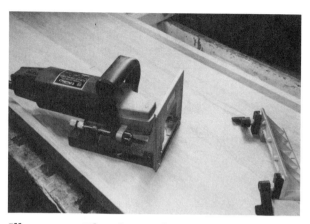

Illus. 3–114. The plate or biscuit joiner is used to reinforce butt and mitre joints. It has many uses in laminate fabrication.

serve as a registration (for positioning) and reinforcement (Illus. 3–115). Glue is used in addition to the plate to ensure a good bond.

When more than one piece of sheet stock is needed to fabricate a countertop, the two pieces can be joined with plates. This assures that the two surfaces will align properly. Edge bands can also be installed with plates. This provides strength and alignment.

There are three sizes of plates: 0, 10, and 20. Use the largest size (20) whenever possible. The largest plate offers more strength and gluing surface. Mark centerlines on the mating pieces and adjust the fence to position the kerf in the approximate middle of the work. Cut the kerfs into the mating pieces at the centerlines. The pieces are then ready for plates and glue. Always put the glue into the kerfs and not on the plates. The plates will swell, and may not fit the kerfs.

The reason the kerfs are cut at the approximate center of the edges is also due to this swelling. If the kerfs were closer to the top surface, the swelling of the plate could raise the surface of the work. This could "telegraph" through the plastic laminate and show on the finished surface.

Always clamp stock when cutting kerfs for plate-joining. Feed the unit into the work slowly until it hits the stop. Retract it slowly and move to the next mark. The fence and plate-joiner base have marks that align with the centerlines on the work. Be sure to keep your hands clear of the blade's path at all times (Illus. 3–116).

Illus. 3–115. The biscuits or plates go into slots cut by the plate joiner. When glue is added, the wooden plates swell and provide additional strength.

Illus. 3–116. Line up the plate joiner with the position mark and make the plunge cut. Keep your hands clear of the blade's path.

PORTABLE DRILL MOTORS AND DRILL DRIVERS

Portable drill motors and drill drivers are also used in the laminate shop. Drill motors can be used to drill pilot holes for screws and to drive screws into these pilot holes. Most backsplashes are screwed to the countertop, and this is a place where drills and drill drivers are frequently used.

Drills are also used with boring jigs to position joint-tightening devices in counters. Separate spe-

cialty bits can be used for this purpose (Illus. 3–117).

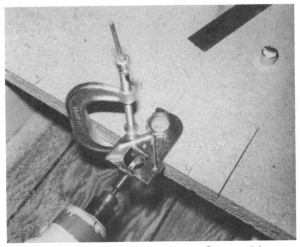

Illus. 3–117. Drilling jigs are used to position tightening devices in counters. They may require specialty bits.

Drill drivers are also used for the installation of laminated materials in the field. Work carefully in the field. Drill bits can scratch the finished surfaces (Illus. 3–118). It is possible to drill through the finished surface when you have not marked your drill bit for depth. When using powerful drill motors to drive screws, it is possible to drive them through the finished surface without being able to stop. Drivers with a clutch reduce the chance of this occurring.

Illus. 3–118. Bits such as this Phillips driver can scratch laminate surfaces. Work carefully and protect finished surfaces if there is a chance of scratching them. (Photo courtesy of Porter-Cable Corporation.)

Illus. 3–119. Keep your hands clear of the nail's path when using a pneumatic nailer. Always wear protective glasses.

When working with drills or drill drivers, always clamp your work. Keep your hands away from the path of the drill or driving bit. With the breaking of a drill bit or slipping of a driving bit, you could injure your hand if it is in the way.

STAPLERS AND NAILERS

Staplers and nailers are used in the fabrication of laminate blanks. They are used to join buildups and other parts. Virtually all staplers and nailers are powered by compressed air. These tools are referred to as pneumatic tools. A few staplers and nailers are powered by electricity or butane fuel. The butane fuel is ignited by a spark plug. The resulting explosion provides the energy to drive the nail or staple.

When working with nailers or staplers, always remember that they could drive a fastener through your flesh (and bones) as easily as they go through sheet stock. Keep your hands clear of the fastener's intended or unintended path (Illus. 3–119). The intended path is obvious; the unintended path is the possible path that occurs when the fastener bends in the wood. It could hit a knot or hard area and bend. It may come out through the edge or some other spot. Keep your hands clear of this area.

Also wear protective glasses when using nailers or staplers. Staples and nails can ricochet off any surface. Treat the nailer or stapler like a loaded weapon; only point it at the work surface. And always disconnect the compressed air or butane

fuel before loading, adjusting, maintaining, or cleaning the nailer or stapler.

Most staplers use narrow-crown staples. This means that the distance between the two legs of the staples is about $3/16$ inch. The nails and staples are usually from $3/4$ to $1\frac{1}{4}$ inches in length. Longer nails could penetrate and go through the top surface when the two pieces are nailed together.

Be sure to use the correct amount of air pressure when driving nails or staples. Too little air pressure may not set the staple or nail heads below the wood surface. This requires an additional operation with a hammer and a nail set. Fasteners which are not set may scratch or damage plastic laminate or router bases. Too much air pressure is harmful to the gun. Check air pressure frequently.

When working with nailers or staplers, hold their point snugly at the work surface (Illus. 3–120). If the gun jams or misfires, disconnect the air hose or butane fuel from the gun before inspecting or dismantling it.

POWER SHEAR

The power shear is a specialized laminate tool. It may be air- or electric-powered. The power shear is designed to cut plastic (Illus. 3–121). It is hand held and works best for straight cutting, although it will also cut curves. The adjustable guide is a straight

Illus. 3–120. Make sure the point of the nailer is snugly on the work surface before firing. Always disconnect the air hose before inspecting a jam or misfire.

Illus. 3–121. The power shear cuts plastic laminate quickly and accurately. It is equipped with a fence for cutting uniform strips.

fence that allows cuts up to 10 inches wide. The guide is inserted in the shear, and the width of cut is set. The setting is held by tightening a screw in the shear (Illus. 3–122).

Another way of using the shear is to mount it in a table. The table is sold as an accessory and comes with a fence and a mitre gauge. This allows you to use the shear much like a table saw. It can make rip cuts in pieces up to 7 inches wide, and crosscuts in

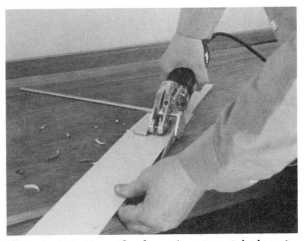

Illus. 3–122. Once the fence is set, a strip is cut easily.

pieces up to 12 inches wide. The mitre gauge can be turned to cut mitres for specialty work.

This tool is extremely efficient and one of the best ways to cut laminates is a shop where not many are being cut. In high-volume shops, this tool can take the load off production equipment.

Power shears are also available as an attachment for your drill motor, which allows you to use the shear with it. This "ties up" your drill motor, and a shear used in this manner is not as handy as the self-contained unit.

HEAT GUN

The heat gun is a common tool used in the bending of plastic laminate (Illus. 3–123). Heat increases the flexibility of plastic laminate.

Postforming and standard plastic laminates are designed to bend to tighter radii with the application of heat. The heat gun is one of the tools used to apply heat to the laminate. Work carefully with the heat gun. Not only can you burn yourself, you can also damage the laminate. Too much heat can cause the surface to blister or discolor. There are special crayons to mark the laminate. When the temperature is correct, the color changes, indicating the laminate is ready to bend.

When working with heat guns, it is best to use gloves. They will reduce the chance of burning your skin and make working more comfortable. Always be alert to fire hazards when using a heat gun. Keep flammable items such as wood finishes and contact cement away from the work area.

Illus. 3–123. Heat guns are frequently used to help bend plastic laminates to tight radii. If used improperly, they can blister the decorative finish.

For tight outside radius bends on counter edges, a Chromalox heater can also be used. This heating unit works only with postforming laminates. The plastic laminate is bonded to the substrate with contact cement. The laminate is cut long enough to extend beyond the radius. A temperature-indicating lacquer is brushed onto the laminate and the laminate is mounted in the heater. (Temperature-indicating lacquers are described in Chapter 7.) When the temperature-indicating lacquer appears glass-like, the stock is rotated by the clamping mechanism. The laminate is bent against the substrate and held in place by the clamping mechanism. Once the blank cools, it is removed from the clamps.

The heaters and clamping units range in size from two to twelve feet in length. When working near any heating device, protect yourself from burns. Also be alert to fire hazards near the heating unit. Keep your work area clean at all times.

GLUE-SPREADING EQUIPMENT

In the laminate trade, most bonding is done with contact adhesive or cement. The spreading of the glue is an important part of successful bonding. Too much contact cement is wasteful and slows down the process. Thicker coatings take longer to dry. Coatings that are too thin can promote poor bonding or delamination.

The simplest approach to applying contact cement is also the slowest. Brushes and rollers are used for hand applications (Illus. 3–124). For small shops in which laminate is not used much, this is probably the least expensive method. This is because no spray booth is required.

For small areas such as edge bands and back-

Illus. 3–124. This wide roller would be used to apply contact cement to a countertop or other large surface. Note the foil lining in the tray to make cleanup easier.

splashes, a brush is usually selected. Brushes should be 1 to 3 inches in width. The brush you select should be slightly narrower than the width of the area you are working on. Most paintbrushes can be used to apply contact cement, but you should select them according to the type of contact cement you will be applying. Brushes that work well with water-based cements may break down quickly when used with solvent-based cement. Foam brushes generally work well when used with water-based cement, but they are not suitable for solvent-based cement.

For larger areas, rollers can be used to apply contact cement. These rollers are also painting tools adapted for spreading glue. Roller frames hold the fabric rollers, which apply the cement. Roller

frames are available in 3-, 4-, 7-, and 9-inch lengths. The fabric covers are available in corresponding lengths.

Not all fabric covers are suitable for applying contact cement. Poor-quality covers may shed. This leaves debris between the laminate and the substrate and results in a poor bond. Solvents in contact cement can dissolve the glue holding the fabric roller together. Short-nap roller covers are best for applying contact cement. The best roller covers have tapered ends and a plastic coating on the tube. This increases the life of the roller cover.

Some special contact-cement roller covers have a pebble-like surface. The raised "pebbles" keep the roller from sliding across the surface when loaded with cement. These "pebbles" reduce waste and allow greater coverage in less time.

Roller trays are usually stamped from steel. They have a rust-resistant coating on them to withstand corrosion. There are plastic liners which can be used with these trays. The liners are designed to be thrown away. This reduces the mess and cleanup problems.

Some laminators line the tray with heavy-duty aluminum foil to reduce cleanup (Illus. 3–125). This method works well. You can also use the foil to cover the pan, brush, or roller when they are not being used. This keeps the contact cement from setting up and allows you to use the applicators longer.

When brushing contact cement onto any surface, there is a temptation to work out of the glue container. This is not a good practice. Any debris picked up by the brush could be deposited into the container. As the debris builds up in the glue, it may be difficult to apply, and you may have to discard it. Work out of a clean can; add contact cement only as it is needed.

If you spray contact cement onto a surface, the work will take less time and the adhesive can be applied in a more uniform fashion. Most contact cement is applied using a pressure spray gun. The contact cement is contained in a sealed pressure tank. The tank size can be two gallons or more. Air pressure on the tank causes the contact cement to flow to the spray gun. Compressed air at the gun causes the contact cement to atomize or mix with the air.

When spraying contact cement, keep the spray gun moving at all times. Try to overlap your strokes about 50%. This will ensure a more uniform coating. Use the trigger on the gun while the gun is in motion. Pull the trigger just before reaching the edge of the work. Release the trigger as you complete the stroke or spraying path. The triggering action will reduce waste.

When spraying solvent-based contact cement, there is a potential fire hazard. Flammable and non-flammable vapor must be removed through an approved spray booth and exhaust system. Many local zoning agencies do not approve of certain exhaust systems or vapor contaminants. Always check with local agencies before spraying contact cement.

Be sure to protect yourself when applying contact cement. Wear eye protection, and, if you are spraying the cement, wear a respirator. Some solvents may cause skin problems. If you are sensitive to these materials, wear an apron and rubber gloves.

Illus. 3–125. Smaller rollers are available for applying contact cement to edges and backsplashes.

Planning the Job

All laminate jobs require planning. The better you plan the job, the easier it is to execute. Knowing the environment where the laminated piece will be used can help you make some planning decisions. The following questions about the environment will help you make these decisions:

1. *If the counter is to fit against the wall, is the wall straight or should special considerations be made?*

 This question is asked because if the wall is not straight, then an extra allowance must be made for scribing the counter to the wall (see pages 111 and 112). Most laminates allow a ¼-inch scribe (Illus. 4–1). This allows for a wall deviation that exceeds the length of the laminate by ¼ inch. On some remodelling jobs, this is not enough al-lowance. By checking the wall with a straight-edge, you can determine how much allowance for scribe you will need.

2. *If the counter is to fit in a corner, is that corner actually a right angle? If not, can you copy that angle to use it for layout purposes in the shop?*

 This question is posed to help you make a counter that can be installed in a minimum amount of time. Some laminate shops have a tool that re-sembles a large sliding T-bevel. This tool could be used on the job to make the correct layout.

3. *How large a counter can I get into the space? How big is the elevator, how wide is the staircase, what size are the doors, and are there any tight turns?*

Illus. 4–1. The backsplash has a ¼-inch scribe attached to its back. This will allow it to be fit-ted to the wall and compensate for wall irregularities such as drywall seams.

The answers to these questions will help determine whether the counter should be one or more pieces so it can be more easily installed and moved. They can also help you determine what sizes of sheet stock and plastic laminate should be ordered, to reduce waste.

4. *If this is a multiple-piece counter, where should the joints be?*

How the counter will be used may influence where the joints will be (Illus. 4–2). Any cutouts may also influence where joints will be. In most cases, joints are moved away from wet areas such as sinks and dishwashers.

5. *Are there any other limiting factors in the environment that must be considered?*

There may be some factors that will dictate how the counter will be built. For example, a U-shaped kitchen is not always a perfect U shape. The sides may not be parallel and the kitchen could be wider than deep. This makes it more difficult to bring the counter into the opening. It may also require that the counter be built without the backsplashes in place. This would allow enough clearance for the counter to be installed.

DESIGN CONSIDERATIONS

The design of the job or counter may also have some effect on the planning or your work. The following questions about the design will help you with planning decisions:

1. *What grade of laminate do I need? Does the laminate have a pattern which will require additional waste?*

The grade of laminate you decide to use—standard, vertical, or postforming—will depend on your specific job. But waste is also a factor in this determination. For example, two different grades cannot be mixed at a joint because they have different thicknesses.

Patterns can present problems as well. For example, grain patterns must be joined in a mitred fashion at corners, and doors usually have a vertical grain pattern. Specialty applications may be designed to have the grain at an angle for a herringbone look. These considerations can determine the amount of laminate you will need, the amount of material that will be wasted, and the actual cost of the material.

2. *Are there any cutouts that must be made, and will any reinforcement be needed near those cutouts?*

A cutout must be sized precisely to the object that fits it. Having precise measurements or a template can make layout and cutting easier. If the cutout reduces the strength of the counter, it may be necessary to make the cutout at the time

Illus. 4–2. How the counter is used will influence where its joints are. On this job, the counter spans the cabinet joint. It is a good practice to stagger cabinet and counter joints.

of installation and to reinforce the area around the cutout. Some objects such as a range or sink may not weigh much by themselves, but when loaded with cooking pots or water their weight could damage the countertop.

When cutouts are made in the shop, special handling and shipping arrangements may be required. Always think these things through. Any damage in the shop during transportation or installation is usually the responsibility of the fabricator.

3. *How will the counter be attached to the cabinets, rails, or supports?*

The answers to this question will help you determine where additional cleats or supports must be positioned in the counter. As a general rule, every two square feet of counter area should be supported. That means that if a ¾-inch-thick counter blank is two feet wide, cross supports should go across the buildup at two-foot intervals. These supports will reduce the chance of countertop sag. When possible, these supports should also be positioned with consideration for the supporting members. For example, it would make it easier to mount the counter to cabinets if these cross supports were positioned where the parts fit together. It may be necessary to put additional cross supports in the counter blank just to allow for attachment. These considerations must also be included in your plan.

4. *Where shall I position my laminate seams in the counter? Are seams necessary in the counter?*

Seams are necessary as mitres in corner counters with wood-grain patterns. If there are long lengths of laminate, then a seam may be necessary. For example, a 12-foot length may require a seam if only 10-foot lengths are available. This may require a seam in both the top and the edge band. If this is the case, then they should be staggered or offset by at least one foot.

It is best to avoid a seam whenever possible, but when you must have a seam be sure to position it strategically. It is best to avoid seams near water, when possible. This may be in sink areas or other places where water is present. However, some fabricators do just the opposite, with good results. They position the seam under the sink.

They then use the rim of the sink to hold the laminate securely to the substrate. The rationale for doing this makes sense: there are only 4–5 inches of seam instead of 25 inches, and the seam has to fit tightly only over 4–5 inches instead of 25. This can greatly reduce labor costs.

A seam on a wood-grain laminate is usually made as a mitre in a corner or right-angle installation. Some fabricators mitre the joint (substrate) and the seam (laminate). The thinking is that it is easier to trim the laminate to the substrate, which has already been mitred. The two mitred blanks can then be assembled on the job. Other fabricators make a solid corner blank and mitre the seam on the substrate. This method may reduce installation time and will produce a stronger corner. Actual fabrication time will be about the same. This is because no joint fasteners need to be installed.

A mitre seam is usually the most difficult seam to make. This is because it is about 36 inches long, and because the wood-grain pattern has to match at the mitre. If there is a flaw due to trimming or mismatching of the pattern, it is very obvious. Make a careful layout when using seams; make sure the parts fit well before applying contact cement. Use registration or alignment marks to help ensure the grain pattern will match when positioned.

5. *Are there any radii that need to be cut on the blank? What is the specified measurement of the radius, and is it critical?*

A radius is a curve on the edge of a blank. The curve may be an inside or outside curve. Outside curves are used to soften corners. This reduces the chance of injury if you bump into the corner. A larger radius may be used on the end of a counter to form a dining area. An inside curve may be used rather than an outside one, which produces a square corner. This will reduce the number of edge seams and give the counter a smoother appearance.

It is not good practice to have a seam in a radius. The seam could delaminate because of the stress of the radius. Always try to make a seam at least 12 inches away from either end of the radius. If the radius is very tight (less than

nine inches), then you will need to use vertical laminate to make the radius. This means that you may have to heat the plastic laminate to bend it to the desired radius. Be sure to order the appropriate plastic laminate.

If the radius is not the specified size, it could create problems. A radius that is too small for the design could make the countertop too small for the object it is to cover. Inside curves could present the same problem above corner cabinets. Always check the blueprints for specifications.

How well you plan for a radius affects how easily and effectively it can be laminated. If the edge is not square to the surface, the radius will be difficult to laminate. This is because the edge-banding material will tip upwards or downwards as it is bonded to any area which is not square. If the laminate strip has been cut too narrow, it may not cover the entire edge. In addition, there is no backing behind the edge, so it doesn't have the sound of a solid piece of wood. It has a hollow sound.

Radii are best rough-cut with a saw, and the final trimming done with a router and a template. This ensures a square edge. The buildup should also be trimmed to size with a router and a trimming bit. This keeps the buildup square and uniform to the original template. How fine the substrate particles are and how sharp the router bits are will determine if any sanding is necessary (Illus. 4–3). If sanding is necessary, be sure to block-sand the radius lightly, using 80-to-100-grit abrasives.

It is good practice to make a dry run with the

Illus. 4–3. The radius on this blank is very smooth. It will not need sanding.

Illus. 4–4. Test the fit of the laminate around the radius before applying contact cement. This will ensure a good fit.

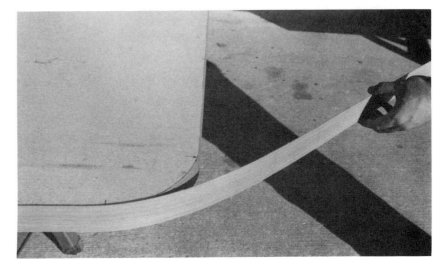

plastic laminate when making a radius (Illus. 4–4). This allows you to plan a starting and ending point. Make starting and/or ending marks to ensure a good fit. If a radius ends in a corner, use a laminate that runs in the opposite direction to block it in the corner. This will reduce the chance of delamination.

6. *Are there any special edge-band requirements such as wood or metal edge bands? What allowances for expansion/contraction are needed?*

When working with wood edge bands, you will have to decide whether they should be installed before or after you have laminated the top (Illus. 4-5–4-7). The width of the laminate also has to be taken into consideration when you are cutting parts.

 If you join wood edge bands to the counter edge before laminating the counter, then extra care will be needed to protect the wood edge from contact cement. Special provisions must be made to mask the bands. When solid-wood bands are installed first, the laminate usually goes over the surface of the wood band. The laminate is then trimmed flush with the front edge of the wood band. Any decorative edge-shaping is done at this time. When the decorative shape is being made, the laminate is usually cut

Illus. 4–6. Cut the edge band to its exact length and angle. The edge band can make or break the job. (Photo courtesy of Formica.)

Illus. 4–7. Tape holds the edge band in place while the glue cures. What other methods could you use to hold the band in place? See Chapter 3 for some ideas.

and made part of that shape. The wood edge band can now be stained, sanded, and finished. If the entire edge is removed, then protecting the wood is not as critical. Just remember, wood with contact cement in its pores does not finish very well.

 If the wood edge bands are added after the laminate is glued in place, some provision for expansion and contraction of the wood and laminate should be part of the design. Generally, a

Illus. 4–5. This wood edge band is being installed after the top has been laminated. (Photo courtesy of Formica.)

slight-relief rabbet is cut on the inside edge where the edge band contacts the counter. The rabbet is about ⅛ inch wide and slightly deeper than the thickness of the plastic laminate. This allows either the wood or laminate to move without causing problems with the finished product.

When wood bands must be wrapped around curves, there are additional considerations. The biggest question is where the mitre joints will be positioned and how the blank should be cut. For example, the blank may be cut as a hexagon or octagon first. The solid-wood bands would then be mitred and joined to the blank. The arc or radius could be cut before the parts are installed, but it is usually cut after the parts are installed. This would allow the fabricator more latitude when fitting the edge band to the blank.

The solid-wood edge band could be cut in a number of ways, but due to the size and weight of most counter blanks, the cutting will probably be done with portable power tools. Rough-cutting can be done with a portable circular saw or a sabre saw. Clean up the rough cuts with a router controlled by a template or with a belt sander.

GUIDELINES FOR MAKING A SCRIBE AND BUILDUP

A scribe is used on backsplashes and the edges of counter wherever they contact a wall. The scribe has one function: to make the counter easier to fit against an irregular wall. The scribe is usually ¼–½ inch thick and ½–¾ inch wide. The most common material used is ¼-inch-thick plywood, but solid stock is also commonly used.

If the walls are not true (such as in a remodelling job), then the scribe should be ½ inch thick. If you are using thicker scribes, it is better that you make them out of solid wood. The scribe is glued to the edges of the counter where it touches walls. This may be one or more edges.

Scribes are attached after the blank is made. When making the counter blank, allowances must be taken into consideration to compensate for the scribe. When the counter blank is positioned next to the wall, you may have to cut the scribe somewhat to make it fit the irregular wall. Since the scribe is not as thick as the counter, it can be sanded, routed, or cut to fit any irregularity easily.

The counter blank is marked or *scribed* for trimming so it will fit into the wall. Hence the term scribe. The scribing is done with dividers or a compass. One leg of the dividers rides along the wall, while the other marks the counter. This line shows the irregularities of the wall and represents the material that must be removed.

Some laminate trimmers will actually scribe the back of the counter when set up properly (Illus. 4–8). The counter blank is clamped a predetermined distance from the wall. The laminate trimmer rides along the wall while the bit trims the scribe. If you use this approach, make sure that there are no nails or staples in the bit's path. Gluing the scribe in position would be the best approach if you plan to trim it in this way.

Scribes should be mounted to the blank with the

Scribing of Backsplash to Wall

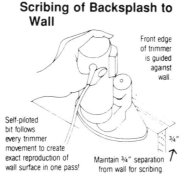

Front edge of trimmer is guided against wall.

Self-piloted bit follows every trimmer movement to create exact reproduction of wall surface in one pass!

Maintain ¾" separation from wall for scribing.

¾"

Operation—The guide assembly must be removed. Using the self-piloted bit, the Offset Trimmer scribes accurately to the wall surface.

In-and Out-Trimming of Installed Corner

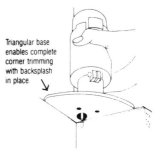

Triangular base enables complete corner trimming with backsplash in place.

Operation—The Offset Trimmer will trim into and out of 90" corner with ease using self-piloted bit.

Illus. 4–8. Drawing courtesy of Porter-Cable Corporation.

same care and fabrication techniques used to make any other part of the blank; any carelessness with the scribe could ultimately affect the overall quality of the counter.

A buildup is the material used to make a ¾-inch-thick counter appear to be 1½ inches thick. A buildup also reinforces the counter and provides a place to anchor the blank to the cabinet or mounting brackets. There are no specific size requirements; however, anything less than two inches in width is too small. Many fabricators do most buildup work with 2¼-inch widths. Some specialty areas require wider pieces, but for general fabricating this width works well.

Some specialty areas where wider pieces of buildup are needed include joints and radius blocks. More buildup is needed across a joint, to reduce the chance of flexing. Flexing could crack the plastic laminate. A joint-reinforcement buildup may be as wide as 8 inches. This buildup should be glued and screwed (or nailed) in position. This extra reinforcement will make the joint as strong as the sheet stock. The addition of a buildup the long way will make the entire blank more rigid.

Radius blocks should be solid rather than a series of mitred pieces. The biggest reason for this is that people are often tempted to sit on a radiused corner. The weight of an adult may be enough to break the corner off the counter. By extending the radius block back into the support area, there is less likelihood of breakage.

Radius blocks are attached to the corner after the counter has been radiused. Begin with a 10- or 12-inch square. Mark it using the radius on the counter. Saw it to rough size (leave the line or a little more). Glue and fasten (screw, nail, or staple) it in place. Leave the excess exposed for trimming.

When placing the radius block in position, remember that it is a buildup and goes on the bottom of the blank. If it is positioned on top of the blank, you will have a mirror image of the intended counter. (One of the first marks that should be made on stock during fabrication is "top/bottom." Without these identifying marks, many errors will be made.)

Once the radius block is in position, the rest of the buildup strips can be glued and fastened in place. Always leave them so they overhang the actual blank slightly. The outside perimeter can then be routed with a laminate-trimming bit. This final trimming ensures that all edges are uniform and perpendicular to the top. Laminating always goes best over flat, true surfaces.

Text continues on page 121

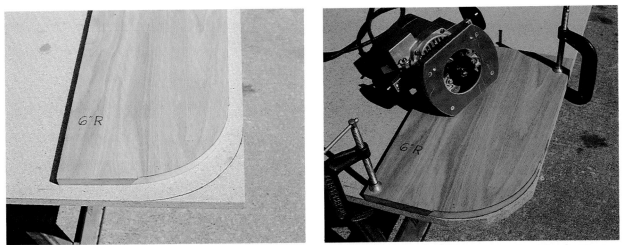

The photographs in this section illustrate the techniques involved in building a counter blank. First, cut the blank out. Then, as shown on the left, use a carefully made radius block to lay out the curve for the countertop blank. Make sure it is marked on the correct corner. At right, a router with a follower guide is used to trim the arc. Note that there are no "steps" between the arc and the straight edges. Careful positioning of the templates reduces the "steps."

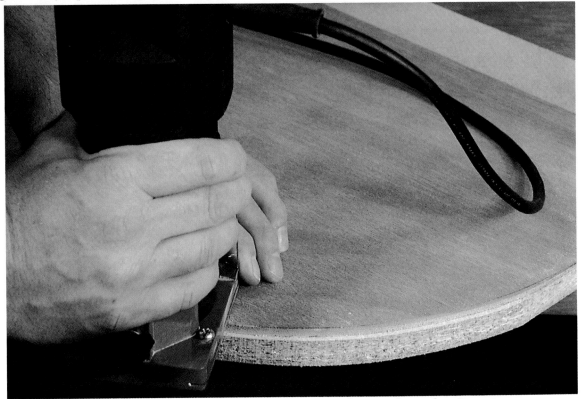

Hold the router firmly on the work surface and against the template edge. Do not force the tool. (Photo courtesy of Skil Power Tools.)

The radius can be "feathered" at the ends by block-sanding. (Photo courtesy of Skil Power Tools.)

Installing the buildup. This block will extend back under a cabinet. It is laid out with the desired radius. (Photo courtesy of Skil Power Tools.)

The corner block is rough-cut and then glued and nailed in position. (Photo courtesy of Skil Power Tools.)

A laminate trimming bit will cut the buildup flush and square with the blank.

Apply the buildup strips. Cut them to length as needed.

First, attach the strips which go the long way. Glue and nail the buildup securely to the blank.

Next, install the pieces which go the short way. These pieces should be no more than 24 inches apart.

Trim all the buildup overhang with a laminate trimming bit. Guide the router or laminate trimmer from left to right. (Photo courtesy of Skil Power Tools.)

Scribe buttons are attached to the blank on the surfaces which touch a wall. You can cut the scribe buttons oversize and then trim them to size. (Photo courtesy of Skil Power Tools.)

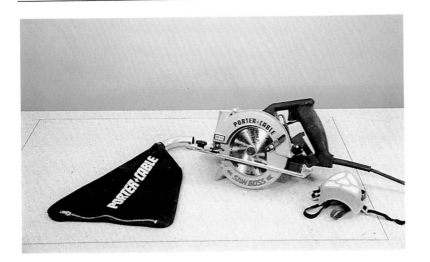

Cutouts are made in countertops to accommodate sinks, stove tops, cutting boards, and electronic devices. Once the cutout has been positioned, lay the blank out. Measure and mark the blank accurately.

Radiused cuts are frequently made in cutouts. They are made by drilling. Drill these corners before doing any cutting. Corners with a radius are less likely to cause stress cracks in the plastic laminate.

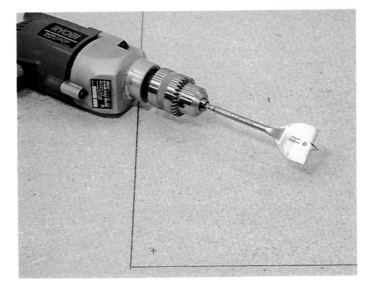

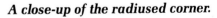

A close-up of the radiused corner.

Above left: Next, make the straight lines by plunge-cutting with a portable circular saw. Once the saw cuts through the countertop, guide it along the layout line. Keep the blade on the waste side of the line. Above right: If the cuts require hand-sawing, do the sawing before removing the screws.

Test the fit of the object in the cutout. Make any needed adjustments.

Plate joinery is a convenient way to attach hardwood edge bands to countertops.

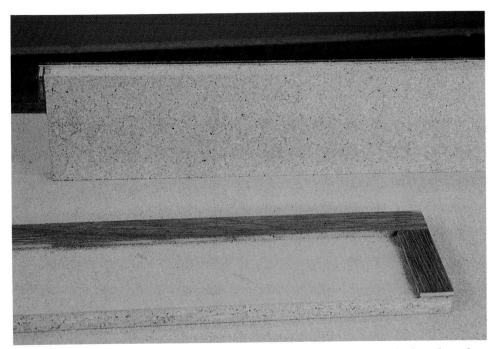

The next step consists of making the backsplash. Cut the backsplash to length and width and then glue the scribe material to its back side.

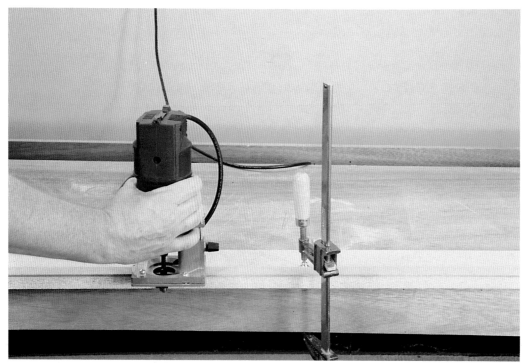

Trim the scribe using a laminate trimmer and a ball-bearing laminate-trimming bit. (Photo courtesy of Skil Power Tools.)

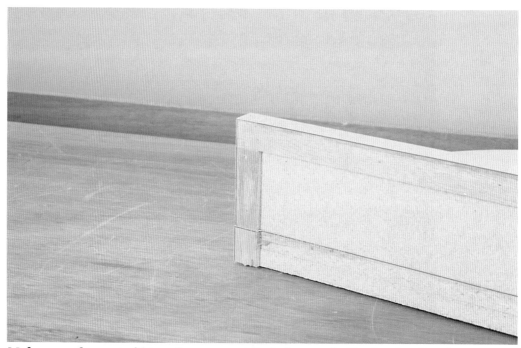

Make sure the parts fit together accurately before and after laminating them. Careful layout and fitting are important to a successful laminating job.

CHAPTER 5

Fabrication Procedures and Techniques

The process of fabricating with plastic laminate is very simple. However, before you begin any project it is important to understand all of the components involved. Since laminates do not possess enough internal strength to stand on their own, they must be adhered to a core material with an adhesive in order to gain rigidity and stability and maintain flatness. It is important to understand the possible problems involved with using three different materials to create one project. By careful selection of the laminate, core material, and adhesive, it will be possible to create a project that will maintain its function and beauty for many years.

CHOOSING A SUBSTRATE

When selecting a substrate (Illus. 5–1), it is important to consider the following criteria to ensure that the project will withstand day-to-day wear.

Dimensional Compatibility

By choosing a substrate that has expansion and contraction characteristics similar to those of the laminate, the chances of warpage are greatly reduced. If the laminate and substrate move somewhat in the same fashion, the adhesive bond will be under less stress and perform better. Tighter seams and joints, as well as reduced stress cracks in the laminate surface, are possible if both materials have similar expansion and contraction characteristics.

Illus. 5–1. A sampling of substrates.

Smooth Surface

Smooth surfaces are required for proper bonding on any laminate surface (Illus. 5–2). It is possible, over a period of time, for any surface imperfection to be

121

Illus. 5–2. To ensure proper adhesion between the laminate and the substrate, the surface must be free from debris. (Photo courtesy of Wilsonart.)

transmitted through to the surface of the laminate, especially when it has a gloss finish.

Weight and Strength Ratios

Impact resistance is a very important factor to consider for case goods that will be under heavy use and impact. It is recommended that all substrate material be at least ¾ inch thick (Illus. 5–3). Stiffness should be considered in areas where load-bearing applications exist, such as shelves, tables,

Illus. 5–3. Counters are generally made out of ¾-inch-thick material; by the time the buildup is put on, the counter will give the appearance of being 1½ inches thick. (Photo courtesy of Wilsonart.)

computer stands, and countertops. The internal bond strength will tell you how well the material will hold together, or fall apart. It is recommended that substrates have an internal bond strength of at least 45 pounds density per square inch.

Screw-Holding Property

Substrate material should be able to hold screws without being torn or chipped. A good substrate will allow screws to safely hold hardware and mounting brackets.

Moisture Resistance

Substrates that absorb a lot of moisture should be avoided because they have a tendency to warp and rot when installed in high-moisture areas. Remember, if the substrate absorbs moisture rapidly, the laminate will crack or delaminate.

Edge Smoothness

The smoothness of the edges is sometimes overlooked. Almost all laminated projects require some type of edge-banding. Some sides must be left exposed; in this case it is much better to have a smooth surface (Illus. 5–4).

Fire Resistance

In some applications, it is required by law to provide a substrate material that meets a specific fire code or regulation. There are substrates that are manufactured to meet these requirements. Remember to check the cost of the fire-rated substrates before bidding on a job.

Additional Guidelines

After evaluating the criteria necessary for selecting a substrate, it is best to refer back to NEMA (National Electrical Manufacturers Association) to get the specifics on which products are applicable. NEMA states that "Good-quality particleboards, medium- and high-density fibreboards, and smooth-faced plywoods are satisfactory for use as substrates since they supply the degree of rigidity needed to support the laminate and offer a suitable face for bonding."

Remember to keep the substrate surface as clean

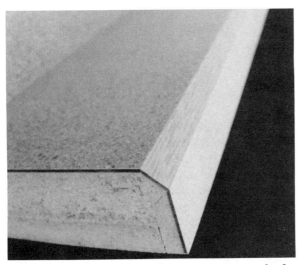

Illus. 5–4. Edges that will get some type of edging, as well as all exposed sides, should always be smooth and free from debris.

as possible. The surface should be sanded smooth and be free from dust, dirt, chips, oils, and waxes, since these materials might interfere with adhesion. NEMA suggests that plasterboard, gypsum board, plaster, cardboard, Styrofoam, cardboard tubing, bendable-grade plywood, and concrete *not be* used as a substrate because they do not have sufficient internal bonding strength.

The following definitions and Table 5–1 will help clarify the differences between plywood, particleboard, and medium-density fibreboard (MDF).

Plywood

There are two different types of plywood (Illus. 5–5). *Veneer-core* plywood is made by gluing odd numbers of thin wood plies together to create a type of wooden "sandwich." *Lumber-core* plywood has a core of lumber as the internal or center portion of

Characteristics of Wood Veneered Panel Products							
Panel Type	Flatness	Visual Edge Quality	Surface Uniformity	Dimensional Stability	Screwholding	Bending Strength	Availability
Industrial Particleboard Core (Medium Density)	Excellent	Good	Excellent	Fair	Fair	Good	Readily
Medium Density Fiberboard Core (MDF)	Excellent	Excellent	Excellent	Fair	Good	Good	Readily
Veneer Core - All Hardwood	Fair	Good	Good	Excellent	Excellent	Excellent	Readily
Veneer Core - All Softwood	Fair	Good	Fair	Excellent	Excellent	Excellent	Readily
Lumber Core - Hardwood or Softwood	Good	Good	Good	Good	Excellent	Excellent	Limited
Standard Hardboard Core	Excellent	Excellent	Excellent	Fair	Good	Good	Readily
Tempered Hardboard Core	Excellent	Good	Good	Good	Good	Good	Limited
Moisture Resistant Particleboard Core	Excellent	Good	Good	Fair	Fair	Good	Limited
Moisture Resistant MDF Core	Excellent	Excellent	Good	Fair	Good	Good	Limited
Fire Resistant Particleboard Core	Excellent	Fair	Good	Fair	Fair	Good	Limited

NOTES: Various characteristics above are influenced by the grade and thickness of the core and specific gravity of the core species. Visual Edge Quality is rated before treatment with edge bands or fillers, and Visual Edge Quality for lumber core assumes the use of "clear edge" grade. Surface Uniformity has a direct relationship to the performance of the fine veneers placed over the surface. Dimensional Stability is usually related to exposure to wide swings in relative humidity. Screwholding and Bending Strength are influenced by proper design and engineering.

Table 5-1. This table, developed by the Hardwood Plywood and Veneer Association and the Architectural Woodworking Institute, outlines the characteristics of wood veneered panel products.

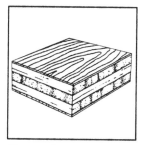

Veneer Core

Lumber Core

MDF Core **Particleboard Core**

Illus. 5–5. These drawings show the different cores of decorative hardwood products. (Drawing courtesy of Hardwood Plywood and Veneer Association.)

the "sandwich," and veneer cross bands under the veneer face.

Typically, veneer-core plywood is a better choice than lumber-core if you want to use a plywood-type substrate when working with laminates. However, veneer-core plywood is not as good as particleboard and medium-density fibreboard. (Plywood is very stable dimensionally. Laminate can expand and contract quite a bit. Because of these differences, plywood is not the best choice of substrate.) Veneer-core plywood has a tendency to warp more than other manufactured boards, and because the edges have alternating grain directions edge-gluing applications are simply not that good. If a water-based adhesive is being used, the wooden fibres on the veneer surface will rise and possibly "telegraph" through to the laminate surface.

Hardwood Grades of Plywood

Hardwood plywoods are graded by several factors: quality of veneer, type of grain, face defects, color of the veneer, and the type of core being used. Below I describe different grades of plywood:

FACE-GRADE DESCRIPTIONS

AA This is the best face-grade available. It is used for casework doors and panelling.
A This grade of plywood is used where the appearance of the substrate is very important but its face does not have to be AA grade. This grade of plywood is used in cabinets and furniture.
B This grade will allow the natural characteristics of the wood to show.
C, D, and E These grades will provide sound surfaces, but will allow only limited color variations. They allow variations in size: C-grade plywood has the fewest size variations and E the most. These grades can be used where surfaces will be hidden or where a natural look is desired.
Specialty These are grades of plywood in which the appearance needed is not standardized and is determined by the individual buyer and seller.

BACK-GRADE DESCRIPTIONS

Back-grades are designated by numbers, from 1 to 4. The requirements of grade 1 are the most restrictive, with grades 2, 3, and 4 being progressively less restrictive. All openings in the veneers on grades 1 and 2 plywood have been repaired. Grades 3 and 4 have some open defects.

VENEER-INNER-PLY-GRADE DESCRIPTIONS

J, K, L, and M Inner plys also have a grading system. Grade J is the most restrictive, allowing minimal size openings. Grades K, L, and M are progressively less restrictive.

Note: For more information on plywood, contact: Hardwood/Plywood & Veneer Association, 1825 Michael Faraday Drive, P.O. Box 2789, Reston, Virginia 22090-2789.

Particleboard

Particleboard (Illus. 5–6) is a wood-panel product that is used worldwide by many different manufacturing groups. Particleboard was developed in the 1930's, but did not become popular in the United States until the 1960's. Panels can be made in a variety of sizes, shapes, and densities. A particleboard panel is made up of planer shavings, edgings, sawdust, and other residual materials. These wood leftovers are bonded together with a synthetic resin or binder under extreme heat and pressure. It is possible to add other materials during the manufacturing process to make the board more

Illus. 5–6. Particleboard.

stable, or even fire-resistant. Over the last several years, industrial-grade particleboard has become the choice substrate for working with plastic laminates. Particleboard is favored because of its stability, flatness, favorable density properties, consistent thickness, strength, and workability.

Working with Particleboard

Unlike solid wood, particleboard has no definite grain direction. Particleboard is of a homogeneous construction with uniform properties in both length and width, and is more solid and brittle than solid wood. As a result, there are specific saw blades that are designed to produce clean cuts and maximize tool life. All standard woodworking tools and machines can be used to cut particleboard; however, it is recommended that carbide-tipped blades be used. Following are some guidelines by the National Particleboard Association for proper selection of saw blades:

For Smooth Cuts, with Little Tear-Out, Use a Blade with the Following Characteristics:

1. Alternate-top-bevel teeth (15 degrees)
2. Positive hook (10 degrees)
3. Five-degree side clearance
4. Ten-degree outside-diameter clearance
5. A low-approach angle (a blade that projects ½ inch or less through the top of the material)

For Very Smooth Cuts and Minimal Tear-Out, Use a Blade with the Following Characteristics:

1. Alternate face bevel (10 degrees)
2. Increased positive hook (15 degrees)
3. Increased side clearance (7 degrees)
4. Increased number of teeth (80)

To Improve the Smoothness of the Cut, Do the Following:

1. Increase the RPM and/or the rim speed of the blade.
2. Decrease the feed speed.
3. Use a blade with a greater tooth approach (a blade that just barely projects through the surface of the work).

To Ensure a Longer Saw Life, but Rougher Cuts, Use a Blade with the Following Characteristics:

1. Flat-top teeth or a triple chip-cutting design
2. Negative hook or reduced positive hook
3. Heavier body
4. Low outside-diameter clearance
5. Decreased tooth-approach angle (blade raised to its highest position)

In All Instances, Follow These Guidelines:

1. To prevent saw vibration, make sure that the hold-downs are sturdy, that there are no loose nuts, and that there are no worn bearings, sleeves, and throat plates.
2. Make sure the collars are clean.
3. Make sure that there is smooth "runout," that is, that there is no wobble.
4. Use a blade with sharp, properly ground teeth.
5. Remember that portable 7½-inch circular saws can chip out the top of the panel.
6. Remember that table saws and handsaws can chip out the bottom of the panel.
7. Remember that a radial arm saw can chip out the bottom side of a particleboard panel and that its blade should have a very low hook angle.

Routing and Shaping Particleboard

Routing can be done either by hand or on a stationary table (which takes on the same characteristics as a shaper). The rules for routing and shaping particleboard are much the same as mentioned for cutting with saws. The tool design, RPM, feed rate, direction of feed, and type of cutter being used will all affect the cut being produced. It is important to remember when using a router to remove particleboard in small amounts. Cuts that require heavy stock removal or intricate routing or shaping may require a series of passes to produce a smooth cut. Single-, double-, and spiral-flute cutters all work well for cutting particleboard.

Preparing Particleboard for Gluing and Edging

Particleboard can be glued to particleboard with white or yellow glue or urea-formaldehyde glue. The surfaces of particleboard will bond very well when glued together; however, edge-to-edge gluing will require some type of joinery reinforcement to support the joint. The smoother the surface, the better the glue will hold. One way to achieve a totally smooth edge, or repair any void, is to use automotive fillers. After the filler has dried, sanding is required to smooth out the surface for either edge-banding or gluing.

Fastening Particleboard with Screws

Wood screws are not recommended for particleboard. There are specially designed screws that have larger threads and smaller shank diameters that hold much better and grab considerably tighter than wood screws. Their holding strength increases the deeper they penetrate the board rather than according to the diameter of their screw shanks. It is also recommended that you predrill or make a pilot hole prior to screwing, to increase the screw's strength and to minimize splitting and chipping (Illus. 5–7).

Note: For more information on particleboard, contact: National Particleboard Association, 18928 Premier Court, Gaithersburg, Maryland 20879.

Medium-Density Fibreboard (MDF)

Medium-density fibreboard is one of the fastest-growing man-made composite boards in the world. It is recommended by professionals as the best sub-

Illus. 5–7. It is always a good practice to pre-drill (make a pilot hole prior to screwing) any screw hole in sheet-stock material.

strate for laminate and veneer work. The surface of medium-density fibreboard is flat, smooth, uniform, stable, dense, and knot-free. The edges can be shaped, sanded, and finished to resemble real wood. Because MDF is so stable and strong, it works very well for pattern components and small, precise parts. It can be used as a good substitute for solid wood in interior applications, except where wood is needed for strength or stiffness.

MDF is made by cooking the wood in a steam-pressure pot to break it down into fibres. These fibres are refined and mixed with a resin, and then heated and pressed into sheets at 40–50 pounds of density. These sheets are sanded to their final thickness, cut, and inspected before being shipped to the lumber mills.

Working with MDF

MDF, like particleboard, is homogeneous in the layup of its fibres' direction. It will expand/contract pretty much the same amount in both its length and width. MDF is considerably heavier than plywood and particleboard and costs more. Its surface is free from defect and can be polished/sanded with abrasives of up to 220 grit. All standard woodworking tools and machines can be used to cut MDF; however, it is recommended that carbide-tipped blades

be used. The guidelines for blade selection are the same as listed above for particleboard.

Fastening MDF

Polyvinyl-acetate (PVA), epoxy, urea, and hot-melt glues, as well as contact cement, are all acceptable adhesives for bonding MDF to laminate. If dowels are being used, it is better to use a spiral-groove dowel instead of a straight-flute dowel. If biscuits or plates are being used, it is best to place them in the middle of the edge surface. If screws are being used, there should always be a pilot hole drilled. It is recommended that you countersink all screws to prevent the surface fibres from rising. The holding strength of the screw will increase more if the screw is driven in at a greater depth than if the diameter of the screw shank is greater. Staples and nails may cause splitting in a plane parallel to the surface. One way to eliminate the splitting is to use a smaller-gauge staple or nail that has been resin-coated. The resin on the nail heats up as the nail is driven, causing the nail to set securely. Nails or screws should not be driven within ¾ inch from the edge.

Routing and Shaping MDF

One of the best features of MDF is its ability to maintain a sharp and clean routed edge. As with particleboard, tool design, feed rate, direction of feed, and depth of cut will determine the outcome of the final cut. If a series of passes are being made to complete the cut, it is recommended that enough material be left so that you can produce "chips" on the final cut; this material will help to prevent you from burning and "fuzzing" the edge.

Note: For more information on MDF, contact: National Particleboard Association, 18928 Premier Court, Gaithersburg, Maryland 20879.

Formaldehyde in Composite Materials

Many consumers are becoming increasingly concerned about the formaldehyde contained in the composite materials they use. They think of particleboard, plywood, and MDF as the main contributors of this type of gas emission in the house. However, formaldehyde is also used in other products such as shampoo, lipstick, toothpaste, disinfectant, and permanent-press clothing. High amounts of formaldehyde can be irritating to the eyes and nose, and formaldehyde in such a concentration has been listed as a possible carcinogen.

Manufacturers have been working very hard to find ways to reduce the levels of formaldehyde emissions from composite materials. They have started using resins that emit low levels of formaldehyde, changed the manufacturing procedures, and now add an ammonia treatment to the board material after processing.

Two factors actually play a part in reducing the levels of formaldehyde in composite material by up to 95%. These factors are described below.

Aging

A new sheet of material always emits a higher level of formaldehyde than an older one. In time, the emission from a sheet of material will start to dissipate. Within about six months, the emission levels will have fallen by half. As the sheet-stock material continues to age, the emission of formaldehyde gas will lower even more.

Coating the Composite Material

It is possible to nearly eliminate the emissions from composite boards by sealing the edges of the boards first with some type of sealer finish. Veneers and laminates make good barriers on the face and bottom surfaces, and edge tapes, veneer, and laminate strips make good edge sealers. It is not necessary to use both sealer finish and veneer or laminate together. However, it is important to make sure that all exposed surfaces have been covered in some fashion. This process is only necessary if the removal of formaldehyde emissions is mandatory.

If you have further questions about the effect of formaldehyde, or know of better ways to control emissions, contact the National Particleboard Association at the following address: 18928 Premier Court, Gaithersburg, Maryland 20879.

THE PROCESS OF BALANCING

Balancing, which is the equalization of the forces on both sides of the core material, is the biggest factor in panel warpage. Laminate panels are susceptible to warpage if they are not physically restrained. When daily humidity changes, the plastic laminate

and the substrate material will be affected. Movement in wood is perpetual: you can control it, but you cannot stop it. This movement and its subsequent stresses are caused by the expansion or contraction of paper fibres in the laminate skins and wood fibres in wood-composite cores as they respond to relative-humidity changes. The stress and dimensional movement, generated by the laminate surface, is transmitted to the core material through the glue line. The forces involved are tremendous and, if they are not properly considered in the panel design, will cause the panel to warp. Warp results when these stresses become excessive and are no longer equal (Illus. 5—8).

Guidelines For Avoiding Panel Warpage

1. All the components should be acclimated to the same environment at least 48 hours prior to assembly. Under extreme conditions, materials that have not been properly acclimated to the same conditions prior to fabrication can buckle or delaminate as well as warp.
2. For critical applications requiring a well-balanced assembly (doors, etc.), the same laminate should be used as the skin material on both surfaces. Less critical applications may only require a cabinet liner or backer sheet. Any mechanically restrained panels, such as countertops, do not need to have a balancing sheet.
3. Thick panels warp less than thin panels. For critical applications, the thickest core material allowed should be used.
4. Laminates expand and contract twice as much in their cross directions as they do in their long directions. Always align the sanding marks of the front and back laminates in the same direction. It is best to align the grain direction of the laminate with the longest panel dimensions. It is also advisable to align the grain and cross-grain direction of the laminates with that of the substrate.
5. Use the same adhesive and application techniques for both sides of the panel.
6. Moisture barriers such as paint, varnish, and other coverings will *not* balance a panel. Coatings of materials of this type do not exhibit the same strength or dimensional-change characteristics as laminate. Remember, the strength and expansion/contraction rates of the face and back skins must be matched for proper balancing.

CHOOSING THE ADHESIVE

Within the last 50 years, the adhesive industry has developed the science of gluing to the point where any material can be adhered to another. Adhesives are one of the most critical components of working with wood. Even though there are as many glues as there are days in the year, NEMA recommends only five types as satisfactory for working with laminate: contact adhesive, polyvinyl acetate, urea-formaldehyde, hot-melt glue, and epoxy glue. Contact adhesive is the most common glue adhesive used to bond laminate to a substrate, although it is not the most effective. The most effective adhesives would be polyvinyl acetate (PVA) or urea-formaldehyde, although their use is not practical because of the pressure required during clamping and the time required for the adhesive to cure. Hot-melt and epoxy glue round out the top five choices, but each has a specific limitation.

Remember when selecting an adhesive that the core material and the laminate will be moving—

Illus. 5—8. This counter was stored improperly. Since it was not balanced on both sides, a bow formed.

and probably not together. A strong adhesive will help create a rigid glue bond that will transfer expansion/contraction to the substrate. A less strong adhesive will allow the laminate and substrate to expand and contract independent of each other.

Following is a description of the types of adhesives that can be used to bond plastic laminate and the substrate. No matter what adhesive you choose for your laminating projects, read the manufacturer's instructions for proper application. And remember that all adhesives have a short shelf life. Never use old glues.

Polyvinyl Acetate (PVA)

Polyvinyl acetate glues are white or yellow glues. (Yellow glues have an aliphatic resin added to them, but they are still in the polyvinyl acetate family.) These glues are water-based and are not waterproof. PVA's are probably the most common glues available today. These glues should not be exposed to high amounts of moisture or heat. Because pressure and a cure time are required when you are working with them, they are rarely used in the small shop when laminates are being used. PVA's will produce a rigid bond that will pass inherent stress on to the substrate. These glues are thermoplastic glues.

Urea-Formaldehyde and Resorcinol

These glues come in powder form and must be mixed with water or a special hardener before application. They are thermosetting resins, which makes them very rigid. (Thermosetting resins are cured by chemical reaction through catalysts or heat.)

Urea-formaldehyde was one of the first glues to be used in the decorative laminate industry. This type of glue requires long clamp time and is very temperature-sensitive. Urea-formaldehyde is heat- and water-resistant, and resorcinol is totally waterproof.

Hot-Melt Glues

These glues are like plastics that liquify when they become heated. They will solidify and bond as they cool. The only common application for working with laminates and this type of glue would be in adhering edge bands. This is the gluing system used in commercial edge-banding machines.

Epoxy Glues

Epoxy glues are two-part glues that cure when a resin and a hardener are mixed together. Epoxies create a rigid glue bond that cures by heat or through chemical means. They have good gap-filling and low-shrinkage properties and are used for bonding laminates to impervious cores such as metal. Once set, epoxies are completely waterproof and are unaffected by most common solvents.

Contact Adhesives or Cement

Contact adhesives are low-viscosity solutions that are either solvent- or water-based. In either case, the solvent or water should be evaporated completely before satisfactory bonding can take place.

This type of glue requires no clamp-type pres-

Illus. 5–9. A proper contact-adhesive bond will require a momentary rolling pressure.

sure. The bond occurs when the dry rubber on one surface comes in contact with the dry rubber on the other surface. A rolling pressure is then applied that will make the bond occur (Illus. 5–13). Contact adhesive is undoubtedly the most common adhesive for working with plastic laminate (Illus. 5–12)—simply because of its ease of application. However, contact adhesives have a low resistance to heat, cold, and solvents.

The sections below discuss the different types of contact adhesives.

FLAMMABLE SOLVENT-BASED CONTACT ADHESIVE

These are the most common types of contact adhesives used today by the commercial laminate industry. This does not necessarily mean that these are superior to other solvent-based adhesives. The solvents flash off, or evaporate, very quickly, allowing for faster bonding and quicker production. Typically, smaller shops do not use this type of adhesive because it requires special handling and storage. Also, proper ventilation is required, and shops sometimes require special fire-liability insurance.

NONFLAMMABLE SOLVENT-BASED CONTACT ADHESIVE

This type of adhesive works just as well as the flammable type, but requires a longer open assembly time for the solvent to flash off. (An open assembly time is the time interval between the spreading of the adhesive on the parts and the completion of assembly of the parts for bonding.) This type of adhesive does not require special storage and can be used in any size shop. Even though these finishes are considered nonflammable, they still should not be subjected to high temperatures. Under extreme heat (900 degrees Fahrenheit [483 degrees Celsius] or higher) they tend to decompose, yielding potentially dangerous vapors.

WATER-BASED CONTACT ADHESIVE

These adhesives are nonflammable and emit no harmful fumes into the atmosphere. They are the safest of all the contact adhesives, and are applied just like the others. Typically, water-based adhesives will require a longer drying time for both the solvent and condensing water to evaporate. On days when the humidity is high, they will take longer to

dry completely. It might be better to use a heat gun to help dry the surface; larger surfaces could require the use of a much larger heat source, such as an infrared heater. Water-based contact adhesives are the only contact adhesives that are not freeze/thaw stable. When frozen, they will solidify, and will not reliquify when warmed.

BRUSHABLE-GRADE CONTACT ADHESIVE

Brushable-grade contact adhesives can have any solvent base. If a contact adhesive is formulated to be brushable, it will have slightly more solid content, causing the viscosity of the material to be thicker.

When brushable-grade adhesives are used, they will have to be brushed (or rolled) over *all* of the surfaces, to ensure that both surfaces have proper coverage for best bonding performance. A stiff brush with two-inch natural bristles will work best (Illus. 5–10). Soft bristles are not recommended because they do not spread the adhesive well and may have a tendency to "ball up." The rollers should be low nap and stiff. It is best if the core of the roller is made of phenolic, to resist solvents in the adhesive. There are several brushes and rollers made specifically for use with contact adhesives (Illus. 5–11). One coat of adhesive will probably be sufficient for all flat surfaces, and two coats will be required on all end-grain surfaces, to fill the rough voids. Make

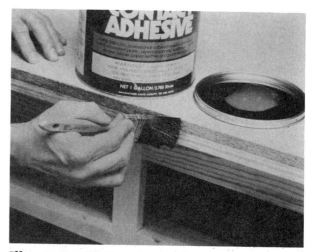

Illus. 5–10. Stiff brushes will work the best for brushing on contact adhesive. Remember to always follow the manufacturer's recommendations on how to apply its product. (Photo courtesy of Wilsonart.)

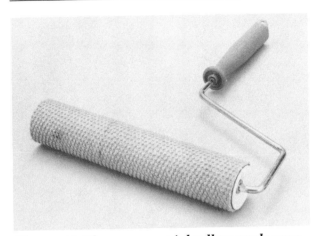

Illus. 5–11. There are special rollers made especially for rolling contact adhesive.

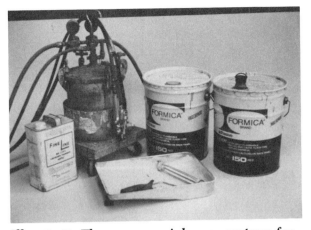

Illus. 5–12. There are special spray systems for spraying contact adhesive.

sure to follow the recommendations for coverage as prescribed by the manufacturer.

The optimum temperature for brushable-grade adhesives is around 72 degrees Fahrenheit (23 degrees Celsius). Temperatures higher will cause the solvents to evaporate too quickly and become thick. This will cause the brush to drag. If the temperature is too low, it will take longer for the solvents to evaporate. Since every adhesive has a slightly different makeup and property, it is advisable to always check the directions by the manufacturer. A used brush or roller can be stored in a plastic air-tight container. The solvents in the container will help keep the roller or brush soft for several months—no cleanup will be necessary.

SPRAYABLE-GRADE CONTACT ADHESIVE

Sprayable-grade contact adhesives can have any solvent base. If a contact adhesive is formulated to be sprayed, it will have a slightly less solid content than brushable-grade adhesive; this will create a lower viscosity, which, in turn, allows the adhesive to be atomized (Illus. 5–12). Spraying-grade contact adhesive only has to be sprayed on 80% or more of the face of both surfaces that are going to be bonded. Edges will require complete coverage, to ensure that the pores have been filled and covered.

Spraying contact adhesive is about 8 to 10 times quicker and covers more surface area per gallon than brushing it on. It is better to spray contact adhesives through a high-pressure system. Airless systems will work, but can cause the finish to be too smooth. When spraying, an "orange peel" or "pit-

ted" type of surface is desired. Sprayed contact adhesive takes longer to dry at lower temperatures and dries more quickly at higher temperatures. If it becomes necessary to thin the contact adhesive, it is important to use only the manufacturer's recommended thinner.

Sprayable-grade contact adhesive will require special spray equipment. Each manufacturer will include an owner's manual with the equipment that will help solve problems that might be encountered during the setup and dismantling of the system.

APPLYING CONTACT ADHESIVE

Once the type of contact adhesive has been selected and a suitable method for application has been chosen, the process of applying the adhesive is rela-

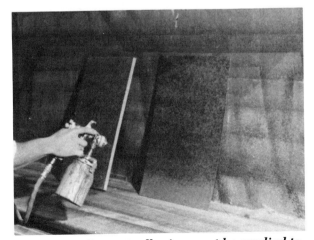

Illus. 5–13. Contact adhesive must be applied to both surfaces.

tively simple. The following are necessary for the successful use of contact adhesives:

1. Make sure that sufficient adhesive is applied to both surfaces to be bonded (Illus. 5–13).
2. Make certain that the adhesive is completely dry and free from moisture before bonding (Illus. 5–14).

Illus. 5–14. Make sure that the contact adhesive has dried before making the bond; you can determine its dryness by touching the contact surface with the back of your hand.

3. Use a J- or pinch-roller to gain the required 45 pounds of pressure required to achieve a sufficient bond. There is no such thing as too much pressure with contact adhesives. Make sure that there is pressure applied on the entire surface being bonded (Illus. 5–15).
4. Do not try to bond the surfaces after the recommended open time for the contact adhesive has passed. Bonds made too late may eventually develop problems. In most cases when the open time has been exceeded, a very light overspray or light recoating of the contact adhesive will assist in reactivating it.

Application Methods

Contact adhesives can be applied by brush, paint roller, notched trowel, roller coater, curtain coater (a uniform-coating glue machine that can coat the entire surface of laminate or substrate with the adhesive being used), or air-atomized spray. It can also

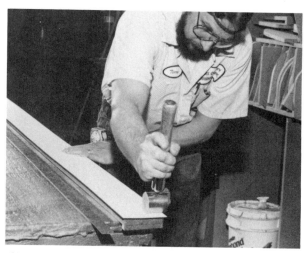

Illus. 5–15. Pressure must be applied over the entire surface area.

be applied hot or cold (at room temperature). It should be noted that most contact adhesives have a shelf life of only *one year* if they are in their original unopened container. Typically, contact adhesives do not need to be stirred if they have been stored properly or are fresh from the factory. However, they do contain ingredients that will settle to the bottom during long storage or freezing conditions. It would be prudent always to agitate a new container or one that has been sitting for some time.

Contact adhesives are very sensitive to specific weather conditions. High humidity and cold temperatures both slow down the drying time of the adhesive and allow it to soak into the substrate being coated. During high humidity, the rapid evaporation of the solvent from the surface will cause the air to cool below the dew point and cause water to condense on the surface. This is known as *blushing*. The surface will eventually dry, but will take additional open time. If laminated surfaces are bonded under these wet conditions, the surface moisture will cause the bonding failure.

Blushing can be seen and felt. If you rub your hand on the coated surface, it will either feel dry, which indicates that no blushing has occurred, or slick (wet), which means that there has been blushing. Sometimes the adhesive will change colors. For example, red adhesives will become cloudy and turn pink.

If blushing occurs, it can be remedied by drying the surfaces with a heat gun or by applying two light

coats of adhesive instead of one heavy coat. Always allow good air movement around the drying components.

Cold temperatures can slow down the cure time of the adhesive by 25–50 percent or more. It is possible to reduce the bonding strength if the contact adhesive is applied too cold. To ensure that cold bonds do *not* occur, apply the adhesive with both the substrate and adhesive at a temperature of at least 65 degrees Fahrenheit (19 degrees Celsius).

When applying contact adhesive, make sure to uniformly coat both surfaces. When these surfaces are dry, the adhesive will appear tacky. There should be a glossy look on the entire surface; if there is a dull spot, it is probably an area that has not been completely covered with adhesive. Extremely porous surfaces will always require two coats of adhesive.

Remember that contact adhesive must be completely dry before proper bonding can take place. One way to tell if the adhesive is dry is to press the back of your finger on the adhesive surface and pull away; if you pull up stringy glue, the adhesive is still wet (Illus. 5–16). The adhesive may feel tacky, but there should be no material pulled up from the surface. If there is any doubt at all, it is recommended that you wait a few more minutes. Do *not* touch the surface with the front of your fingers or hand because oils and dirt may be transferred to the surface and ultimately affect the bond.

Illus. 5–16. This is an example of how stringy wet contact adhesive can be. Always check laminate with the back of your hand.

Most contact adhesives have an open time of about one hour. This is the time from when the adhesive is dry until the bond with the greatest possible strength can be made. However, the best bonds are made as soon as the material is dry. Once the pieces have dried, position the two pieces by carefully aligning one piece over the other. It is best to have some type of barrier between the surfaces. For example, dowel rods, laminate strips, venetian-blind strips, newspaper, etc., all will help keep the surfaces from prematurely joining. Without these barriers, you will quickly learn why this adhesive is called contact adhesive. If unwanted contact takes place between surfaces, it is best not to lift up on the bonded area, since the rebonded area will not bond as strongly as the original bond.

Once the surfaces have been aligned, barriers can be removed and the surfaces can be joined. A J- or hand roller will be necessary to produce the 45 pounds of pressure per linear inch required by NEMA to make an accurate bond. Tapping with a block of wood and a mallet will *not* provide sufficient uniform pressure and might possibly result in a surface with bubbles. Contact adhesive overspray can be cleaned up with chlorinated solvents or lacquer thinner. Do not saturate the surface with any type of solvent because it can get into the glue line and cause delamination. Remember to extinguish pilot flames and keep a safe distance from any heat or spark-producing elements.

Guidelines for Ensuring a Proper Bond

1. Both surfaces should be clean, dry, and free from oils and waxes (Illus. 5–17). The adhesive should have full contact with the face surface, to ensure maximum adhesion.
2. Make sure that the adhesive is not outdated and has been stirred thoroughly.
3. Both surfaces must have a good coverage of adhesive. Follow the recommendations of the manufacturer for the percentage of the surface area that should be covered.
4. The optimum bonding and room temperatures for all the components is 70 degrees Fahrenheit (22 degrees Celsius).
5. When the temperature is over 70 degrees Fahrenheit and the humidity is over 80 percent, moisture may condense on the surface as the solvent

Illus. 5–17. Clean all debris from the surface before spraying or rolling on all contact adhesives.

evaporates; this causes blushing. Under these conditions it is advisable to force-dry the surface before bonding.

6. Do not bond surfaces that are too dry or not dry enough. If assembly is made before the adhesive is dry or after the allowable open time is exceeded, an unsatisfactory bond will occur.

7. Bonding takes place by means of pressure. Forty-five pounds of pressure per linear foot must be applied over the entire surface. This is achieved by rolling pressure or with a rotary-type press (pinch roller). All hand rolling should be done from the middle outward towards the edge, to ensure that air bubbles are removed properly. Hand-roll all edges twice.

FABRICATING PROCEDURES
Methods of Cutting

One of the first steps when working with laminates is to cut the material. Since laminates are brittle and thin, they will require special care when machining. It is recommended that laminate *always* be cut faceup whenever a table saw (Illus. 5-18–5-20), hand shears, router, band saw, scoring knife, or radial arm saw is being used. If you are cutting the laminate with a jigsaw or portable circular saw (Illus. 5–21), it is recommended that the laminate be cut from its back side or facedown, although there are special blades made to use in a jigsaw that will perform better on the face side of laminate. It is

Illus. 5–18. Typically, the laminate will be thinner than the gap between the fence and the table-saw top.

Illus. 5–19. In order to ensure your safety when cutting laminate on the table saw, it is best to place a filler material next to the fence to raise the laminate past the gap between the fence and the table-saw table.

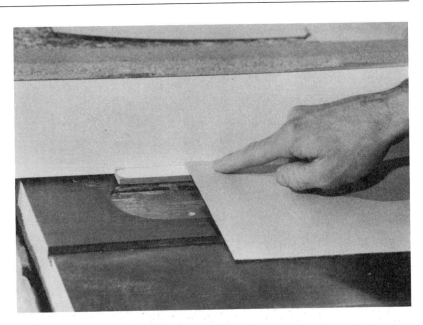

Illus. 5–20. Laminate on a table saw should always be cut with its decorative face up.

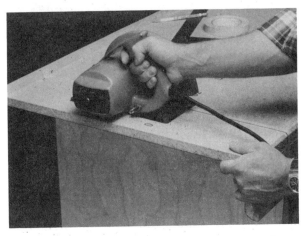

Illus. 5–21. When using a circular saw, it is best to cut decorative laminate facedown. With a circular saw and jigsaw it is always best to cut the laminate after it has been adhered to the substrate.

always best to support the laminate whenever possible, no matter what the cutting method (Illus. 5–22). Carbide saw blades and router bits are preferred, and they should be well maintained. Bearings should be maintained with special bearing lubricants, not solvents such as lacquer thinner or acetone.

Laminates can be marked on either face before cutting or during layout with a pencil or grease

Illus. 5–22. Laminate always cuts best if it is supported. Here a worker supports the cutout portion of a sink unit during the fabrication process of a countertop.

marker. If a grease marker is used on the back surface, the surface should be cleaned off before the adhesive is applied. Remember always to leave 3/16 inch or more of the laminate than needed when cutting initially, to allow for "play." during the bonding process.

All inside corners or cutouts (such as on sinks, chopping blocks, L-shaped countertops, etc.) should have a smooth-rounded radius. It is recommended by NEMA that at least a 1/8-inch radius on all internal cuts at corners be made (Illus. 5–23). Laminate should never be cut square. Stress developed during expansion and contraction can cause a square corner to crack radially.

Although sheet stock is squared up during the manufacturing process, it will still be a good idea to double-check for squareness before cutting. Never use a factory edge as a finished or exposed edge.

Refer to Chapter Three for the correct procedures and proper tools for cutting laminates.

Surface Preparation

All surfaces that will be laminated should be clean and free from debris and contaminants. Laminate will adhere best to a smooth surface. If there is a burr on the edge of the substrate or on the laminate, it should be removed with a sanding block or a file prior to laminating (Illus. 5–24). Any holes or chips should be filled with an automotive-body filler and sanded flush with the surface after the filler has cured. Remember to acclimate all materials to be fabricated.

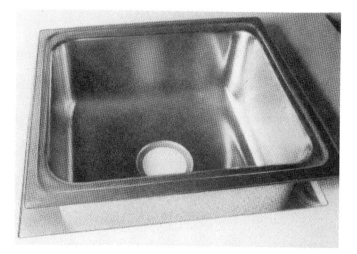

Illus. 5–23. Notice the radiused corners in the laminate. Never cut laminate square in corners; always leave a small radius to ensure that stress will be distributed evenly throughout the area. (Photo courtesy of Formica.)

Illus. 5–24. Sanding blocks with 100- or 120-grit paper from a belt sander work great as a flat sanding surface. This sanding block will ensure that the surface is smooth prior to laminating.

Assembly

A basic rule when fabricating with laminate is to apply all the edges before the surface sheet (Illus. 5–25–5–27). This will cause the top laminate to overlap the edge laminate, allowing for easier cleanup on the horizontal surface.

There are countless ways to apply edges to a laminate project. Whether laminate, wood, or metal is being used, the techniques for application are similar. For square or self-edge of counters (self-

Illus. 5–25. Bevelled edges can be purchased from the laminate distributor. These edges can be applied to the front before the laminate is applied to the top surface. Yellow glue and tape will hold the edge on until the glue dries.

Illus. 5–26. Taping the bevel edge into place.

Illus. 5–27. The finished edge application.

edge counters are counters that have a 90-degree angle at their surface and edge), the practice for fabrication is as follows:

1. Apply any necessary buildups to the core substrate. Smooth and clean the surface to be laminated. Cut the desired edge-laminate material so that it overlaps the buildup core by approximately ½ inch; this will allow for "play" during bonding. Apply contact adhesive to the back of the edge laminate and to the surface of the counter edge (Illus. 5–28–5–29). Note that it is recommended that both surfaces be completely

Illus. 5–28. Here ¾-inch-thick solid front-edge material is being used. This edge is being glued to the substrate before the laminate is placed on the top. This will allow the laminate to lap over the wood edge and help protect it from water.

covered with adhesive, to compensate for absorption into the porous edge on the counter; two or more coats should be sufficient.

2. When the adhesive is completely dry, bond the edge strip of laminate to the core, using your fingertips to keep both surfaces apart, and position the pieces as you work (Illus. 5–30).

3. After the strip is positioned, apply pressure with a J-roller. Be careful near the ends to avoid breaking any laminate that is overhanging the edge. If this delicate edge breaks because of overaggressive rolling, it will still be functional if it breaks long instead of short. If the laminate does break or crack to the short side, you will have to remove

the entire edge strip by using heat or solvent and completely replace it.

4. Trim the excess laminate with a straight flush-cutting carbide cutter in a trimming router (Illus. 5–31–5–34). Make certain that the router is held square to the top surface.

5. After you have routed the laminate flush with the substrate, there will most likely be some additional cleanup required before you can proceed. With a smooth file or sanding block, work the edges one more time to ensure that the laminate edge is flush with the top surface. Keep the file or sanding block flat on the top surface and push in towards the core, to prevent chipping and pulling on the laminate.

Illus. 5–29. Clamp the wooden edge on until the glue dries. After the glue dries, sand the wooden edge flush with the top surface; then place laminate over the entire top.

Illus. 5–30. *Applying the front edge to the counter.*

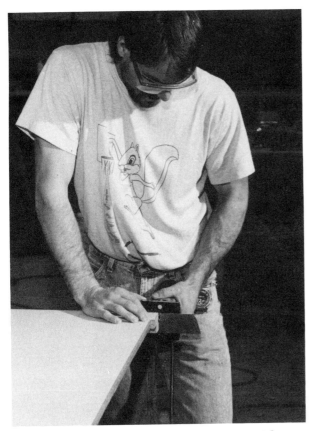

Illus. 5–31. *By using a trimming router with a flush-cutting bit, it is easy to cut the laminate edge so that it is level with the substrate.*

Illus. 5–32. *Trimming routers cannot rout all the way into corners.*

Illus. 5–33. *Another view of what the trimming router could not reach.*

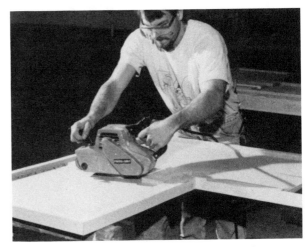

Illus. 5–34. *The best way to remove the laminate overhang that the trimming router missed is to sand or file it down flush to the substrate. Do not round over the front or exposed edge. Always remember to push the laminate towards the substrate when sanding. Never pull the laminate away from the substrate when sanding.*

6. When rounding edge corners that have small radii, remember that standard- and vertical-grade laminates are specifically limited as to how tightly each will bend. It would be a good practice to use vertical-grade laminate whenever possible and align the sanding marks on the back of the laminate perpendicular to the direction of bend. Heat is probably the best way to bend laminate without creating internal stresses in the laminate. The heat source should *not* be a flame-producing type of heater. A hot-air gun will be sufficient.

Since laminates can blister and even melt, it is advisable to monitor the heat. Tempilaq is a liquid product that has a specific melting point. When edge-bending laminate, it is recommended that you use 315 degrees Fahrenheit (158 degrees Celsius). Tempilaq will change colors, indicating when this specific temperature has been reached.

You can heat and bend laminate after it has been coated with an adhesive. As heat is applied, the laminate will become pliable and can be shaped nicely. Once you have bent the laminate, roll the area with a J-roller and proceed as you would on any other self-edging application.

Assembling the Top or Face Surfaces

Once the core has been edged, and machined, the final laminate process is ready to begin. Precut the laminate to approximately ½ inch larger than needed on all sides (this will allow for "play" when the material is being bonded). Seams need to be planned out, to minimize cross-grain direction (according to the sanding marks on the back side of the laminate), inside corners, and any unnecessary cutouts. From an aesthetic standpoint, the best place to put a seam is in the sink area; however, mechanically this is a very poor place for a seam because of its high interaction with water. If a seam is placed in an area where there is to be a cutout, it will be necessary to build up the underside of the substrate so it can support the additional weight of the sink or cooking top.

The easiest way to make a tight seam cut is to cut all adjoining laminates to exact same size and shape before bonding the laminates to the surface. Unfortunately, the seam will not become invisible; however, the better prepared the abutting edges are, the better the end result. There are special routers that help make joining laminates together at seams easy (refer to Chapter 3 and see Illus. 5–35). For most countertops and any horizontal application of laminates, the practice for fabrication is as follows:

Illus. 5–35. Laminates can be easily cut to the exact same size and shape with a seaming router.

1. Make sure that the surface is in good condition, is free from debris, wax, dirt, holes, and is filed or sanded flat on all its edges (Illus. 5–36). Apply the contact adhesive to the back of the laminate and to the top of the substrate core. Follow the adhesive manufacturer's recommendations concerning the amount of glue to be spread.

2. The adhesive is dry and ready to bond when the glue does not transfer to your fingernail when you touch it. Remember not to use the oily side of your hand to test the dryness of the adhesive.

3. Use clean dowel rods, newspaper, laminate strips, venetian blinds, or any other material to support the laminate over the surface of the core as you align the laminate. Once you have lined up the laminate, you can start removing the separation sticks. When possible, it is best to start removing the sticks in the middle first.

4. Apply pressure to the entire surface with a J-roller. Contact adhesive requires up to 50 pounds of momentary pressure to make the bond occur. *Note:* A hammer hitting a block of wood will not produce enough pressure to make an efficient bond.

5. Trim the excess laminate by using a carbide flush-cutting router bit (Illus. 5–37). It is possible also to use a bevel bit to finish the edge, to

Illus. 5–36. The surface must be smooth, in order to ensure a proper adhesion bond between the laminate and the substrate.

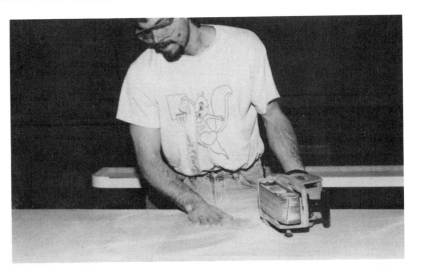

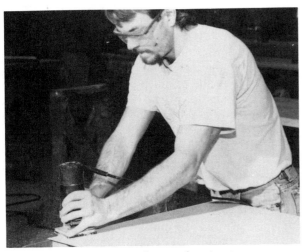

Illus. 5–37. Trimming the top laminate.

Illus. 5–38. Laminate edges are sometimes sharp. It is important to remove any burrs left from the router or sharp edges between the laminate top and edge. This is best done with a fine Plasti-Cut file available from the laminate distributor.

avoid a lot of hand-filing. Set the cutter depth accurately.

6. The edges where two pieces of laminate overlap will be very sharp. If a bevel bit has not been used as a final routing procedure, it will be necessary to file the edge with a smooth or plasti-cut file (Illus. 5–38).

7. The process of using contact adhesive will be messy and will probably leave a lot of necessary cleanup. You can clean contact adhesive off a surface by using the solvent that is recommended by the manufacturer. Do not saturate the surface with the solvent, because it can cause the laminate to come loose. On a soft cloth, apply the recommended solvent sparingly. With the cloth and a lot of elbow grease, proceed to rub the

contact adhesive off the surface (Illus. 5–39 and 5–40). For normal care and cleaning of the laminate surface, periodically wipe with a damp sponge using a mild soap or detergent. General household cleaners such as Pine-Sol liquid cleaner are also effective. *Do not use abrasive powders or cleaners!*

INLAYING LAMINATES

There are three ways that laminates can be inlaid. The first two work best if the laminate is already bonded to the substrate. One method involves using a router or table saw to create straight-line grooves

Illus. 5–39. If you have used a waterproof silicone on the backsplash, any excess silicone that squeezes out is best cleaned up with a small scrap piece of laminate.

Illus. 5–40. Any overspray of contact adhesive can be removed with a cloth lightly dabbed with lacquer thinner. Remember to extinguish any pilot burners when using this solvent. There are safer solvents that can be used to clean up contact adhesive overspray. Contact your laminate distributor for more information.

that will be replaced by other laminate strips of a different color. The second method uses a router and bushing/bearing set to make image cuts into the laminate surface. The third method requires that the inlay be cut in the laminate before the laminate gets adhered to the substrate.

The first method is done by simply using a fence system to act as a guide for the router or table saw to follow on while cutting the grooves. These grooves should be no deeper than the pieces being inlaid. It is best that the new inlay be glued in place with white or yellow glue.

The second method uses a plunge router and a bushing/bearing set that will allow geometric inlay shapes. There are several manufacturers of the type

of bushing/bearing sets described here, and they are relatively inexpensive.

This system requires a template that will be appropriately oversized to compensate for the bearing and router bit diameter. Once you have established a pattern or template that is the proper size, the first cut requires that the bearing be on the bushing on the router. The depth of the bit should be set to just below the thickness of the existing laminate, and just break into the contact adhesive.

The first cut is to be made in the piece that will be receiving the inlay. Plunge the router bit into the laminate surface, keeping the bearing in contact with the template at all times (if the bearing comes off the edge, it will make no difference in this cut). After the cut is complete, plunge the bit back up and remove the template. If you carefully pry up the waste portion of the laminate, a cavity will remain.

The second step requires that the bearing be removed from the bushing and that the template be placed over the piece that is going to be inlaid. In order to keep the inlaid piece from moving when the router makes its final cut, it is advisable to either glue the laminate down with hot-melt glue or use exterior-grade double-sided carpet tape. The depth of the router bit in the plunge router should be set so that the bit cleanly cuts through the piece that will be inlaid. Once the template is set and the router is ready, the cut can be made. This cut will require that your router bushing stay on the template edge at all times. If there is any deviation at all from the template edge, the inlay will be ruined. To make the cut, plunge the router bit into the laminate and move the router clockwise. Once the laminate has been completely cut, plunge the router bit up and away from the surface to avoid damaging the inlay piece. This new piece should fit exactly into the cut that was made into the receiving surface. It will be best to use contact adhesive on both surfaces. The contact adhesive will allow some leeway in the height of the new piece.

For multiple or production-type inlays, it is best to use clear acrylic as the template material.

The third method is just like the second method except that it is best if the inlay is cut in the laminate sheet before being adhered to the substrate. Simply cut the inlay into the background laminate and tape it into place (the tape goes on the face side). Proceed with the normal fabrication techniques.

Building the Counter Blank

BUILDING PROCEDURES

Once all the measurements have been taken, a working drawing can be developed. The working drawing must consider overall counter size, which usually extends one inch beyond both ends and the front edge of the cabinet. The drawing must also take into account allowances for scribe buttons and hardwood edges. The counter blank size must be reduced to account for them. Scribe buttons are used between the countertop blank and the wall. They keep the countertop spaced from the wall so that little scribing or cutting is required to fit it to the wall. Scribe buttons are used on some countertop blanks shown later in this chapter.

After a working drawing is developed, make up a bill of materials. The bill of materials lists all the parts included in the project. It tells you the name of the part, the size of the part, and the number of parts required. The first part to be cut is the countertop blank, because it is the largest. Smaller parts such as the buildup and the backsplashes are cut from the remainder of the board stock or other cutoffs in the shop.

The best counters are made from ¾-inch-thick high-density particleboard. The size of your shop and the type of equipment you have will determine how you cut your stock. Remember to save your square factory corners for strategic positioning on the countertop blank. For example, if a corner is to be radiused after being cut out, it is hardly necessary to make this corner the factory corner.

After the blank is cut out, the backsplashes and buildup can be cut. The buildup is generally 2 inches wide, and the backsplashes are usually 4 inches wide. Many shops cut extra buildups and backsplashes so they will be ready when needed. This is a good way of using cutoffs and other scraps of particleboard (Illus. 6–1).

Illus. 6–1. The backsplashes have been positioned on the blank for a perfect fit. Backsplashes and buildups are usually made from particleboard cutoffs. (Photo courtesy of Skil Power Tools.)

Working the Counter

Since the buildup is nailed to the bottom of the counter, it is best to position the counter upside down before working it. Position it on sawhorses or place it on a bench with spacers underneath. The spacers keep blades or router bits from cutting the workbench.

Cut the outer edges of the counter to their desired shapes. The radii are best cut with a router. Keep in mind that your counter is upside-down. This means that its radius is not in the same position as it is on the plans. A portable circular saw can be used to remove most of the waste stock before the counter is routed.

A carefully made radius block can be used to lay out the curve (Illus. 6–2 and 6–3) for rough-sawing

Illus. 6–2. This radius template controls the follower guide on the base of the router. The bit plunges through the follower guide to trim the blank.

Illus. 6–3. The radius template can be used to lay out the curve on the counter blank. Make sure that it is marked on the correct corner.

and routing. After rough-sawing the curve, clamp the radius block to the counter. The edges of the radius block are lined up with the edges of the work (Illus. 6–4).

Illus. 6–4. The radius template has been clamped in position. The bit will trim the blank into a smooth square radius.

A follower guide is attached to the router base. This controls the path of the router (Illus. 6–5). It rides along the radius block. A straight-cutting or stagger-tooth carbide-tipped bit can be used to do the cutting. Both ensure a smooth edge. Hold the router or laminate trimmer firmly on the radius

Illus. 6–5. The bit has trimmed the arc. Note that there are no "steps" between the arc and the straightedges. Careful positioning of the template has eliminated the steps.

block (Illus. 6-6–6-10). This will ensure a square edge. Guide the router from left to right (counter-clockwise) when you cut a radius or other profile.

A sabre saw can also be used to cut radii. This is not the best way to cut a radius, because the blade may bend. If the blade bends, the edge will not be perpendicular to the counter. This makes the application of edge bands more difficult. The edge band will turn upwards or downwards when it is glued to an irregular area. You can belt- or block-sand the edge to make it square (Illus. 6–11). Check the edge periodically to be sure it is perpendicular to the face of the counter. If the edges are not perpendicular to the face, it will be difficult to apply the plastic laminate in a straight line.

Illus. 6–6. The laminate trimmer cut this arc in a single pass. This tool would be too light for production work, but it can be used to trim a radius. (Photo courtesy of Skil Power Tools.)

Illus. 6–7. Hold the router firmly on the work surface and against the template edge. Do not force the tool. (Photo courtesy of Skil Power Tools.)

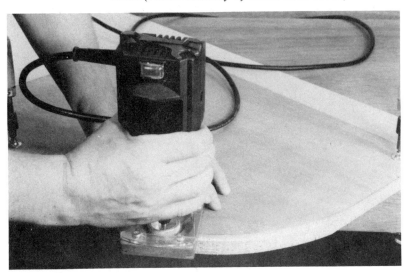

Illus. 6–8. The template must be positioned carefully to allow for the offset of the follower guide. Be sure to clamp the template securely. (Photo courtesy of Skil Power Tools.)

Illus. 6–9. The radius formed by the straight bit is very smooth. A spiral bit could make it even smoother. (Photo courtesy of Skil Power Tools.)

Illus. 6–10. You can "feather" the radius at its ends by block-sanding it. (Photo courtesy of Skil Power Tools.)

Illus. 6–11. Use 80-grit abrasive to sand the edges of counter blanks. Be sure to check the edge with a square.

Installing the Buildup

The buildup is glued and nailed to the underside of the counter. The buildup makes the counter appear thicker. This enhances the look of the counter. It also makes the counter stronger because it is used to support the counter over the cabinet joints. Remember, the counter is upside down. Install the buildup with this in mind.

If there is a radius on the counter, begin there. Use a block large enough to extend back to the cabinet or other support (Illus. 6–12). These radius blocks should be the first buildup parts to be installed. Mark the radius on the block with a pencil and cut off the waste before fastening this piece of buildup. Leave enough stock so that the buildup may be trimmed after it has been fastened (Illus. 6–13). It should extend beyond the counter by about ⅛ inch (Illus. 6–14 and 6–15).

Illus. 6–12. This block will extend back under the cabinet. It is laid out with the desired radius. (Photo courtesy of Skil Power Tools.)

Illus. 6–13. The corner block is rough-cut and then glued and nailed in position. (Photo courtesy of Skil Power Tools.)

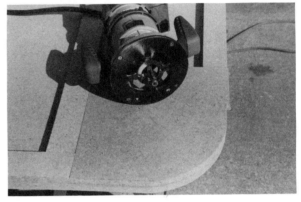

Illus. 6–15. A laminate trimming bit will cut the buildup flush and square with the blank.

Illus. 6–14. Allow a slight overhang with all pieces of buildup. They can be trimmed after the glue cures.

Buildup Strips

Buildup strips are used as supports on both sides of a sink. They should be at least one inch away from the cutout on either end. This makes it easy to use the sink clip fastening system to anchor the sink to the countertop.

Buildup strips go the long way (end to end) and are attached after the radius blocks (Illus. 6–16 and 6–17). Add them anywhere you wish to anchor the countertop to the cabinet or base. Glue and nail or screw them to the counter blank (Illus. 6–18), and make sure they are spaced more than 24 inches apart.

After the radius buildup is installed, add the strips that go the long way (Illus. 6–19). These pieces should also extend slightly beyond the exposed edges of the counter. The rear edge of the buildup is recessed slightly when no backsplash is

Illus. 6–16. Buildup supports are cut into strips. They can be cut to length as needed.

Illus. 6–17. The strips, which go the long way, are attached after the radius buildup, if it is needed. Glue and nails secure the buildup to the blank.

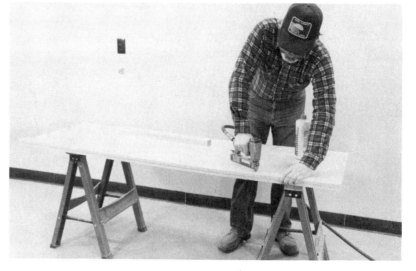

Illus. 6–18. Keep your fingers clear of the nailer and be sure to wear protective glasses.

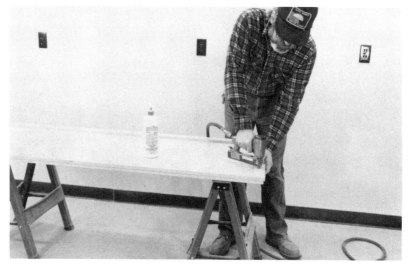

Illus. 6–19. In limited production applications, a buildup can be attached with nails. Remember, the blank is upside down; be sure the radius block and the buildup are positioned correctly. (Photo courtesy of Skil Power Tools.)

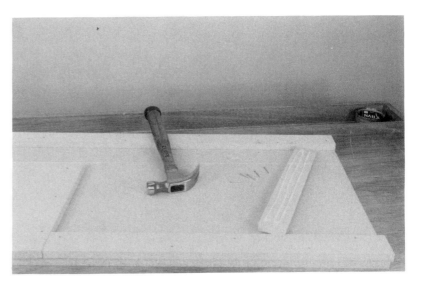

Illus. 6–20. Some buildup pieces may not be installed until after a cutout is made. (Photo courtesy of Skil Power Tools.)

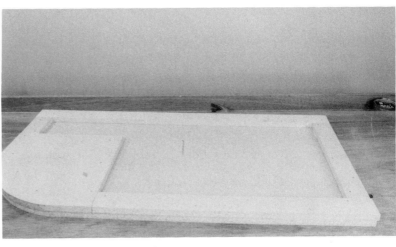

used. This allows the rear edge to act as the scribe along the wall. If a backsplash is used, the rear edge of the buildup should be even with the top.

Install the buildup parts that go the short way. These pieces should be no more than 24 inches apart (Illus. 6–20). These pieces go on both sides of a sink or other opening. In some cases, these pieces are not installed until the openings have been cut.

Trim the overhang on the buildup with a router or laminate trimmer. Use a laminate trimming bit for this job (Illus. 6–21 and 6–22). Work carefully; be

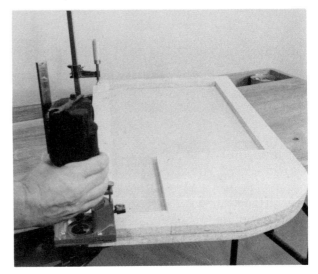

Illus. 6–21 (right). Trim all of the buildup with a laminate-trimming bit. Guide the router or laminate trimmer from left to right. (Photo courtesy of Skil Power Tools.)

Illus. 6–22. The bit cuts the buildup smooth and square. Inspect the joint for a tight bond. (Photo courtesy of Skil Power Tools.)

sure to hold the router flat on the buildup. Tilting the router can damage the edge. It is important that the edge be square with the top.

Add scribe buttons when necessary. Fasten them with glue and tacks (Illus. 6–23). Make sure that the edges of the scribe buttons are flush with the buildup and the top and bottom of the counter (Illus. 6–24 and 6–25). Block-sand the scribe buttons and the front edge lightly with 60-to-80-grit abrasive. Turn the countertop over and inspect the top and exposed edges.

Use wood filler or auto-body filler to repair any dents or holes in the buildup or countertop. Allow the wood filler to dry completely, to keep the surfaces smooth and true.

Making Cutouts

Cutouts are made in counters to accommodate sinks, stove tops, cutting boards, and electronic devices. Position and lay out the cutout carefully. If you are not sure of its exact size, it is best to make it smaller than necessary. You could also make a cutout in cardboard, to be sure that the hole is the correct size. A cutout that is too large is almost impossible to repair. When a repair is made, the area around the repair will be weak and may not support the object placed in the cutout.

Once the layout is made, the method of cutting the counter must be decided (Illus. 6–26). Some cutouts require round corners, while others can be made with square corners. Remember, there should be a radius in square corners, to prevent stress from cracking laminates. Generally, if the object going into the opening has radiused corners, the cutout itself should have radiused corners.

Radiused corners are made by drilling. Select an appropriate drill diameter and keep the bit inside

Illus. 6–23. Scribe buttons are attached to the blank on surfaces which touch a wall. Be sure to deduct the scribe thickness (usually ¼ inch) from the blank or the blank will be oversize. (Photo courtesy of Skil Power Tools.)

Illus. 6–24. Scribe buttons can be cut oversize and then trimmed to size. (Photo courtesy of Skil Power Tools.)

Illus. 6–25. A belt sander was used to trim the scribe buttons to size on this blank. Hand-sanding with 80-grit abrasive and a sanding block would also trim the scribe buttons.

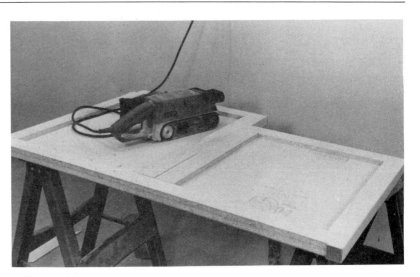

Illus. 6–26. Once the cutout has been positioned, the blank can be laid out. Measure carefully and mark the blank accurately.

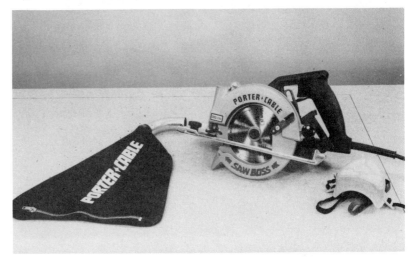

the layout lines. Note in Illus. 6–27 how the radi-used corners are laid out. The straight lines may now be plunge-cut with a portable circular saw (Illus. 6–28 and 6–29). As the cuts progress, you can support the scrap by driving sheet-metal screws into the saw kerfs (Illus. 6–30). This will prevent the scrap from binding on the saw blade. The scrap is freed by removing the screws (Illus. 6–31). Support the scrap while removing the screws. Test the fit in the blank and make any needed adjustments (Illus. 6–32).

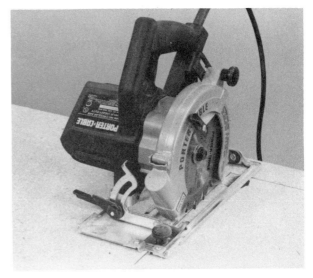

Illus. 6–27 (right). Drill the corners before doing any cutting. Corners with a radius are less likely to cause stress cracks in the plastic laminate.

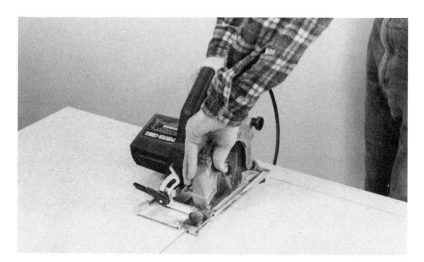

Illus. 6–28. A portable circular saw is used to plunge-cut the opening. The depth of cut is slightly greater than the counter thickness.

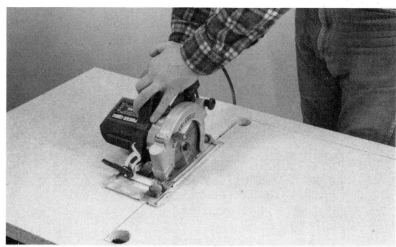

Illus. 6–29. Once the saw cuts through the countertop, guide it along the layout line. Keep the blade on the waste side of the piece.

Illus. 6–30. When the kerf is complete, a sheet-metal screw will hold the piece in place while the other kerfs are cut. The sheet-metal screw will keep the cutout from binding on the saw blade.

Text continues on page 158

Postforming is the process of bending laminate around a core by using heat and applied pressure to create any specific radius or curve. *(Photo courtesy of Westinghouse Micarta.)*

Light-color laminates will require special attention during the bending process. *(Photo courtesy of Formica.)*

Darker-color laminates will heat more quickly and bend more easily than light-color laminates. (Photo courtesy of Formica.)

Through-color laminates offer a monolithic appearance, and intricate patterns can be routed in them. (Photo courtesy of Wilsonart.)

Through-color laminates are a designer's dream. (Photo courtesy of Formica.)

Through-color laminates can be stacked, bevelled, and routed to create visual edge effects. (Photo courtesy of Wilsonart.)

Through-color laminates used in the interior of an elevator panel. (Photo courtesy of Formica.)

Pinstripes can add interesting contrasts to the edges of plastic laminate. (Photo courtesy of Wilsonart.)

One typical problem associated with working with plastic laminate is cracking of the laminate. Cracks are caused by stress generated in the laminate either by dimensional change or by physical force. To alleviate stress in the plastic laminate and prevent this sink cutout from cracking, the corners have been cut with a slight radius. (Photo courtesy of Wilsonart.)

If laminates are cared for properly, they should last a lifetime.

Illus. 6–31. If the cuts require hand-sawing, do the sawing before removing the screws.

Illus. 6–32. Test the fit of the object in the cutout. Make any needed adjustments.

A sabre saw can also be used to make the cutout. Select a blade with 4 to 6 teeth per inch. Keep the blade on the layout line and guide the saw slowly. Do not force the saw. This could move you off the layout line.

If a buildup is required around the cutout, it can be installed now. Glue and nails can be used. If nails are not desirable, the buildup can be glued and clamped in position. In some cases, the buildup should not be positioned next to the opening. It should be ½ to 1 inch away from it. This allows clearance for clamps or fastening devices that are mounted to the object going in the opening.

Using Solid-Wood Edges

Many counters and other laminate jobs require the use of solid wood as an exposed edge. The wood edge is usually a furniture hardwood that gives the counter a decorative look. In most cases, the hardwood edge is attached to the exposed edges after the buildup is attached and trimmed. Plan the counter accordingly. It should be narrower than its finished size so that when the hardwood edge is added, the counter will be the correct width.

The hardwood edge can be attached with visible or hidden fasteners; visible fasteners include nails and screws. Pneumatic nailing and glue is the simplest method of fastening. Nail holes must be filled, however, and may detract from the overall beauty of the counter. In addition, the nails may get in the way of machining. Some hardwood edges are shaped or chamfered after the laminate is glued on (Illus. 6–33).

Screws can also be used to secure the hardwood edges. The screw holes are counterbored and filled with hardwood plugs. Cut these plugs with a plug cutter using a drill press. Some plugs are made from a hardwood of a contrasting color or grain. These plugs stand out and are used to decorate the edge.

Hardwood edges can use "invisible" attachments such as dowels, splines, or plate joinery (Illus. 6–34). Dowels are driven into holes that have been drilled into the countertop and the hardwood edge. Careful layout is essential to proper fastening with dowels. Dowelling jigs may be helpful in ensuring accurate fitting. Clamp the edge securely until the

Illus. 6–33. Some hardwood edges are shaped or chamfered after the laminate is glued on. Do not allow contact adhesive on the hardwood surfaces or they will not finish well.

Illus. 6–34. Some type of fastening can be used to hold the solid-wood edging in place. Dowels, splines, biscuits, nails, and screws can be used in conjunction with glue.

glue cures. Clean excess glue off and block-sand the joint lightly after the clamps are removed.

Splines are inserted into a groove that has been cut on the mating edges of the two parts. The groove can be cut with a router or with a circular saw blade. In some cases, these grooves must be blind so they will not be visible at the end of the counter. The size of the piece may also determine the way the groove is cut. Larger pieces will have to be cut with portable tools.

Plate joinery, like dowelling, is convenient for attaching hardwood edge bands to counters (Illus. 6–35). Grooves are cut into the counter blank and

the edge band. There is some latitude in the positioning of the edge band when plate joinery is used. The edge band can be shifted from side to side slightly until the plates or biscuits swell.

Regardless of how the edge band is secured to the counter, clamps should be used to hold it against the counter until the glue sets. The band should be sanded if it is not even with the top of the counter. A router can also be used to cut the edge band even with the top of the counter. A laminate trimming bit would be used to make this cut. Some specialty router attachments can also be used (Illus. 6–36 and 6–37).

Illus. 6–35. The plate joiner cuts kerfs in the hardwood edging and the counter blank.

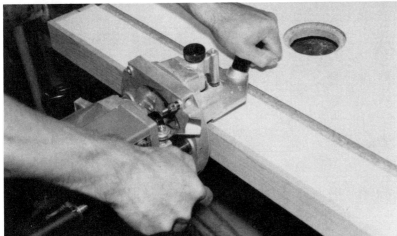

Illus. 6–36. This specialty router attachment trims wood edge bands flush with the laminate. It has microadjustment and is used with a straight-cutting router bit.

Illus. 6–37. The wooden trim is cut flush with the laminate. Approximately 1/16 inch has been removed.

Making the Backsplashes

Cut the backsplashes to their width and length. The length of the backsplash should be exact, but the backsplash should be slightly oversize in width. Glue the scribe material to the back side of the backsplash (Illus. 6–38). Use clamps or tacks to secure it while the glue cures. Keep the tacks well away from the edge. The scribe should be even with the tip of the backsplash, but a slight unevenness is permissible since the backsplash will be trimmed later. The scribe which is fastened to the ends should be attached more carefully. It should be even with the front and back of the backsplash.

Trim the backsplashes to width using a laminate-trimmer and a ball-bearing laminate-trimming bit (Illus. 6–39) or a table saw. This trimming will ensure that all backsplashes are the same width. It will also make the tops even and square. Since scribe strips are not needed on the bottom edge of the backsplash, some strips of stock must be taped to the bottom edge if they are sawn to width. This will keep the backsplash flat while you are sawing. Make sure that the blade you use produces a smooth cut; otherwise, the sawn surfaces may be too rough for gluing.

Work carefully while using the table saw. Keep the blade low and feed the work into the saw with a push stick. This job can be done with a guard mounted on your saw. Use it to make the job as safe as possible.

Illus. 6–38. Scribe material has been glued to this backsplash. It has to be trimmed to exact size. (Photo courtesy of Skil Power Tools.)

Illus. 6–39. The scribe is trimmed with a laminate trimmer and a ball-bearing laminate-trimming bit. (Photo courtesy of Skil Power Tools.)

ATTACHING THE BACKSPLASHES

Locate the backsplashes on the counter and clamp them securely. Drill through the bottom of the buildup into the backsplash. The bit you select should make a pilot hole for the screws you are using (Illus. 6–40). Most laminate shops use hardened number 6 or 8 screws. These are bugle-head screws with a special thread. This thread grips well in particleboard, and the bugle head allows it to countersink itself when it is driven into the wood. Make sure that the holes are drilled accurately. If the screw breaks through the backsplash (Illus. 6–41), the backsplash must be reworked.

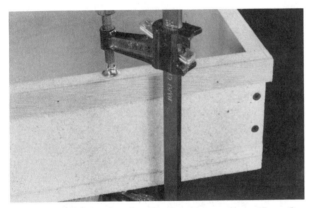

Illus. 6–40. The backsplashes are screwed to the counter blank. Screws are also used to join the corners. (Photo courtesy of Skil Power Tools.)

Illus. 6–41. If the screws are not positioned correctly, they could break through the backsplash. Drill pilot holes and be sure they are perpendicular to the counter blank.

Join the corners in the same way, using smaller screws. All joints must pull together snugly. Once assembly is correct, it can be disassembled for laminating. Be sure to mark the pieces so that they go together the same way they were fitted (Illus. 6–42).

Illus. 6–42. The parts should fit together accurately before and after laminating. Careful layout and fitting are important to a successful laminating job.

In some cases, the backsplash is not fitted to the counter or trimmed until after the laminate is applied. The decision on whether to pre- or postfit the backsplash is determined by the following:

1. *The size of the counter.* If it is a large top, prefitting would be helpful.
2. *The number of joints or corners.* The more complicated the counter, the more important prefitting becomes.
3. *The width of the backsplashes.* Wider backsplashes make the counter more difficult to install, so they should be fitted after the laminate is applied.

End-Joining Counters or Backsplashes

Counter length is determined by the maximum length of sheet stock and plastic laminate. Transportation and installation problems are also factors. Very long runs of counter may not be able to make turns in hallways or stairways. Joints in counters or backsplashes must be strategically placed and fit well.

There are many types of mechanical fastening methods for counters. The joint is usually a butt joint. No fancy joinery is used; dowels can be used to join sections of the counter. These joints can be fastened with glue at final assembly. This method does not allow for disassembly, and pulling the parts together is difficult.

Metal mechanical fasteners act like dowels and allow the parts to be pulled together for a tight fit (Illus. 6–43). These mechanical fasteners allow for quick disassembly; some mechanical fasteners require that the counter edges and buildup be drilled. The metal fasteners are then inserted into the holes. Other metal fasteners require that the buildup be routed. The metal parts are then inserted into the routed openings.

All mechanical fasteners have a threaded core. The threaded core allows the two mating parts of the counter to be pulled together. A bolt or other threaded device is turned to pull the parts together.

Backsplashes are usually joined in the corners with screws. Long runs of backsplash can be joined with screws if pocket holes are drilled. Biscuits or dowels can also be used to join the parts. Glue should not be applied to the dowels or biscuits until the counter is ready to be installed.

The metal fasteners used to join the counter parts together are usually not suitable for attaching the backsplash. This is because the backsplash is thinner than the counter and its buildup. Biscuits or dowels can be used, or a thin cleat can be glued and stapled from the back side.

All provisions for joining the counter or backsplash together should be made before the laminate is applied. Successful plastic laminating requires preplanning and attention to details.

CUBES AND ROUNDS

Many decorators use laminated cubes and cylinders as coffee tables, end tables, or other accessories. These pieces rarely require buildups or other details.

Cubes are usually made up of ¾-inch-thick particleboard. They are usually glued and nailed together. Usually a base or "riser" is fastened to the bottom. This riser is much like the toe space on a kitchen cabinet. In many cases, the toe space is covered with a dark-colored plastic laminate.

Cylinders are made from preformed parts. Most cabinet suppliers offer them as full, half, or quarter cylinders. This allows you to use only what you need. For example, if you were making an oblong table, you would attach the half cylinders to each end of a rectangular piece of sheet stock. A quarter cylinder would be used to make a radius at the intersection of two perpendicular surfaces. It could also be used as a door between a cabinet face and cabinet end.

When buying cylinders, specify the diameter of the cylinder or the radius of the curve. This will ensure that the piece will suit your needs. If a riser is required under a circular or oblong table, select another half cylinder with a smaller radius. The only consideration is that the radius is not too tight to accommodate the laminate.

REPAIRING THE BLANK

In some cases, the ends or edges of the particleboard counter or backsplash become damaged during assembly. These defects must be repaired before the plastic laminate is applied. Many woodworkers use the old standby treatment: they mix sawdust and glue to fill any voids or cracks. The sawdust and glue cures to a mass which is not softened by the solvents in contact adhesive. This means that the contact adhesive does not damage the bond. If you plan to use a commercial wood filler or auto-body

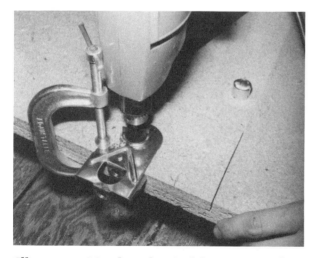

Illus. 6–43. Metal mechanical fasteners can be used to join counters. Each fastener works differently; be sure to read the manufacturer's instructions.

filler, make sure that it will not be damaged by the solvent in the contact adhesive. If you are uncertain, test the filler on a piece of scrap. Powdered wood filler, which is mixed with water, works well for repairing defects and damage. Auto-body filler also works easily and sets up quickly.

When filling cracks or defects, build the area up higher than it needs to be. This will allow for some shrinkage. Any excess filler can be sanded off when the surface is prepared for gluing. *Note:* The glue and sawdust patch will have a tendency to load the sanding belt when the area is sanded. Use an old belt for initial sanding. This will increase the life of your newer sanding belts.

CHAPTER 7

Postforming

Postforming is the process of bending laminate around a core by using heat and applied pressure to create any specific radius or curve (Illus. 7-1–7-4). Since laminates are always sold in flat sheet stock, the term "postforming" indicates that bending will take place after the initial manufacturing process. All laminates will bend to a certain degree; however, there is a postforming-grade laminate that is manufactured with special papers, resins, and precisely controlled press cycles, and is slightly thinner than standard-grade laminate. (For more information on postform-grade laminates, refer to Chapter 1.) This special grade of laminate can bend to a much tighter radius with more control than other grades. Each laminate manufacturer offers a full line of colors, polishes, and patterns for postforming-grade laminate.

Postformed edges have been popular for well over 50 years. They offer a smooth line and can produce a monolithic or streamlined appearance. Postformed tops are very resistant to chipping, since their edges are softer and not at a sharp angle. These soft edges or radiused corners are safer than

Illus. 7–2. Bullnose edge profile. (Photo courtesy of Wilsonart.)

Illus. 7–3. No-drip, double-radius edge profile. (Photo courtesy of Wilsonart.)

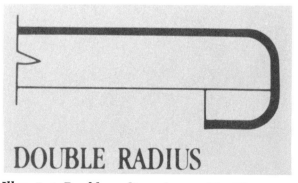

Illus. 7–1. Double-radius edge profile. (Photo courtesy of Wilsonart.)

Illus. 7–4. Waterfall edge profile. (Photo courtesy of Wilsonart.)

sharp edges. These edges have no laminate seams; they are comprised of one continuous piece of laminate. Since there are no seams, there are no areas for water or other material to leak through or penetrate the substrate. This would be of great value when hygiene and cleanliness are important. Postformed edges being seamless, they also require less maintenance and will perform better over a long period of time.

One of the greatest advantages of postforming is that the unsightly brown line (the phenolic resin backing sheet that is visible on all self-edge applications) can be completely eliminated. One interesting feature of postforming laminates is that lighter colors tend to be more difficult to bend than darker ones.

Postforming can be either a hand or mechanical operation. Both methods will require a heat source, a preshaped core, contact adhesive, some type of fixture to apply pressure during the cooling process, and, of course, postforming-grade laminate. It is important to know that no laminate can be bent into compound shapes. If a bend is desired in more than one plane, it will be necessary to design the shape for two pieces of laminate instead of one. Also, it is important to know that postforming laminates will require adhesives with specific attributes, the most important being a long open time and hot green-strength (hot green-strength refers to the strength of contact adhesive while it is still in the hot stage). If you are considering a postforming application, use an adhesive that is specifically made for the task.

The mechanical method will require large and expensive equipment that certainly goes beyond the scope of this book (Illus. 7–5 and 7–6). The process requires that the core be prepared and covered with the correct amount of contact adhesive. The laminate that is to be used must also be covered with contact adhesive. Both materials are fed into

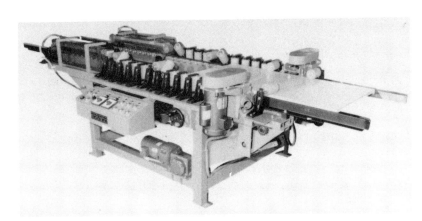

Illus. 7–5. A double-sided, single-stage automatic postformer. This Model 6100 Form-O-Matic machine is used for countertops, desk tops, doors, and drawers. (Photo courtesy of Evans Machinery.)

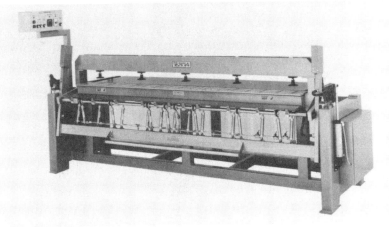

Illus. 7–6. This Model 0138 All-Form machine will wrap laminates at 90, 180, and 360 degrees. It is designed to hold down the laminate while it cools, with either a vacuum or clamp system. (Photo courtesy of Evans Machinery.)

the roll-forming machine. This machine has radiant heaters that will heat the laminate to a specific temperature before the bending process occurs. Once the laminate is heated, an assembly unit that is supported on a carrier will move the laminate and core to a forming bar that is progressively slanted to press the laminate onto the core material and hold it in place until the laminate has cooled and bonded. Automatic machines can make postform slabs for countertops, desks, doors, tables, tub and shower enclosures (Illus. 7–7), and architectural casework.

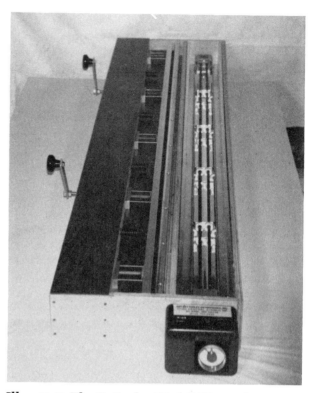

Illus. 7–8. The Betterley Model CD 78 chain-drive postforming clamping system enables the one-man shop to perform postforming operations similar to larger shops.

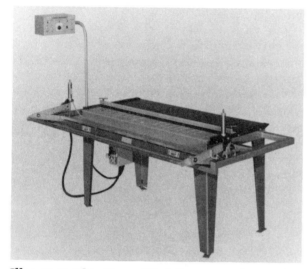

Illus. 7–7. This Evans Model 0130 postforming machine is capable of wrapping laminate to a full 360 degrees. It is best suited to be used for bath and shower enclosures. (Photo courtesy of Evans Machinery.)

Hand-postforming is inexpensive when compared to the mechanical method; it is also considerably slower. The major drawback is that you will be limited to bending only what you can heat at one time. This method requires some type of consistent heat that can be uniformly distributed over the desired surface. A hot-air gun will not heat the surface consistently, and is not recommended for large surfaces (surfaces wider than 4 inches).

There are small postforming machines that allow the one-man shop to produce a wrapped edge. Betterley Enterprises, Inc., makes a machine that uses a Chromalox radiant heater along with either a chain-drive or pneumatic clamping system to heat and hold the laminate (Illus. 7–8 and 7–9). These sys-

Illus. 7–9. After the laminate has been heated, the clamping system behind the heating elements will allow bending and pressure to take place.

Illus. 7–10. The Evans Model 0100 manual Ezy-Form allows the smaller shop to perform economical production of postformed countertops. (Photo courtesy of Evans Machinery.)

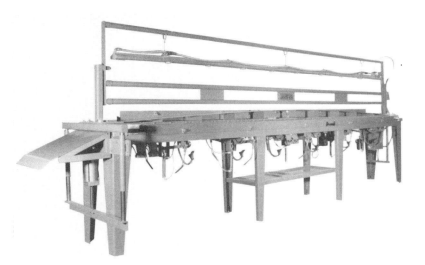

tems are helpful and relatively inexpensive when compared to the big commercial postforming machines. Evans Machinery also makes a small and affordable manual postforming machine that can produce a 12-foot countertop in just six minutes with only one operator (Illus. 7–10).

It is possible to make your own postform machine by simply using a Chromalox or quartz heating element that is held in some type of trough. These heating elements can be purchased in any length; just remember that you should only bend what you can physically handle. The trough will allow the laminate to be held over the heat source until the proper temperature is reached. A clamp-type fixture will also be necessary to hold the laminate and core material together tightly, until after the laminate has cooled.

The most important factor in successful postforming is heat. There are several temperature-indicating materials available that may be in the form of liquids, pellets, markers, or labels. Crayons, such as the coloring type that children use, are *not* a good temperature indicator for laminate because their melting point is not nearly high enough. Tempilaq (Illus. 7–11) is a commercial heat-sensitive wax material that has a specific melting point, and is available from most laminate distributors. Use Tempilaq only in small amounts if it is applied to the contact side of the laminate; because it is a wax product, the adhesive will not bond in the area of application. For best results, use a drop of Tempilaq no larger than a dime. The optimum postforming temperature will vary from one laminate manufac-

turer to another, but should be somewhere between 313 and 325 degrees Fahrenheit (157 and 163 degrees Celsius). It is important to remember that lighter-color laminates tend to reflect heat, while those with darker colors will absorb heat more readily.

Illus. 7–11. Tempilaq is a wax product with a specific melting point. It is generally available from laminate distributors.

A good way to ensure a successful postforming project is to take a small (8 × 8-inch) sample of the pattern you are about to postform and apply your heat source until the laminate blisters. Note the amount of time it takes to blister the laminate and subtract about 5 to 8 seconds. This is because the best bending point for laminate is very close to its blister point. If it takes 45 seconds to blister, the

laminate should not be heated that long or else it will blister every time. Five to eight seconds are subtracted to ensure that the laminate is hot enough to bend but does not blister. If the heat source takes more than a minute, the heat is being applied too slowly for optimum results.

Since postforming laminates have a specific moisture content, and their optimum bending temperature is above boiling, they must be heated at a certain speed or blisters and cracking will develop. The general rule is that the heating time for every .001-inch thickness of laminate should be no more than one second. For example, if standard-grade postforming laminate is .042 inch thick, it should take around 42 seconds to reach 313 to 325 degrees Fahrenheit (157 to 163 degree Celsius).

When the laminate has reached the proper temperature, it is important to remove it from the heat source and immediately complete the bend by using some type of uniform pressure or clamping fixture. Once the bend is complete, the laminate cannot be reformed by reheating. It is important to pay close attention to details during the process of postforming.

Hand postforming is more desirable than mechanical postforming for unusual configurations or limited-quantity runs. There are two common manual techniques: the rollover wrap (Illus. 7–12) and the 180-degree wrap (Illus. 7–13). Both will require a heat source, a preshaped core, and adhesive, but only the 180-degree wrap will require a clamping fixture. Each technique is described below.

ROLLOVER WRAP TECHNIQUE (ILLUS. 7–12 AND 7–13)

The first step is to form the core material to its desired shape. Then spray or roll the contact adhesive on the core and the laminate and allow it to dry. Place the laminate on the core and allow the lami-

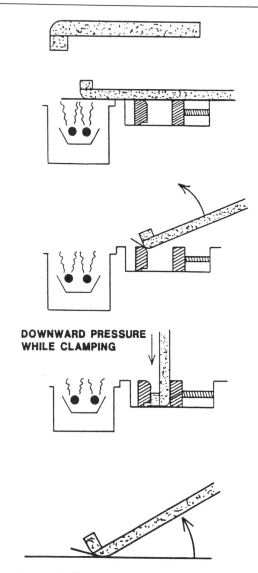

DOWNWARD PRESSURE WHILE CLAMPING

Illus. 7–13. Rollover wrap technique.

nate to extend past the area where the postforming will take place. Roll the flat surfaces with a J-roller to make a proper bond.

Next, set the core and laminate over the trough with the Tempilaq easily visible. Allow the laminate to heat to the desired temperature. Then exert downward pressure while rotating the core and laminate against a flat surface.

Next, use a J-roller to roll over the entire surface, including the section that has just been formed. This rolling is necessary because no clamp-type fixture was used. Finally, trim all excess.

Illus. 7–12. Rollover wrap.

180-DEGREE WRAP TECHNIQUE (ILLUS. 7–14 AND 7–15)

First, form the core material to its desired shape. Then spray or roll the contact adhesive on the core and the laminate and allow it to dry.

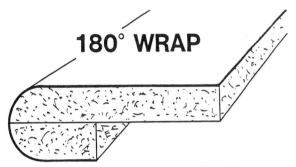

Illus. 7–14. One-hundred-and-eighty-degree wrap.

Illus. 7–15. One-hundred-and-eighty-degree wrap technique.

Next, place the laminate on the core and allow the laminate to extend past the area where the 180-degree wrap will take place (allow extra material that can be routed off later). Roll the flat surfaces with a J-roller to make a proper bond.

Set the core and laminate over the trough with the Tempilaq easily visible. Allow the laminate to heat to the desired temperature.

When the Tempilaq indicates that the proper temperature has been reached, slip the laminate and core into a forming or clamping fixture and let them cool. Then roll the entire project. Finally, remove and trim all edges.

CONDITIONS THAT AFFECT POSTFORMING

Successful postforming requires special attention to several factors. The rules for both hand- and mechanical postforming are similar. There are some special considerations that must be observed before you begin postforming any laminate. Preconditioning, temperature control, drafts, and equipment maintenance will all directly affect the outcome. Each is described below.

Preconditioning

Postforming laminates are slightly hygroscopic. This means that they will be able to absorb and lose moisture just like a sponge. If postforming laminate is exposed to dry areas, the natural moisture in the material will be low, which, in turn, will cause major postforming problems. Actually, post-forming-grade laminates respond better when stored in an area with elevated atmospheric humidity.

The rules for preconditioning postforming laminate are the same as those for standard-grade laminate. Acclimation must take place for at least 48 hours prior to fabrication, with an ideal relative humidity of 50 percent. Postforming laminates can be easily and economically stored in small shops in a room with a humidifier.

Remember, seasonal changes will directly affect postforming conditions inside the shop—especially in the winter months, when typically it is dryer.

Temperature Control

The optimum postforming temperature will be be-

tween 313 and 325 degrees Fahrenheit (157 and 163 degrees Celsius). Lower temperatures will cause the laminate to crack from stress, and higher temperatures may cause blistering, cracking, discoloration, and gloss changes. If any of these conditions occur, the following solutions should be considered: change the temperature on the heater to either hotter or colder, speed up or slow down the heating process, or check the temperature indicator that is being used for damage (it may have been dropped, mishandled, or affected by moisture).

Drafts

Make sure that there are no open windows or doors near the postforming equipment. Sudden drafts can cause sudden temperature changes on the heated surface, which could bring about cracking and crazing. (Crazing is fine cracks which may extend on or under the surface of or through a layer of adhesive.) This is especially important during cold winter months. It is not uncommon for the heating elements to warm a room to the point of discomfort, and opening a door or window seems normal; just remember to keep the cooler air off the heated laminate. The use of temporary or permanent partitions to help avert drafts over the heating area might be a good idea.

Equipment Maintenance

Commercial or custom-made postforming equipment will perform better if it is maintained on a regular basis. Heating elements can develop hot or cold spots after a period of time. Contact the manufacturer if a problem occurs.

TROUBLESHOOTING TECHNIQUES

Table 7–1 is a list of common postforming problems and ways to correct them:

OTHER POSTFORMING TECHNIQUES

Hot-Rod Forming

Hot-rod forming is a technique that is common throughout the American Southwest. It involves either an aluminum or copper tube or rod that can vary in overall diameter and length. The rod can be heated to a consistent temperature from one end to the other. This rod typically runs parallel to the

edge of a table, with a couple of inches of clearance between the rod and the table edge. General-grade laminate is placed directly on the rod at the desired area of bending; the rest of the laminate lies flat on the table surface. Once the laminate is heated to the proper temperature, it will start to droop or bend over the heated rod. Care must be taken so that too much or too little of the laminate is not placed on the rod.

The newly bent L-shaped laminate will be used for onsite fabrication; this allows the laminate to sit on the counter and run up the wall to the underside of the cabinets. This technique will give the counter a built-in look, as well as help protect the back wall from grease and water. This practice also works well for tub and shower enclosures.

It should be noted that this technique works well in drier climates where there is little atmospheric change from season to season. Since the laminate is adhered to a particleboard or plywood substrate on the counter surface, and the backsplash portion of the counter is applied to either drywall or plaster, there is the possibility that the two surfaces may contract or expand a lot. Some large laminate manufacturers do not accept this technique as a practical fabrication application in all regions of the country. It is truly a localized application and requires very consistent atmospheric humidity.

Vacuum-Pressing

Vacuum-pressing is an old technique that has just recently been discovered by the woodworking industry (Illus. 7–16). Vacuum presses suck or remove the air inside their bags and take in atmospheric air to produce pressure. It is possible to generate up to 1,764 pounds of pressure per square foot at near sea level. The higher the altitude, the less pressure used. These systems are becoming more easily available, and they certainly cost less than a shop full of clamps. Vacuum presses can press flat and/or irregular surfaces by applying total pressure throughout the entire piece being pressed (Illus. 7–17).

Laminates can be bent in a vacuum press to larger radii, to produce, for example, column wraps or larger rounded edge details. Any irregular shape that is to be bent out of laminate can also be produced in a vacuum press. Standard-, vertical-, and postforming-grade laminates can all be used. As an

Common Postforming Problems

PROBLEM	CORRECTION
A. Cracking or crazing due to insufficient heat.	A. Increase the temperature or rate of heat.
B. Cracking or crazing due to improper heater position.	B. Adjust heater to focus on bend area.
C. Cores with irregular radii.	C. Sand core.
D. Cores that were poorly machined.	D. Check cutter alignment.
E. Cold cores.	E. Store cores at at least 65 degrees Fahrenheit.
F. Contaminated or dusty cores.	F. Clean cores prior to forming.
G. Cores with radii too tight.	G. Increase the radii of cores.
H. Poorly aligned equipment.	H. Align equipment.
I. Dirty equipment.	I. Clean equipment.
J. Wrong grade of laminate.	J. Use proper grade of laminate.
K. Dry laminate.	K. Humidify storage area.
L. Blister formed by too much heat.	L. Reduce heat.
M. Glue-line delamination because there was insufficient heat to soften laminate.	M. Increase heat.
N. Glue-line delamination due to too much heat.	N. Reduce heat.
O. Glue-line delamination because the core radius is too tight.	O. Increase the radius of the core.
P. Glue-line delamination because the equipment is poorly aligned.	P. Align equipment.
Q. Glue-line delamination because there is insufficient adhesive.	Q. Increase the spread rate of the adhesive.
R. Glue-line delamination because of insufficient drying time in oven.	R. Increase the drying time or oven temperature.
S. Gloss change because of too much heat.	S. Reduce heat.
T. "Spongy" edge on glue line because too much adhesive is used.	T. Reduce the amount of adhesive on the edge.

Table 7–1.

Illus. 7–16. Vacuum-pressing systems today have helped small-shop owners to affordably resolve large clamping needs.
(*Photo courtesy of Vacuum Pressing Systems, Inc.*)

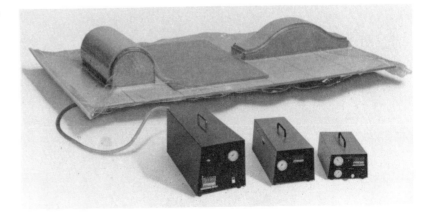

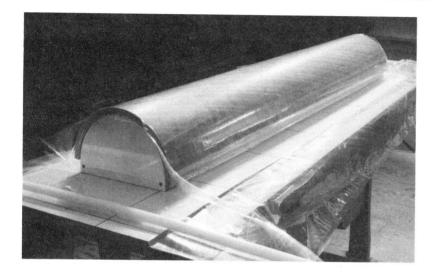

Illus. 7–17. Laminates can be bent to a variety of shapes in a vacuum press. (Photo courtesy of Vacuum Pressing Systems, Inc.)

example, standard-grade laminate will bend to a 9-inch radius without heat. In a vacuum press, it is possible to bend long lengths of material to radii as tight as 3 inches. This method will *not* require heat, and allows almost any glue to be used since there is a consistent holding pressure.

To bend laminate in a vacuum press will require a bending fixture custom-made for the bend and a curved mould or core board (see glossary) that can either be purchased ahead of time or actually made in the press. This core board will be the same as the flat substrate used on typical laminate applications; the laminate will be glued on it. Once the fixture and core are made and cleaned up, the laminate can be cut to size, approximately ½ inch larger than the core stock per side. The best glue to use will be white, yellow, urea-formaldehyde, or epoxy. There will need to be some type of a protective board to go between the laminate and bag, to protect the bag from the sharp laminate edges. After all the components are cut and prepared, the glue can be applied and the laminate can be placed over the core on the fixture, with a protective cover over the entire project. The bag can be sealed up and the press turned on. Within a matter of seconds, the bend will be completed and ready for curing.

Working with Through-Color Laminates

Through-color laminates (Illus. 8–1) were developed in the early 1980's, and have found a niche in the upper-end design market. It is possible to stack several layers together, thus creating many color variations; also, the material can be torn just like a piece of paper to give a contemporary look. Through-color laminates make good edge accents and can be used with laminate, wood, metal, and solid surfacing. They have many of the same characteristics of regular laminate except that the color extends completely throughout the laminate. This will help eliminate the dark edge line that is often visible with regular laminates. Since there is no brown line, the edges appear more monolithic in appearance. Through-color laminates are only offered in solid colors—patterns or textures are not available. Mat and high-gloss finishes are both offered.

There are some specific rules that apply to working with through-color laminates. Since the material is basically a melamine resin throughout, it is very brittle. This type of laminate expands and contracts more than regular laminate, and will require special attention when you are selecting a substrate and determining the type of glue to use. The following sections contain information on fabricating through-color laminates.

STORAGE AND HANDLING

Through-color laminates can be handled and stored the same as regular laminates. Upon receiving new material, it would be wise to inspect the sheet for damage and to determine that its color matches the substrate before using it.

Illus. 8–1. Through-color laminates can be "torn" to create three-dimensional effects.
(Photo courtesy of Formica.)

Sheets should be stored in a horizontal position, with their good face down. If the material is to be stored vertically, it should have a protective board on both sides that is clamped tightly to the laminate. The material should never be stored directly on the floor near the outside wall and should not be allowed to get wet.

Preconditioning should take place 48 hours prior to any fabrication of all components that will be used. Air should be allowed to circulate around the material during this period.

Full sheets should be carried in a vertical position, and it is recommended that at least two people carry a full sheet. Since through-color laminate material is so brittle, special care will be necessary when moving from area to area. This material comes with a protective plastic cover on its good face that should be left on until after fabrication. Avoid sliding and striking this material; once the surface is damaged, there is no way to repair it.

AVOIDING STRESS CRACKS

Stress cracks are caused by some type of force, whether internal or external, that is greater in strength than the laminate itself. Typically, these forces result more from changing weather conditions than physical abuse.

Stress cracks are avoidable if you practise proper fabricating techniques and have a working knowledge of how the material will expand and contract. There are many special considerations that must be accounted for during the fabrication process. As always, all the components to be used should be acclimatized. Use 45-pound particleboard or MDF as the substrate. *Do not use plywood, drywall, plaster, concrete, or solid lumber as substrate material.* Never cut inside corners square; leave at least a ⅛-inch radius, to help prevent radial cracking (Illus. 8–3). Use rigid glue bonds at all edges and corners (Illus. 8–4). Think about seam placement; try to avoid placing seams inside corners and near cutouts (Illus. 8–5).

BALANCING A PANEL

Balancing a panel will help the panel maintain a flat position during periods of expansion and contraction. To determine if the panel should be balanced, you must first determine whether the panel will be mechanically held in place or whether it will be able to move without restriction. If the panel is to be mechanically held, there is no need for a balancing or backing piece of material. However, if the project is not held in place mechanically, there will have to be a backing or balancing force.

It is possible to back through-color laminates with regular laminate backing sheets. If the back is visible, then it is possible to back through-color laminates with the same color used for standard laminates. For optimum balancing protection, the same grade of through-color laminate should be used on *both* sides. Remember to use the same adhesive on both surfaces and to line up the sanding marks on both laminates in the same direction.

Illus. 8–2. Always allow your material to acclimate properly.
(Drawing courtesy of Wilsonart.)

Illus. 8–3. All surfacing materials, including through-color laminates, must always be cut with radiuses and not have square corners. (Photo courtesy of Formica.)

Figure A Figure B

Figure C

Illus. 8–4. All corners should have a rigid glue bond, to ensure that stress cracks will be minimized. Figure A shows the area that has been taped off during the spraying of contact adhesive on both surfaces. This area will get white glue. As Figure B shows, after the contact adhesive has been sprayed on, the tape can be removed and white glue applied to the area that was not covered by contact adhesive. The white glue should be applied to the substrate only. After the laminate is installed, a clamp and caul board should be applied for at least two hours. This is shown in Figure C. (Photo courtesy of Formica.)

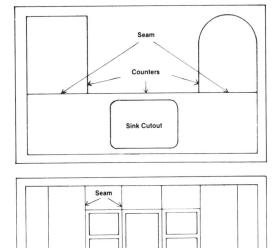

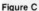

Illus. 8–5. Always place seams in areas where cutouts can be avoided. (Drawing courtesy of Formica.)

SUBSTRATES OR CORE MATERIAL

The choice substrate is industrial-grade particleboard or MDF. Other materials such as plywood are *not* recommended because of differences in expansion and contraction rates. The substrates should be at least ¼ inch thick. Make sure that all surfaces are flat, clean, and free from surface irregularities before fabricating.

CUTTING AND ROUTING THROUGH-COLOR LAMINATES

The same saws and routers that are used to cut regular laminates can be used with through-color laminates.

When using a table saw, cut the material faceup and make sure that the sheet lies flat on the table surface as the material is passed by the blade. The blade should extend above the surface by no more than ½ inch. If the blade is too low, then chipping will occur on the underside of the material.

When working with through-color laminates, you can use routers to perform almost all detail and hand work necessary. The only recommendation is that carbide bits be used that have guide bearings.

It is possible to slit through-color laminates on power-fed slitters with special lower blade spacers.

PREPARATION AND ASSEMBLY

It is best to double-cut through-color laminate to ensure a good mechanical fit. This will also ensure that the glue line will be virtually unnoticeable. (Double cutting is first cutting the material oversize on the table saw and then using a router or jointer to exact-cut the material. This will give you a much better edge for jointing.)

All edges should be applied first. The edges should be cut approximately ¼ inch oversized to avoid cracking during application, handling, and machining. It is best to use white or yellow glue to hold all edges in place. When using a router, it is best to slow up at the end of the cut and corners to allow the cutter to do the job without chipping the laminate.

After the edge is on, rout the overhang flush to the substrate and finish with a hand file or sanding block that is held flat against the substrate. *Do not use a belt sander.*

When cutting the top surface sheet, allow a ¼-inch overhang for "play" during the final process. The application of this top sheet is explained in the section on adhesives below.

ADHESIVES

There are two types of adhesive that should be used to bond through-color laminates to the substrates: contact adhesives and PVA's (polyvinyl acetates); these are also referred to as white or yellow glues. In order to create a rigid glue bond, PVA glue is recommended around all edges. Contact adhesive is used in the middle portion of the panel, but because it is so weak and has such a noticeable glue line it is not recommended for edge applications—no matter what color the contact adhesive is.

This combination of adhesives will create a rigid bond. Rigid bonds around the perimeter will help control expansion and contraction of the edges and prevent hairline cracks from developing. Rigid bonds also allow a thin, strong glue that is almost invisible to form between the different pieces of material. Following are the steps used to achieve the least apparent glue line with the strongest-edge glue bond:

1. Prepare and cut the substrate to the desired shape.
2. Apply the through-color laminate edge strip to the front edge of all exposed sides. This edge piece should be applied with white or yellow glue. The edge piece can be held in place with masking tape until the glue dries (Illus. 8–6). Once the glue has cured, trim and make all surfaces flush.
3. With masking tape, mask off approximately 1½-inch-wide strips around all the edges of the substrate. Do the same procedure on the back surface of the through-color laminate—in the same corresponding area. When all the proper areas are covered with tape, spray or roll contact adhesive over the entire surface. Follow the adhesive manufacturer's recommendations for coverage.
4. Peel off the masking tape from both surfaces and allow the contact adhesive to dry. If the masking tape has left a residue of glue on the edge, it should be cleaned off with solvent prior to the next step. *Use any solvent sparingly and allow it to evaporate completely before proceeding.*

Illus. 8–6. Tape can be used to hold any edge in place until the glue dries.

5. Spread a light coat of white or yellow glue on the previously masked area of the substrate.
6. Position the through-color laminate over the substrate. Once the material is located in the proper spot, allow contact between the through-color laminate and the substrate. Use a J-roller on all the areas where contact adhesive was applied. Clamp with a caulboard the areas where white or yellow glue was applied; this helps protect the surface and distribute the pressure evenly. Clean off any glue squeezeout.
7. After the glue has dried, remove the clamps and trim as you would for a regular laminate project.

EDGE APPLICATIONS

Since through-color laminates are ¹⁄₁₆ inch thick and are the same color throughout, it is possible to rout a ⅛-inch radius on the edge to give the edge a very attractive look. A 10-degree-bevel edge can be used to produce a chamfered look that will eliminate the need to hand-file.

A pinstripe edge (Illus. 8–7 and 8–8) can be created by combining two or more colors of laminate on the edge. If you intend to "stack" different layers, it will be necessary to rough up the face surface to allow adhesion. One-hundred-grit abrasive paper is recommended. There are through-color laminates that are sold in strips that are

Illus. 8–7. Pinstripes can add interesting contrasts to the edges. (Photo courtesy of Wilsonart.)

Illus. 8–8. It is also possible to inlay pinstripes into corners. (Photo courtesy of Wilsonart.)

presanded on both sides specifically for this application. A clear epoxy adhesive is recommended instead of white and yellow glues. Make up a test sample before tackling the entire edge. Once the edge "buildup" is completed, the edge strip can be applied to the substrate in the normal fashion.

After the top surface is applied, rout the desired profile to expose the pinstripe edge.

Wood edges are probably the easiest and most forgiving of all edges used with through-color laminates. There are several different edge possibilities. The best approach is to rabbet the substrate edge and inlay with the wood of choice. Machine the inlaid wood edge flush with the substrate and the remaining particleboard front edge. Overlay through-colored laminate on the front edge and top surface of the inlaid wood. Then rout through the edge with the desired profile of router bit, exposing the underneath wood inlay (Illus. 8–9 and 8–10).

Illus. 8–9. A wooden strip can be rabbeted into the top substrate, machined flush, overlaid with laminate, and then decoratively routed. (Photo courtesy of Formica.)

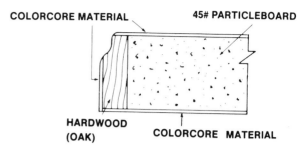

COLORCORE MATERIAL 45# PARTICLEBOARD

HARDWOOD (OAK) COLORCORE MATERIAL

Illus. 8–10. A wood edge can also be glued on the entire front of the substrate, overlaid with laminate, and then decoratively routed. (Photo courtesy of Formica.)

CHAPTER 9

Cabinet Refacing

Cabinet refacing refers to the application of plastic laminates to the face-frame door and drawer fronts of kitchen cabinets or other stationary cabinets in a home or commercial establishment. The act of refacing may also include application of plastic laminate over surfaces which already have a laminated surface. All of these situations present unique challenges for the laminator. In fact, most fabricators who do cabinet refacing specialize in this area.

Refacing has become popular because the cost of installing new cabinets is far more expensive than applying a layer of plastic laminate to the existing cabinets. In most cases, older cabinets just need exterior work. The interior of the cabinets is usually still in good shape. Using plastic laminates to improve the cabinets would also cost about the same amount as refinishing the cabinets onsite.

One problem that occurs when cabinets are being refaced is that the refacing is done in a home or business while people are living or working there. It is difficult to work in an area where people are moving about. For this reason, refacing is often done after work hours in businesses. In the home, the kitchen cabinets are generally those refaced, so the kitchen is usually off limits to the residents until the work is complete. Most professional fabricators prefer to do this work when the owners are on vacation.

Much dust, dirt, and fumes are produced during the refacing of the cabinets. Keeping the work area clean is very important. Drop cloths should be used to cover appliances and other objects in your work area. Be aware of gas connections and pilot lights. Gas leaks could be hazardous, and pilot lights are a potential ignition source. Any flammable glue could be ignited by a pilot light. *Be sure to extinguish all pilot lights and shut off the gas before you start any job.*

As you survey the job, divide it into two parts: the counter and cabinets. Counters can be laminated if they are straight slabs without a form. Counters with a formed drip edge or backsplash cannot be relaminated onsite.

Flat-slab counters can be relaminated easily, but do the following before proceeding with the laminating: First, remove any appliance, sink, or other object from the counter. They are usually held in position with clips. These clips are visible from the underside of the counter. Be sure to shut off water, gas, and electricity before disconnecting anything. Second, check for any loose or delaminated spots. Also check the substrate. For example, water damage could affect the glue bond and the substrate. If the substrate is damaged, it may be best to remove the countertop and replace it with a new one. If all the surfaces are tightly bonded, proceed to the next step.

If the edge is not bonded well or is broken, it should be removed. The surface laminate can then be trimmed with a laminate trimmer. Sand the edge using a sanding block and 80-grit abrasive. Once sanded, the edge can be relaminated.

If all surfaces are still glued in place, then they are ready to be sanded. Use 80- or 100-grit abrasive. Be sure to fill any holes with a good grade of wood filler. Use an orbital, belt, or random-orbit sander. Make sure that all surfaces are sanded completely. This includes inside corners. Remove all dust with a cloth soaked with alcohol.

Begin taking dimensions for your laminate parts; also determine laminating sequence. Certain surfaces such as edges are laminated before the counter. The counter would be laminated before the backsplash. Planning the sequence of lamination allows you to number the pieces so that they are installed in their correct order. If possible, these parts could be cut in the shop rather than onsite. This reduces the dirt and debris in the home or business. It may be necessary to cut parts to their proper widths in the shop and then cut the parts to length on the job.

Before applying contact adhesive to any surface, mask any area the adhesive could damage and make sure that all pilot lights or sources of ignition are extinguished. This includes areas where there is carpeting or other flooring, finished wood surfaces, and walls.

Now, glue and mount only the number-one parts. Avoid gluing anything that would be in the number-two gluing sequence. These parts would attract dust and debris from the trimming of the number-one parts.

It is a good idea to clean up after every trimming operation. This reduces the amount of dust and debris that can contaminate the glued surfaces.

Contaminating glued surfaces will ruin any laminating job. Be sure to brush everything before applying contact adhesive. Look over all surfaces. Any amount of contamination is too much. Be sure to keep your contact adhesive supply clean as well. Any contamination in the contact adhesive is certain to be transferred to the laminate. Keep the amount of contact adhesive in the tray to a minimum and do not hesitate to discard it if there is a chance that it has been contaminated. The cost of doing the job over far exceeds the cost of a few ounces of contact cement.

Apply and trim the laminate using the procedures outlined in this book. Clean up the area well and replace any appliances in the counter cutouts. Reconnect the plumbing and electricity or have licensed plumbers and electricians perform these operations. Relight any pilot lights only after the fumes from any flammable glues or solvents have been evacuated.

If you are refacing any type of cabinetry, your first job is to look over the cabinets carefully. Surfaces must be flat to be laminated (Illus. 9–1). A radius or offset joint will require special treatment. Check the

Illus. 9–1. Use a laminate trimmer to cut the faceplate flush with the side.

way the joints intersect across the faceplate. If you change this style, you change the look of the cabinets. It is a good idea to make a sketch of these joints. Remember to be consistent; the joints on both walls should have the same orientation. If the joints do not intersect the same way from one wall to another, the job will look unprofessional.

Look over the doors to determine if they can be laminated. Solid-wood and raised-panel doors cannot be laminated easily. The solid wood expands and contracts too much, and the angles of a raised-panel door make laminate trimming almost impossible. Use some form of sheet-stock substrate when laminating these doors and drawer fronts.

Most of the prepatory work can be done in the shop rather than on-site. Stock can be cut to rough lengths and widths, and all doors and drawers can be laminated in the shop. The surfaces must be prepared carefully before the laminate is applied. Sand all finished surfaces with 80- or 100-grit abrasives (Illus. 9–2). This will break the glaze of the finish or any oil or material on the door or drawer fronts. Remove any dust with a tack rag before proceeding (Illus. 9–3–9–7).

Doors and drawer fronts are square slabs which are laminated on all edges and at least one face. It is best to laminate both faces, but if the faces have been previously laminated, then a second piece of

laminate is not necessary on the back face. Laminating all surfaces reduces the chance of warping.

If you make new doors or drawer fronts, you can cut slabs out of sheet stock which has been laminated on one face. This will become the back. Begin by applying the strips to the edges. Some laminators do the edges in two stages; that is, they do the sides first and then the top and bottom. This requires two gluing and trimming operations.

Another method allows the edge-banding to be done in one operation. Start by applying the edge band to the left edge of the blank. Align the end flush with the top edge and use a roller on the piece. Next, butt the bottom strip to the laminate, extending beyond the end on the left side, and use a roller on it. The right strip is butted to the strip extending beyond the bottom. Use a roller on it. Next, position the top and use a roller on it. All edges can now be trimmed. After trimming and sanding the edges, glue the laminate face in place.

There is some disagreement among experts as to the laminating sequence to use on doors and drawer fronts. They agree that it is important that the joints are positioned to preserve their watertight integrity, and so should be away from areas where spills are likely, generally along the edges. Some experts, however, feel this may compromise the appearance of the cabinet. The sequence you choose should fit the job you are doing. Compare the appearance of the project from the front to the amount of spills along its edges, and then laminate accordingly.

When working cabinet doors and drawer fronts in the home or business, be sure to follow the same precautions outlined for relaminating the countertop. Mask areas which are not to be laminated. Keep dust out of adjacent areas by covering doors with tarps. Keep the area clean as you work. This will eliminate any imperfections in the laminate job.

It is a good practice to number the parts in a gluing sequence. This allows you to apply the parts in the appropriate sequence. In some cases, the strips must be positioned perfectly. This is because other pieces must join to them squarely to give the appearance of a wood joint. Pieces which join to appear as a wood joint must be cut carefully and accurately. These parts can be rough-cut with a table or radial arm saw and then cleaned up with a router or laminate trimmer if necessary.

There are specialty tools such as the Betterly Underscribe and the Betterly Seaming Router that can improve the quality of the joint you cut. After the first piece is glued in position, position the

Illus. 9–2. Sand all finished surfaces with 80- or 100-grit abrasives. This will improve the bond between the laminate and cabinet.

Illus. 9–3. Attach the side to the cabinet and use a roller on the surface to get a good bond.

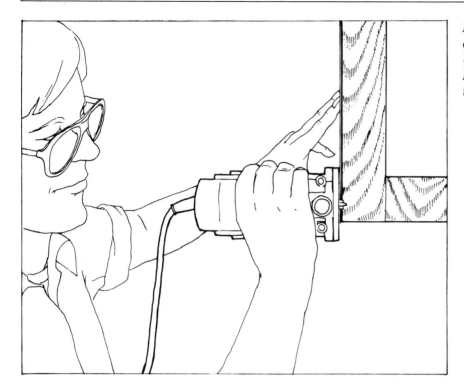

Illus. 9–4. Trim the laminate even with the face frame. Use a ball-bearing pilot-tip laminate-trimming bit for this job.

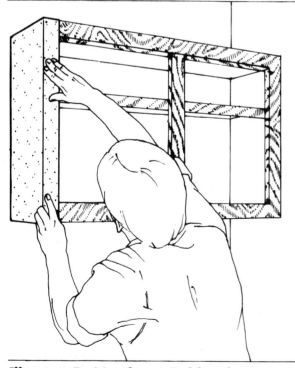

Illus. 9–5. Position the vertical face-frame pieces and attach them to the cabinet. Use a roller on the laminate, to ensure a good bond.

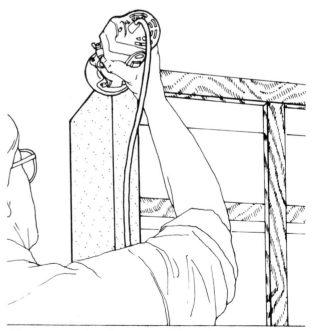

Illus. 9–6. Trim the vertical face-frame pieces. Work carefully; do not rock the laminate trimmer. This could damage the laminate on the cabinet side.

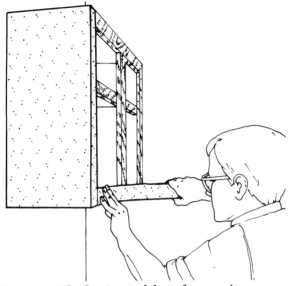

Illus. 9–7. The horizontal face-frame pieces can now be positioned, rolled, and trimmed. The next step is laminating the door and drawer fronts.

second piece, which has been cut oversized, and glue it in place. The underscribe is then used to trim off the excess. The base of the trimming underscribe rides along the edge of the laminate beneath the one being trimmed. The bit is positioned to shave away the precise amount of laminate to ensure a good fit. The chips are deflected above the joint so that the parts fit together well. Be sure to roll the laminate on the face frame to ensure a good bond between the

parts. You can also cut parts to size using a shear. For some applications, this approach will work well. If you cut the parts to size, be sure to mark each piece so that it is positioned correctly after the contact adhesive is applied to the part and face frame. Position the piece carefully, because if it is misaligned the job must be done over. Precise alignment is important; registration or alignment marks may help you position the piece correctly.

Continue gluing the laminates into position until all parts have been placed. Use a roller on all pieces of laminate, to ensure a good bond. Be careful to keep the roller on the face frame. If you go off the frame with the roller, you could break the laminate.

Check the cabinets to see if any trimming is necessary. Use a laminate trimmer to remove the excess. The cabinets are now ready for filing. Be sure to file towards the workpiece. Filing away from the workpiece could cause the laminate to break away from the cabinet. Clean up any excess contact adhesive using lacquer thinner or other recommended solvent. Remove all drop cloths, masking tape, and other protective material.

You can now replace the doors and drawers. Work carefully and position the doors and drawers accurately. Any error in the positioning could mean that a hole was drilled in the wrong position. Repairing the hole in the laminated surface is not easily done. Straightedges or other guides can be clamped to the cabinet face frame to ensure accurate alignment.

Preventing and Repairing Defects in Plastic Laminates

Working with plastic laminates is very rewarding. Your projects will be more durable, require less maintenance, and can be made in a variety of colors, patterns, and textures. However, even the best-made projects have the potential for some type of problem after assembly or delivery (Illus. 10–1). The following sections describe problems that can arise after laminates have been fabricated and possible ways to prevent these problems.

CRACKING OF THE LAMINATE

It is possible for laminate to crack (Illus. 10–2) if a corner has been cut or filed square, so avoid square corners. Always have some radius to an inside cut. As always, improper conditioning, bonding, and poor planning will probably be contributing failure factors. Cracks are caused by stress generated in the laminate either by dimensional change or by physical stress (Illus. 10–3). *Never force laminate to fit in a tight space* (Illus. 10–4).

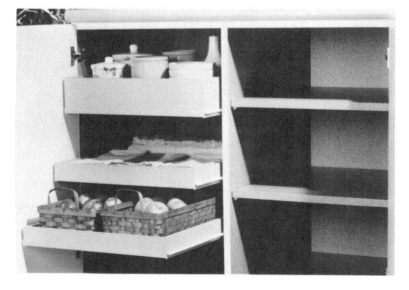

Illus. 10–1. After the cabinet or counter is made and installed, there will always be the potential for problems. (Photo courtesy of Formica.)

Illus. 10–3. Stress cracks, either caused by dimensional change or by physical stress. (Drawing courtesy of NEMA.)

Illus. 10–2. The laminate surface can crack if design and expansion/contraction factors have not been factored into the fabrication process. (Drawing courtesy of NEMA.)

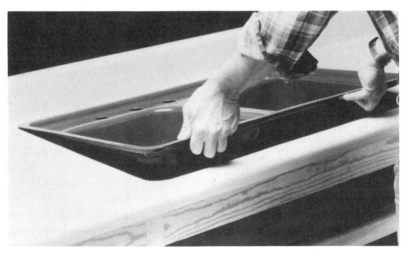

Illus. 10–4. In order to prevent this sink cutout from cracking, the corners have been cut with a slight radius. (Photo courtesy of Wilsonart.)

OPENING OF JOINTS OR SEAMS

Proper conditioning and bonding techniques will help eliminate most openings of joints or seams (Illus. 10–5). Remember to allow for expansion and contraction of the laminate and substrate.

SEPARATION OF THE LAMINATE FROM THE SUBSTRATE

Typically, if the laminate separates from the sub-strate it means that there was a poor glue bond. Something probably happened during the gluing process. Improper conditioning, dirt, wax, glue spread, solvent on the surface, pressure, and moisture could all play a part in the failure of a laminate bond. It is imperative that the instructions on the label of the adhesive be followed exactly. One saving attribute of contact adhesive is that you can heat and reroll it to reactivate the bond.

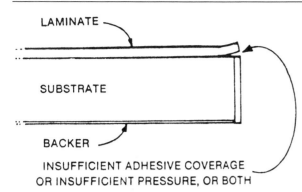

Illus. 10–5. Proper bonding and conditioning techniques will help prevent laminate from opening at the joints or seams. (Drawing courtesy of NEMA.)

BLISTERING OR BUBBLING OF THE LAMINATE

This problem (Illus. 10–6) could be caused by many things. If the bond has failed, then the laminate could pull away; this causes an air pocket under the laminate surface. This can possibly be solved by heating the area and rerolling the laminate to make a new bond. Remember that conditioning is always a potential factor in laminate failure.

Illus. 10–6. Blisters are caused by contact adhesive failure or heat. (Drawing courtesy of NEMA.)

Blistering can also occur because of continual exposure to heat. If a toaster has been set in the same spot for years, and is used every day, chances are that the exposure to heat might cause the contact adhesive to lose its strength. The rule is that laminated surfaces should not be exposed to temperatures over 150 degrees Fahrenheit (66 degrees Celsius) for more than five minutes at a time (Illus. 10–7).

Illus. 10–7. Laminate surfaces should not be exposed to temperatures over 150 degrees Fahrenheit (66 degrees Celsius) for more than five minutes at a time. (Drawing courtesy of NEMA.)

Blistering is a problem that can occur during postforming. Chances are slim that a postformed top would ever make it to market with a blister in the formed area.

LAMINATE WARPAGE

Balancing is the greatest factor in ensuring that laminate will hold a flat position (Illus. 10–8). Some ways to avoid panel warpage include preconditioning, using the same laminate on both surfaces, using a thicker core (the thicker the core, the more stable a panel will be), aligning the sanding marks on the top and bottom sheets, and using the same adhesive on both surfaces. Remember that paints and varnishes will not balance high-pressure laminates.

Mechanically fastened work will not have to be

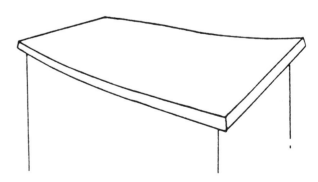

Illus. 10–8. Warp is more than likely the result of improper balancing techniques. (Drawing courtesy of NEMA.)

balanced. In other words, a countertop does not require a backer because it will be screwed to the cabinets. The screws act as the balancing force.

CARE AND MAINTENANCE OF LAMINATES

High-pressure laminates are very resistant to wear, scratches, bumps, mild chemicals, food, alcohol, hot water, and grease. A laminated project will maintain its beauty for many years if you pay attention to the following simple maintenance rules:

1. Wash the laminates regularly with mild soap and water.
2. Avoid washing the laminates with gritty or abrasive liquid cleans and scouring powders.

3. Do not use bleach or any toilet bowel cleaner on the surface.
4. Do not use your counter as a cutting board.
5. Set hot pans on a hot pad or trivet instead of on the laminate.
6. Do not iron on your countertop.
7. Avoid all harsh chemicals. If they come in contact with the laminated surface, an immediate washing is recommended. Do not allow these chemicals to have a long exposure time on the surface of the laminate.
8. Use lemon oil or a commercial countertop product to help periodically restore the beauty of the laminate.

CHAPTER 11

Projects

There are many small projects that lend themselves to laminate work. As you look over these projects in this chapter, choose those you feel will help you develop your skills. Be sure to review the plans and drawings carefully before you begin. Make auxiliary drawings if you think they will make construction easier.

Develop a bill of materials and plan of procedure to simplify construction. A bill of materials lists all the parts and their finished sizes. This list helps you cut parts at the saw. The plan of procedure is an outline of the steps it will take to complete the project. A plan of procedure reduces the amount of time it takes to complete the project; it makes it easier to identify and prepare for the next step.

Some of the projects are completely covered with plastic laminate, while others are partially covered with it. There are some projects which require no laminating. These projects, such as the sawing jig that follows, help you work wisely and safely with plastic laminates.

SAWING JIG

A sawing jig can act as a holding device on table saws when you are cutting plastic laminates. Begin by cutting a piece of ¾-inch-thick sheet or solid stock about ¼ inch narrower than the fence of your table saw. It should be about the same length as your metal fence (Illus. 11–1).

Attach a piece of ¼-inch-thick sheet stock to the edge of the ¾-inch-thick piece. The ¼-inch sheet should be equal in length to the ¾-inch piece. The ¼-inch piece should be two inches wider than the strips of plastic laminate you are cutting. You can use screws or nails and glue to hold the two pieces together (Illus. 11–2).

Illus. 11–1. The fence part of the jig is made from ¾-inch stock and is about the same length as the fence on your table saw.

Text continues on page 193

Laminated tables can be made in many shapes and for many different purposes.

This table has long legs and supports a small television.

Vanities and other specialty cabinets are commonly laminated.

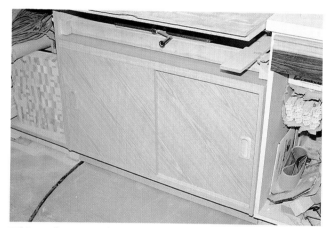

This cabinet is designed to go under a radial arm saw. It was designed to match neighboring cabinets.

The sides and front of the cabinet have been laminated. The front still has to be trimmed.

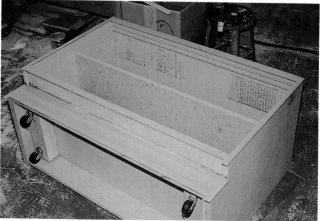

Cut the laminate parts by scoring them with a carbide cutter. After the parts have been rough-cut, they should be trimmed with a router bit.

Right: Position the laminate on a fixed line to make the parts fit correctly. Note the registration arrow for the mating part.

Left: Once the seam has been cleaned up, it will fit tightly and the grain pattern will match perfectly.

Once positioned, the piece can be trimmed and rolled. Rolling before trimming could break this small piece.

Above left: Once the seam has been rolled and trimmed, it is tight and clean. Above right: The next step is to prepare for the hardware. Here a template has been made to guide cutting recesses in the finished door.

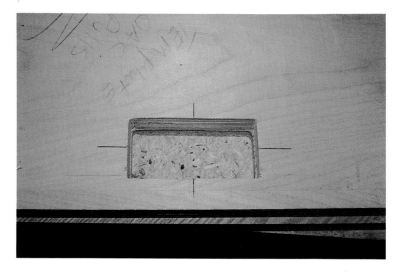

The recess is routed to the desired depth. The recess is slightly smaller than the template. This was accounted for in the design of the template.

The pull fits the opening precisely in the recess. It can be glued in position and stained and finished.

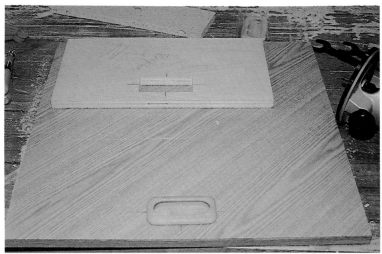

Illus. 11–2. Attach a piece of ¼-inch-thick stock to the edge of the fence. Use glue and metal fasteners.

Next, make the barrier guard out of two pieces of ¾-inch-thick sheet or solid stock. These pieces should each be about eight inches long. The fence strip should be about one inch narrower than the width of the fence. The guard strip should be wide enough to cover the blade when plastic-laminate strips are cut. Add about one inch to the width of the strips and cut the workpiece to that width. Set the fence strip on top of the guard strip and align it with the edge (Illus. 11–3). Glue and screw the pieces together.

Screw the barrier guard to the wooden fence piece. Be sure to position it so that it will cover the blade when the laminate is cut. Allow about ⅛-inch clearance between the bottom of the barrier guard and the ¼-inch sheet stock (Illus. 11–4). Plastic laminate should slide freely between these two pieces.

To mount the sawing jig to the fence, first position the metal fence to the desired rip plus ¾ inch. This will compensate for the wooden fence on the jig. Mount a laminate-cutting saw blade and lower it beneath the table. Position the jig and screw or clamp it to the fence. Turn on the saw and raise the blade through the ¼-inch base and slightly into the barrier guard (Illus. 11–5). The laminate can now be cut by feeding it into the opening in the jig with the straight edge against the wooden fence. Make all cuts with the jig in position (Illus. 11–6).

Illus. 11–3. Join the fence and guard strips using glue and metal fasteners.

Illus. 11–4. Position the fence strip on the fence with about ⅛-inch clearance between the ¼-inch sheet and the bottom of the guard strip. Make sure that the fence and guard strips are located over the blade's path.

Illus. 11–5. Clamp the sawing guide to the fence and raise the moving blade up through the ¼-inch base and slightly into the guard strip.

Illus. 11–6. Feed the laminate into the saw guide opening. Keep the laminate against the wooden fence as you make the cut.

TABLES

Laminated tables can be made in many shapes and can be used for many purposes (Illus. 11–7). Decide on the length, width, and height of the table (Illus. 11–8). Make a sketch of the table and decide how thick the tabletop and legs must be to support the weight. Design the joinery between the legs and tabletop. Make a detailed drawing to help you decide on dimensions (Illus. 11–9).

Develop a bill of materials using your drawings and sketches. Select appropriate materials for all the parts. Plywood and particleboard are good materials to use for the tabletop. Particleboard will work well as a leg if it is glued into a square comprised of two to four pieces.

Begin cutting the parts. Check the parts off your list as they are cut to size. Begin assembling the parts. Be sure to use glue and metal fasteners. Check the assembly to be sure that all parts are square and assembled correctly.

After the parts are assembled, check to be sure the table does not rock. Trim the legs if necessary. Plan the laminating sequence and number the sur-

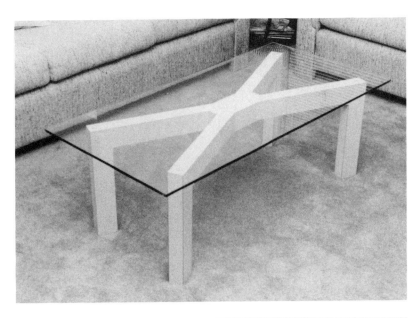

Illus. 11–7. This coffee table is made from plastic laminate. It has clean lines and an interesting shape.

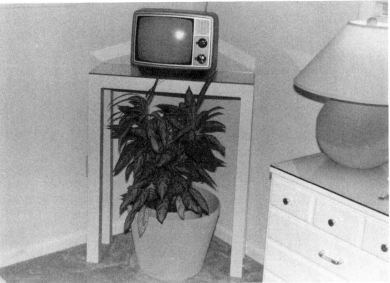

Illus. 11–8. This table has long legs and supports a small television.

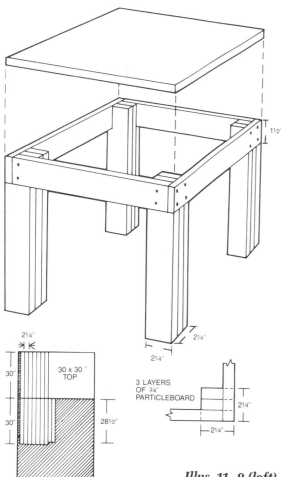

faces according to this. For more information on the gluing sequence, consult Chapter 5.

Develop a bill of materials for the plastic laminates and begin cutting. Keep in mind any pattern that may be in the laminate. You will want the pattern going the long way on all parts. If you are using wood grain, you will also want the pattern going the long way. It is wise to lay out the sheet before doing any cutting. Be sure you can get all the parts out of the sheet before making a cut. Also be sure that you have left an allowance for trimming.

Prepare the surfaces and begin the laminating and trimming process. Review these procedures in Chapter 5 and 6 before you begin.

VANITIES AND OTHER CABINETS

Vanities (Illus. 11–10 and 11–11) and other specialty cabinets are commonly laminated. The actual construction of the cabinet (Illus. 11–12) depends on its location and function. Many fine cabinet-making books will provide you with dimensions of vanities used for specific purposes.

The laminating sequence may dictate that some laminating be done before assembly. It is much easier to laminate internal parts before assembly.

Illus. 11–9 (left). Make a detailed drawing of the table you plan to build. (Drawing courtesy of Formica).

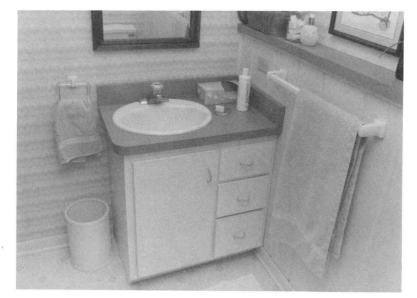

Illus. 11–10. This vanity and countertop were shop-built to fit a space in a remodelled bath. The sink bowl was cut into the laminated top.

Illus. 11–11. This vanity has standard dimensions. (Drawing courtesy of Formica.)

Illus. 11–12 (below). Use the dimensions here to build a vanity. If you decide to make it smaller or larger, you can modify the drawing, but the height and depth are standard. (Drawing courtesy of Formica.)

TOP AND BACKSPLASH LAMINATE

END RETURN. ¾ x 4 x 22¼"

BACKSPLASH. ¾ x 4 x 42"

4"

ASSEMBLE VANITY USING WHITE GLUE AND WELL—SET 6d FINISHING NAILS. FILL SET NAILS.

TOP. ¾ x 23 x 42"

¾ x ¾ x 42"

¾ x ¾ x 22¼"

1¼" x NO. 8 FH SCREW

¾ x 4 x 12"

SIDE—MOUNT DRAWER HARDBOARD

FALSE DRAWER FRONT

3½" x NO. 8 FH SCREW THROUGH CLEAT AND BACK AND INTO WALL STUD

¾ x 1¼" GRIP MOULDING

BACK ¼ x 26¼ x 40½"

DRAWER BOTTOM ¼" HARDBOARD

¼" x ⅜" EDGE RABBET

¾ x 4 x 26 x ⅞"

22"

Side ¾ x 22 x 30" (2 REQU.)

SHELF. ¾ X 12 X 21¾"

MAGNETIC CATCH

SHELF CLEAT. ¾ x ¾ x 21¾" (2 REQUIRED)

BOTTOM ¾ x 21 x ¾ x 40½"

SIDE

3½"

CENTER PARTITION. ¾ x 21¾ x 26"

DRAWER (OF ¾" STOCK)

TOE KICK. ¾ X 3½ x 41¼"

4½"

⅜ X ¾" DADO

FRONT

Working inside a cabinet is awkward. It is much more difficult to get tight-fitting joints and seams. It is also important to protect laminated surfaces during assembly. Careless handling could damage the laminated surfaces.

Laminating to the face frame will be slow, since there are many edges to laminate. In most cases, inner edges of drawer openings are not laminated. This is because they are not visible once the drawer is installed.

The process for laminating door and drawer parts is discussed in Chapter Nine, "Cabinet Refacing." Study this chapter before laminating door and drawer fronts.

Specialty cabinets such as display and trophy cases (Illus. 11–13 and 11–14) add many challenges to the laminating project. There could be specialty hardware, glass doors, elevating mechanisms, lighting, and wood accents (Illus. 11–15). Always consider these features in the design stage of the cabi-

Illus. 11–13. This shop-built trophy case is ready for glass shelves and doors. Install hardware carefully.

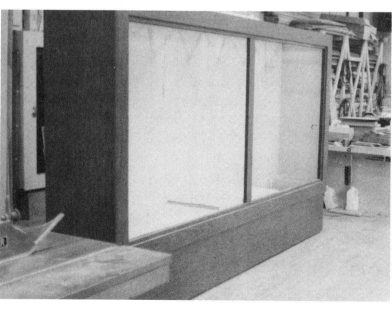

Illus. 11–14. Transporting this case required professional movers. Damaging the case could mean expensive repairs.

Illus. 11–15. Many specialty cabinets also require drawers. Wood pulls and plastic laminates have been successfully blended on this drawer front.

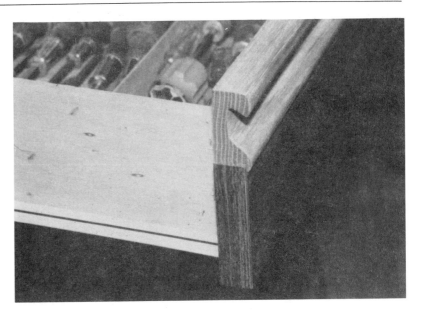

net. Do not forget heat buildup and venting requirements for electric or electronic components.

Work carefully when installing hardware. When you are drilling through plastic laminates, the bit can easily slip and damage surfaces. Always mark the laminate carefully. Use an awl to center the drill bit. When driving screws, work carefully. If the bit slips off, it could scratch the laminated surfaces. Repairs to the surfaces are difficult at this point of construction.

The cabinet shown in Illus. 11–16 is designed to go under a radial arm saw. It is on wheels, so it can be rolled out of the space for cleaning. The cabinet has sliding doors; note how the laminate has been installed at an angle. This was done to make use of some cutoffs scraps of laminate.

Begin by building the carcass out of sheet stock such as particleboard. Make sure the size is correct for the space you have planned for it. Use glue and screws to assemble the parts. Sand and smooth the joints so laminate can be applied.

Apply the laminate to the sides, and then to the

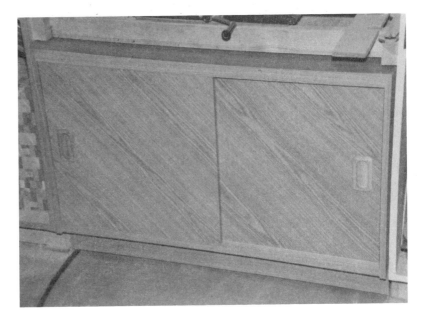

Illus. 11–16. This roll-around cabinet was designed to match neighboring cabinets. It is positioned under the radial arm saw.

front (Illus. 11–17). Note how the laminate was bonded to the door tracks. After laminating and trimming the cabinet, you can start the doors.

Cut the doors to size. Remember to allow for the laminate you will be adding to the edges of the door blank. Apply the laminate to the door edges and trim them. Now you can laminate the door faces.

Cut the laminate parts to rough size (Illus 11–18 and 11–19). The grain angle established in the pattern means that parts must be bonded to a specific point on the blank (Illus. 11–20). The grain must match and the seam must be tight (Illus. 11–21).

All pieces must have smooth edges and matching grain (Illus. 11–22 and 11–23), or the piece could have a mismatched grain or gap. After you have trimmed the piece, its face should look like a single piece of laminate with no seams (Illus. 11–24).

Hardware considerations are next. In this case, a template has been made to guide cutting recesses in the finished door (Illus. 11–25). The template is

Illus. 11–17. The sides and front of the cabinet have been laminated. The front still needs to be trimmed.

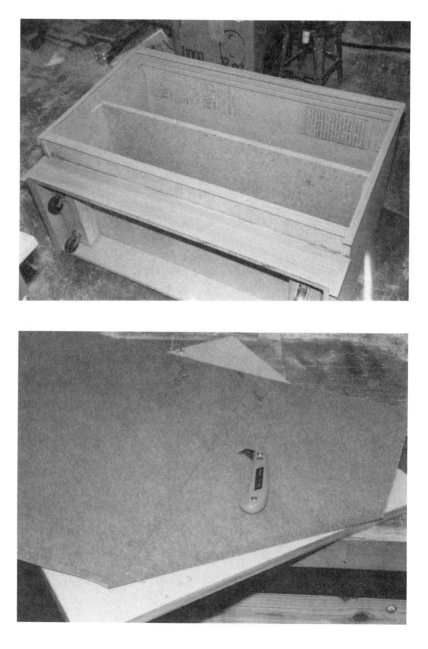

Illus. 11–18. The laminate parts were cut by scoring them with a carbide cutter.

Illus. 11–19. Any joint will have to be trimmed after it has been rough-cut with a router bit.

Illus. 11–20. The laminate must be positioned on a fixed line to make the parts fit correctly. Note the registration arrow for the mating part.

Illus. 11–21. Once cleaned up, the seam fits tightly and the grain pattern is a perfect match.

Illus. 11–22. This small piece will complete lamination of this door. Positioning is important to the grain match.

Illus. 11–23. Once the piece is positioned, you can trim it and use a roller on it. Using a roller on it before trimming it could break this small piece.

Illus. 11–24. The seam is now tight and clean.

positioned on the door and clamped securely (Illus. 11–26). The router bit is set for the correct depth of cut and the opening is cut. The hole is slightly smaller than the template. This is because a fol-

lower guide was used. This offsets the bit (Illus. 11–27). The wooden pull is then fitted to the opening and glued in place (Illus. 11–28).

Illus. 11–25. This template has been sized to accommodate the router bit and follower guide used to cut the openings for the recessed pulls.

Illus. 11–26. The template is located and clamped in position.

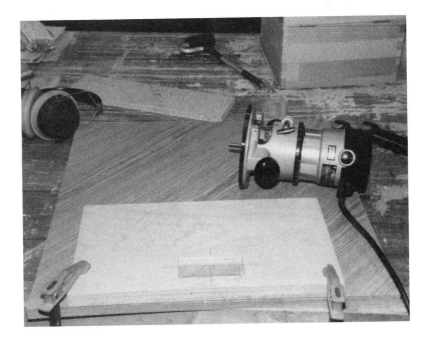

Illus. 11–27. The recess is routed to the desired depth. The recess is slightly smaller than the template. This was accounted for in the design of the template.

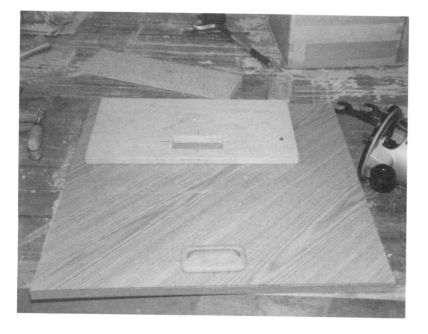

Illus. 11–28. The pull fits the opening precisely in the recess. It can be glued in position, stained, and finished.

PLANTER

The planter shown in Illus. 11–29 has a butcher-block look due to the laminate selection. You could change the look by selecting some other type of laminate. You can use the dimensions provided in Illus. 11–30 or you can adjust them to suit your needs.

For best results, cut the hole for the flowerpot before laminating. That way you can laminate the top and then cut away the plastic laminate to a perfect fit around the opening.

Illus. 11–29. This planter has a butcher-block look because of the laminate chosen to cover it, but you could create other looks by selecting other types of laminate. (Drawing courtesy of Formica.)

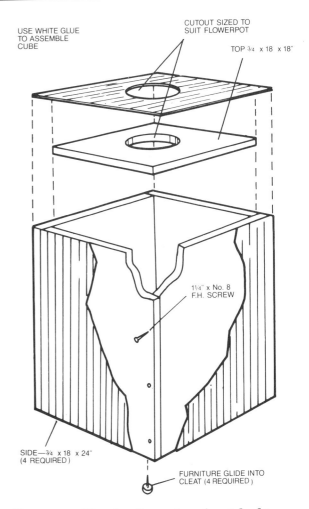

USE WHITE GLUE TO ASSEMBLE CUBE

CUTOUT SIZED TO SUIT FLOWERPOT

TOP ¾ x 18 x 18″

1¼″ x No. 8 F.H. SCREW

SIDE—¾ x 18 x 24″ (4 REQUIRED)

FURNITURE GLIDE INTO CLEAT (4 REQUIRED)

Illus. 11–30. Use the dimensions furnished to make your planter, or modify them to suit your needs or material. (Drawing courtesy of Formica.)

Appendices

Glossary

Backer Sheet A low-cost, nondecorative laminate that is used on the under side or back of freestanding casework or tables.

Backsplash A vertical surface designed to protect the wall behind a counter.

Balancing The equalization of the forces on both sides of the core material. If these forces are not equalized, the panel may warp.

Buildup Material used to make a ¾-inch-thick counter appear to be 1½ inches thick, to reinforce the countertop, and to provide a place to anchor the blank to the cabinet or mounting brackets.

Cabinet-Liner Laminate A decorative laminate that is intended to be used where it will withstand little wear, such as the insides of cabinets and closets.

Cabinet Refacing The application of plastic laminates to the face-frame door and drawer fronts of kitchen cabinets or other stationary cabinets or over surfaces which already have a laminate surface.

Caulboard A protective barrier between the laminate and the vacuum bag in a vacuum press.

Chemical-Resistant Laminate Laminate intended for applications where acids, corrosive salts, solvents, and other destructive or staining substances are required.

Contact Adhesive A low-viscosity glue that is either solvent- or water-based. This type of glue is the most common adhesive for working with plastic laminate because it requires no clamp-type pressure and is easy to apply.

Cove Splash A splash with laminate that bends between the counter surface and the backsplash. It helps prevent liquids from penetrating to the substrate at the back of the counter.

Curved Mould A mould that has a dimensional shape that a laminate can be applied to.

Cutouts Cuts made in countertops to accommodate sinks, stove tops, cutting boards, and electronic devices.

Edge Band A thin, flat strip bonded to edges of panels as a decorative and protective finish.

Edge Squeeze Roller A rolling tool used to roll over edges and drive the laminate edge into contact with the backing.

Engraving Laminates A new type of laminate that was developed for the sign and name plate industry. These laminates have the same features as general-purpose laminates.

Extension Roller Rolling tools used to roll over large areas of plastic laminate.

Fire-Rated Laminates These laminates—evaluated and certified by code-specifying agencies such as the National Fire Protection Association, the Building Officals Conference of America, and other local, state, and federal code agencies—are used where durability, heat resistance, and resistance to stains from ordinary sources are required. Some examples include elevator panels, stairwells, and doors.

Flooring Laminates These decorative laminates, thicker than general-purpose laminates, are made for surfacing panels used for access or for raised-panel floors.

General-Purpose Laminate This is the most common type of laminate, and can be applied to both vertical and horizontal surfaces where good appearance, durability, and resistance to stains and heat are necessary.

Hand Roller A rolling tool in which one or two hands are used to exert pressure on the laminate to form a good bond between the plastic laminate and the backing.

High-Pressure Decorative Laminate A material formed by "sandwiching" kraft-paper resin backing, a layer of color paper, and a thin protective coat of transparent plastic resin.

High-Wear Laminate A laminate intended for applications where high strength and resistance to impact, water, and humidity are required. It can be applied to horizontal or vertical surfaces and, because of its inherently high strength, may be used as a structural material.

Hot-Rod Forming A postforming technique that consists of heating an aluminum or copper tube to a consistent temperature from one end to the other, and then placing general-grade laminate on the rod at the desired area of bending. Once the laminate is heated to the proper temperature, it will start to bend over the heated rod. This bent laminate will be used for on-site fabrication.

Humidity Water vapor mixed with air. High-pressure laminate, like other wood products, moves with changes in humidity.

J Roller A very common laminate roller used for general rolling tasks.

Laminate Slitter A stationary tool used to separate laminate sheets into smaller parts.

Laminate Trimmers Modifications of routers that are used specifically to cut or slit laminates after installation. They are smaller and usually turn at a faster speed than routers.

Medium-Density Fibreboard (MDF) Man-made composite board that is considered the best substrate for laminate work.

Metal Laminate A type of decorative laminate that has a thin metal face on top of a backer of kraft paper and phenolic resin, and is used exclusively for interior fabrication.

Mica Knife A tool used to scrape the cut laminate into a smooth, finished edge.

Mitring Machine A tool used to cut straight lines at any angle in plastic laminate.

Natural-Wood-Veneer Laminate A decorative laminate that consists of a thin layer of wood veneer bonded to a core of kraft paper under high pressure and heat. It should always be used for interior applications.

Panel Stock Any sheet stock. Many forms of panel stock are used to decorate the walls of a home.

Particleboard Sheet material made from glued wood chips or wood particles pressed into a dense, smooth piece of sheet stock.

Pinch Rollers Stationary tools used specifically for laminate work. Laminated surfaces are sent through the pinch rollers with the laminate side up. The rollers exert pressure on the laminate to ensure a perfect bond of the contact adhesive between the substrate and the laminate.

Plastic Laminate A material formed by bonding kraft paper and plastic resin under heat and pressure. It is used as a decorative material on products such as counters, tables, and panelling.

Plastic Laminate Shear A hand-held device used to cut straight lines in plastic laminate.

Postforming The technique of bending laminate around a core by using heat and applied pressure to create a specific radius or curve.

Power Shear A hand-held tool specifically designed to cut plastic. It may be air- or electric-powered.

Radius A curve on the edge of a blank. The curve may be inside or outside.

Radius Blocks Material attached to the corner of the counter after it has been radiused. Radius blocks are part of the buildup.

Rolling Tools Hand tools used to ensure a good bond between the plastic laminate and the backing.

Scribe Buttons Material used between the counter blank and the wall. Scribe buttons keep the counter spaced from the wall so that little cutting is required to fit, or scribe, it to the wall.

Seam Roller A rolling tool used to ensure a good bond where two pieces of plastic laminate form a seam.

Self-Edge A counter that is custom-made with square or chamfered edges.

Specific-Purpose Laminate A laminate intended for applications where high strength and resistance to impact, water, and humidity are required. It can be applied to either horizontal or vertical surfaces and, because of its inherently high strength, may be used as structural material.

Static-Dissipative Laminate Decorative laminate with a conductive layer on its back that is used to conduct electricity to a specific source. This type of laminate is used for benches and tool tops with electronic displays, around photo equipment, on computer displays, and for other applications.

Substrate The material upon which plastic laminate is bonded.

Tambours Material used either as a fixed decorative surface or as functional closure material that slides in a track or routed groove. Decorative tambours are used to clad walls and wainscoting, to "dress up" residential furniture, and for other interior vertical applications.

Through-Color Laminate Laminate that has color throughout its edges. These laminates can be used to create inlays or stacked layers, and can be sandblasted and sculpted.

T Roller A rolling tool that is used to roll over large areas of plastic laminate.

Universal Laminate Shear A hand-held device used to cut curves and patterns in plastic laminate.

Vacuum-Pressing A postforming technique in which laminates are bent in a vacuum press to smaller radii. Vacuum presses suck out the air inside their concealed bags and use atmospheric pressure to produce clamping force or pressure.

Vertical-Grade Laminate Laminate specifically designed for vertical surfaces. It has one or two fewer layers of kraft paper than standard-grade laminate, and is inherently weaker.

Metric Equivalents

INCHES TO MILLIMETRES AND CENTIMETRES

MM—millimetres *CM—centimetres*

Inches	MM	CM	Inches	CM	Inches	CM
⅛	3	0.3	9	22.9	30	76.2
¼	6	0.6	10	25.4	31	78.7
⅜	10	1.0	11	27.9	32	81.3
½	13	1.3	12	30.5	33	83.8
⅝	16	1.6	13	33.0	34	86.4
¾	19	1.9	14	35.6	35	88.9
⅞	22	2.2	15	38.1	36	91.4
1	25	2.5	16	40.6	37	94.0
1¼	32	3.2	17	43.2	38	96.5
1½	38	3.8	18	45.7	39	99.1
1¾	44	4.4	19	48.3	40	101.6
2	51	5.1	20	50.8	41	104.1
2½	64	6.4	21	53.3	42	106.7
2	76	7.6	22	55.9	43	109.2
3½	89	8.9	23	58.4	44	111.8
4	102	10.2	24	61.0	45	114.3
4½	114	11.4	25	63.5	46	116.8
5	127	12.7	26	66.0	47	119.4
6	152	15.2	27	68.6	48	121.9
7	178	17.8	28	71.1	49	124.5
8	203	20.3	29	73.7	50	127.0

WEIGHTS AND MEASURES

Unit	Abbreviation	Equivalents In Other Units of Same System	Metric Equivalent
Weight			
		Avoirdupois	
ton			
short ton		20 short hundredweight, 2000 pounds	0.907 metric tons
long ton		20 long hundredweight, 2240 pounds	1.016 metric tons
hundredweight	cwt		
short hundredweight		100 pounds, 0.05 short tons	45.359 kilograms
long hundredweight		112 pounds, 0.05 long tons	50.802 kilograms
pound	lb *or* lb av *also* #	16 ounces, 7000 grains	0.453 kilograms
ounce	oz *or* oz av	16 drams, 437.5 grains	28.349 grams
dram	dr *or* dr av	27.343 grains, 0.0625 ounces	1.771 grams
grain	gr	0.036 drams, 0.002285 ounces	0.0648 grams
		Troy	
pound	lb t	12 ounces, 240 pennyweight, 5760 grains	0.373 kilograms
ounce	oz t	20 pennyweight, 480 grains	31.103 grams
pennyweight	dwt *also* pwt	24 grains, 0.05 ounces	1.555 grams
grain	gr	0.042 pennyweight, 0.002083 ounces	0.0648 grams
		Apothecaries'	
pound	lb ap	12 ounces, 5760 grains	0.373 kilograms
ounce	oz ap	8 drams, 480 grains	31.103 grams
dram	dr ap	3 scruples, 60 grains	3.887 grams
scruple	s ap	20 grains, 0.333 drams	1.295 grams
grain	gr	0.05 scruples, 0.002083 ounces, 0.0166 drams	0.0648 grams
Capacity			
		U.S. Liquid Measure	
gallon	gal	4 quarts (2.31 cubic inches)	3.785 litres
quart	qt	2 pints (57.75 cubic inches)	0.946 litres
pint	pt	4 gills (28.875 cubic inches)	0.473 litres
gill	gi	4 fluidounces (7.218 cubic inches)	118.291 millilitres
fluidounce	fl oz	8 fluidrams (1.804 cubic inches)	29.573 millilitres
fluidram	fl dr	60 minims (0.225 cubic inches)	3.696 millilitres
minim	min	1/60 fluidram (0.003759 cubic inches)	0.061610 millilitres
		U.S. Dry Measure	
bushel	bu	4 pecks (2150.42 cubic inches)	35.238 litres
peck	pk	8 quarts (537.605 cubic inches)	8.809 litres
quart	qt	2 pints (67.200 cubic inches)	1.101 litres
pint	pt	1/2 quart (33.600 cubic inches)	0.550 litres
		British Imperial Liquid and Dry Measure	
bushel	bu	4 pecks (2219.36 cubic inches)	0.036 cubic metres
peck	pk	2 gallons (554.84 cubic inches)	0.009 cubic metres
gallon	gal	4 quarts (277.420 cubic inches)	4.545 litres
quart	qt	2 pints (69.355 cubic inches)	1.136 litres
pint	pt	4 gills (34.678 cubic inches)	568.26 cubic centimetres
gill	gi	5 fluidounces (8.669 cubic inches)	142.066 cubic centimetres
fluidounce	fl oz	8 fluidrams (1.7339 cubic inches)	28.416 cubic centimetres
fluidram	fl dr	60 minims (0.216734 cubic inches)	3.5516 cubic centimetres
minim	min	1/60 fluidram (0.003612 cubic inches)	0.059194 cubic centimetres

Length

mile	mi	5280 feet, 320 rods, 1760 yards	1.609 kilometres
rod	rd	5.50 yards, 16.5 feet	5.029 metres
yard	yd	3 feet, 36 inches	0.914 metres
foot	ft *or* '	12 inches, 0.333 yards	30.480 centimetres
inch	in *or* "	0.083 feet, 0.027 yards	2.540 centimetres

Area

square mile	sq mi *or* m^2	640 acres, 102,400 square rods	2.590 square kilometres
acre		4840 square yards, 43,560 square feet	0.405 hectares, 4047 square metres
square rod	sq rd *or* rd^2	30.25 square yards, 0.006 acres	25.293 square metres
square yard	sq yd *or* yd^2	1296 square inches, 9 square feet	0.836 square metres
square foot	sq ft *or* ft^2	144 square inches, 0.111 square yards	0.093 square metres
square inch	sq in *or* in^2	0.007 square feet, 0.00077 square yards	6.451 square centimetres

Acknowledgments from Marc Adams

Although many people have contributed in different ways to make this book possible, the following have spent countless hours, time, and energy and should be recognized for their outstanding efforts:

Thanks to John Francis at Wilsonart. He offered continuous support while I wrote this book, and reviewed the text and made important suggestions that have made the book more accurate. Many other people at Wilsonart were helpful, and I would like to single out Alison Demartino and her staff, who took the time to provide many wonderful photographs.

Thanks also to Bill Whetstone at Formica for his leadership and incredible knowledge of laminates (don't try to call him, because he is always on vacation). Kudos also to Denny Krause, who provided information and support.

I would also like to thank the following people and organizations for their help: Darrel Kiel, Jay Justesen, Kim Humphry, the entire gang at KBS, Margaret Newton, Art Betterley, Phil Smith, Zane Powell, Sarah Griffin Peck, Holbrook Plats, Randenbilt-T Inc., Marc Berner, Rich Kerin, Doris Adams, and Roberta Cole.

Finally, a very special thanks to my wife, Susie, my daughter, Markee, and my son, John, named after my father, who inspired me to start woodworking.

Acknowledgments from Roger Cliffe

I have worked with plastic laminates for about 15 years. During that time, I have learned many techniques from other professionals in the field. This book is dedicated to them and to their high professional standards of work and integrity. I would also like to thank Mr. Bradd Schule, a personal friend and mentor in the construction field. Bradd: Your presence as a role model and your incredible knowledge of all facets of construction and woodworking have been very helpful. Good luck in your new life.

Index

Pages in italics are in color